BUSINESS GRAPHICS

500 DESIGNS THAT LINK GRAPHIC AESTHETIC AND BUSINESS SAVYY

CONTENTS

9

IDENTIFY:

LOGOS, STATIONERY, AND BRAND CAMPAIGNS

92

CASE STUDY:

CO ARCHITECTS | ADAMSMORIOKA

98

CASE STUDY:

SACHNOFF & WEAVER | CROSBY ASSOCIATES

104

CASE STUDY:

AMSTERDAM PARTNERS | KESSELSKRAMER

111

COMMUNICATE:

BROCHURES, NEWSLETTERS, AND WEBSITES

166

CASE STUDY:

BE UN LIMITED | HEATH KANE DESIGN

172

CASE STUDY:

MACQUARIE TELECOM | LANDINI ASSOCIATES

178

CASE STUDY:

ASSURANT | CARBONE SMOLAN AGENCY

181

MARKET:

SALES COLLATERAL AND PACKAGING

210

CASE STUDY:

ANKASA MCUBE

216

CASE STUDY:

HARTER | THE MODERNS

224

CASE STUDY:

INTERFACE | THE VALENTINE GROUP

REPORT:

FINANCIAL PUBLICATIONS AND ANNUAL REPORTS

258

CASE STUDY:

DIAMOND BANK | ENTERPRISE IG

264

CASE STUDY:

CHICAGO BOARD OPTIONS EXCHANGE | LISKA + ASSOCIATES

270

CASE STUDY:
ASTELLAS | DELOR

275

PROMOTE:

DIRECT MAIL AND PROMOTIONAL ITEMS

290

CASE STUDY:

LE CIRQUE | MIRKO ILIĆ CORP.

296

CASE STUDY:

S7 | LANDOR ASSOCIATES

300

CASE STUDY:

WEYERHAEUSER | HORNALL ANDERSON DESIGN WORKS

307

OTHER:

MISCELLANEOUS PROJECTS

315

CONTRIBUTORS

320

ABOUT THE AUTHOR ACKNOWLEDGMENTS

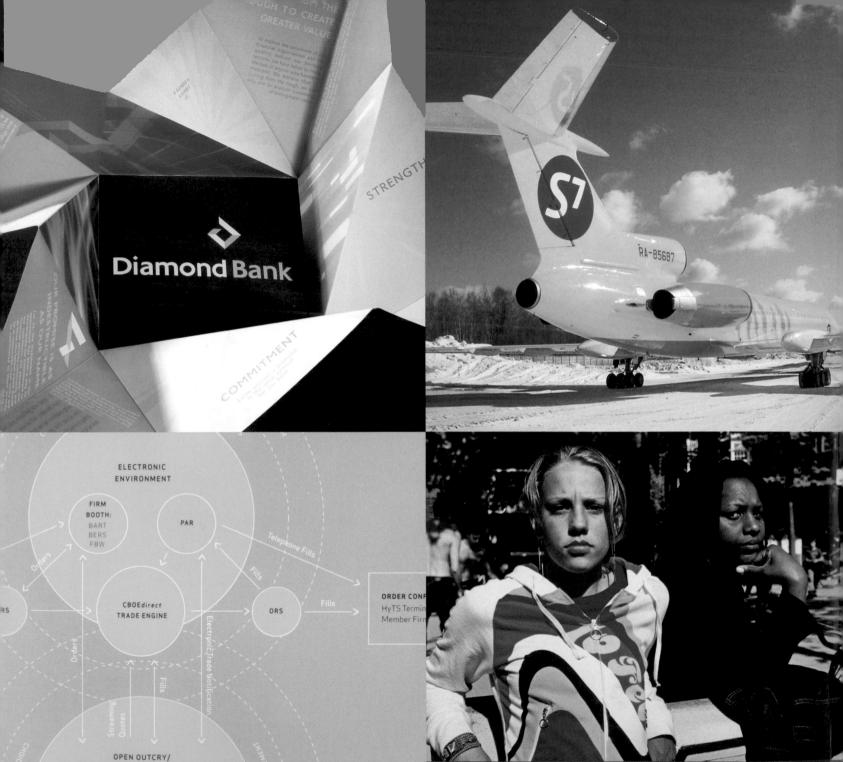

amsterd

O HAVE FLOOR BROKE

TRADING CROWD

DPMs/

MARKET

MAKERS

IN-CROWD

BROKERS

FLOATING

BROKERS

INTRODUCTION

As professional communicators, designers are critical partners in business development, sustainability, and growth. Designers develop visual and verbal systems that help companies identify, clarify, and communicate who they are, what makes them different, and why customers or clients should choose to buy their product or service. Thoughtful and branded design solutions provide memorable visual representations of a company's core attributes, and serve as the primary voice through which a company communicates.

Providing graphic design for businesses requires strategic thinking and creative discipline. It takes the ability to sift through research, listen well (and often), and thoroughly explore the possibilities and problems a company may face—before any designing takes place. Only after such critical analysis can designers create solutions that communicate the essence of a

company and its differentiating characteristics. Whether creating a comprehensive program or producing a specific project, design teams serve businesses best when the design fits within a unified branding system.

Visual systems and editorial voice must be applied consistently—and incessantly—to be effective. Every customer touch point, from advertising and sales to shipping, offers an opportunity to reinforce the qualities that differentiate one business from another. Designers help companies find these opportunities and maximize their potential through accurate and artful communication programs.

This book features fifteen case studies and hundreds of effective design solutions created for businesses. As we juried the projects and pieces submitted, we needed to determine what

constitutes "business graphics." We concluded that virtually all graphic design is created for a business of one type or another. Schools, non-profits, political parties, cultural institutions, self-promotional vehicles—at some level, these are all businesses with similar needs. Each one has an audience to reach, a story to tell, and a desire to persuade; most also have products or services to sell.

We determined that any design project that uses strategy and aesthetics to solve a client's communications issue qualifies as an example of business graphics, which led to an interesting mix for the contents of this book.

We organized the various projects using the key ways that business graphics function: *Identify*, *Communicate*, *Market*, *Report*, and *Promote*. A final category, *Other*, shows additional ways that design supports business communication.

We thank the contributors for inspiring us with their talent, and Rockport Publishers for the responsibility of articulating the elements that comprise effective and compelling business graphics.

- STEVEN LISKA, LISKA + ASSOCIATES

lach:ner lach:ner Lach-Ner s.r.o. Toximi 157, 277 11 Neratovice tel., +420 315 684 008 mobil + 420 606 711 073 e-mail: hrutby@lach-ner.cz www.lach-ner.cz Lach-Ner s.r.o., Továrni 157, 277 11 Neratovice tel. +420 315 684 008, fax +420 315 684 008 www.lach-ner.cz

ZEN CONSULTING, LLC

MOMENTUM

white apron

1 CLIENT: Lach:ner DESIGN FIRM: Bruketa & Zinic

CLIENT: Zen Consulting, LLC DESIGN FIRM: Valiant Media, Inc.

3 CLIENT: Momentum Builders DESIGN FIRM: Octavo Design/ Spark Studio

4 CLIENT: Emhz DESIGN FIRM: Talisman Interactive

5 CLIENT: White Apron DESIGN FIRM: Hartford Design

6 CLIENT: Keys To... DESIGN FIRM: Sussner Design Company

CLIENT: N. Kate DESIGN FIRM: Kinetic

n.KATE

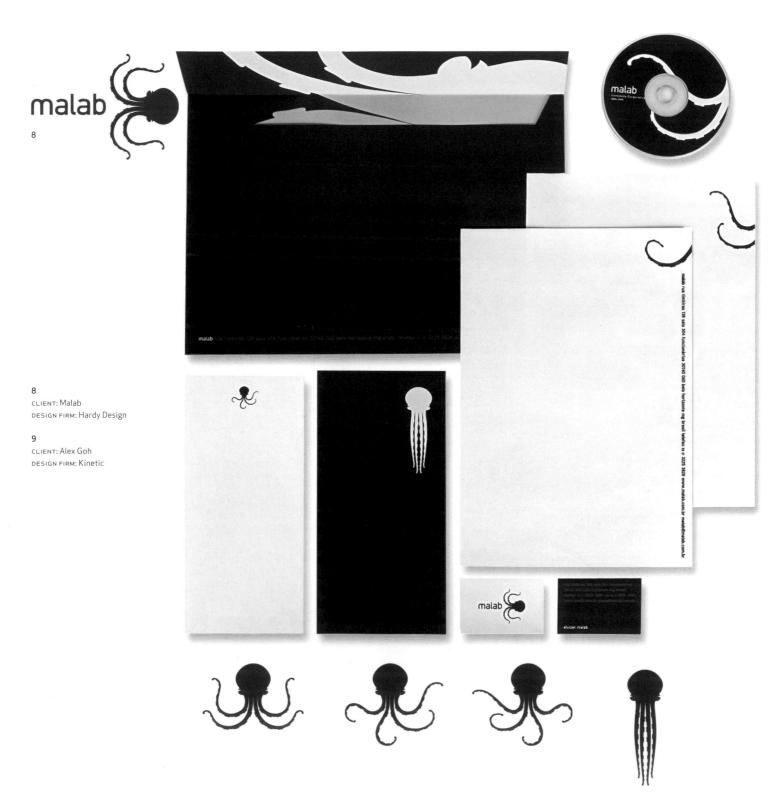

INSPIRING

WORD

Hire

Get in touch to view my book

ALEXS TOPS:

WORDS GET IN THE WAY

- GLORIA ESTEFAN DPAPERBACK WRITER

THE BEATLES

THE BEATLES

NEVERENDING STORY

LIMANL

BJUNGLE BOOK

RICHARD CHERMAN

THE THE PARTY OF T

DABC -JACKSON 5

60

900

OF THE DAY

Alex Geh

O ALPHABET SOUP

My name is Alex Goh.

I am a writer

My name is Alex Goh.

I am a writer.

My name is Alex Goh.

I am a writer.

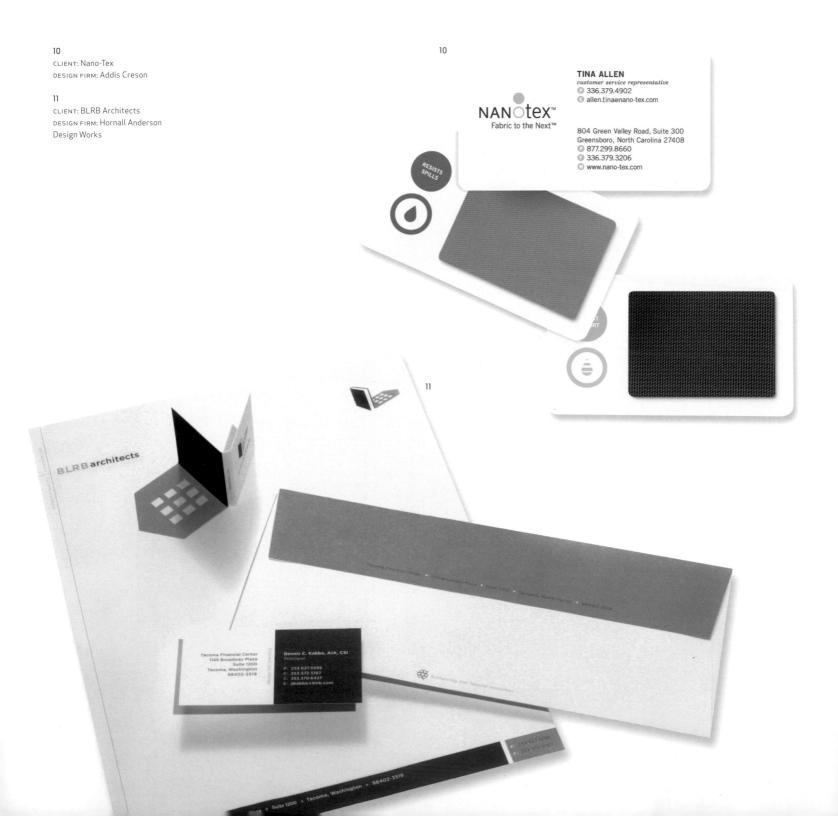

12 сыемт: Cipla DESIGN FIRM: mCube

CLIENT: 3
DESIGN FIRM: 3

14

CLIENT: Allconnect
DESIGN FIRM: Hornall Anderson
Design Works

15

CLIENT: Nikon DESIGN FIRM: Mirko Ilić Corp.

13

alleguneer.

allconnect

14

16
CLIENT: Spark Studio
DESIGN FIRM: Spark Studio

17 CLIENT: Instituto Artivisão DESIGN FIRM: Hardy Design

18
CLIENT: Sundance Institute
DESIGN FIRM: AdamsMorioka

SUNDANCE

18

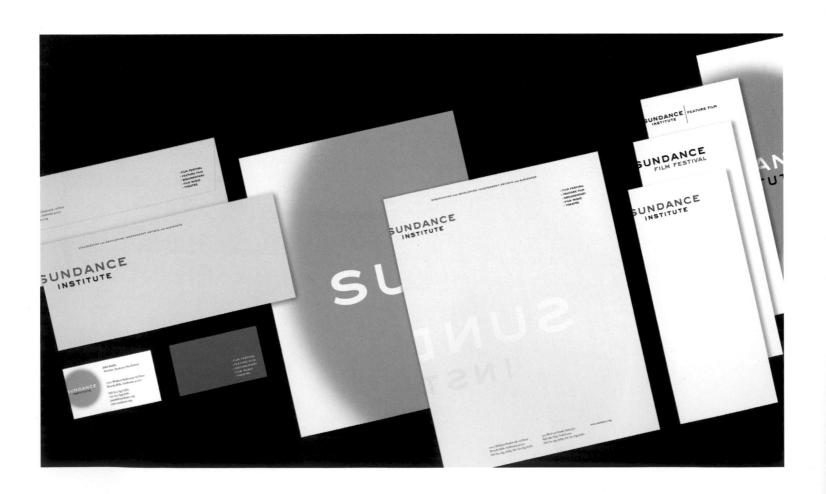

ollateral

Sundance Institute collateral combines multiple elements from the system to create a diverse but cohesive look. Use of shape and texture on covers is strongly encouraged. See Shape and Texture, p. 11

Sundance Institute Identit

zı Usage Examples: Collateral

Sundance Institute promotes creative diversity, embodying the ideals of originality and artistic integrity in support of independent spirit in the art of film and theatre.

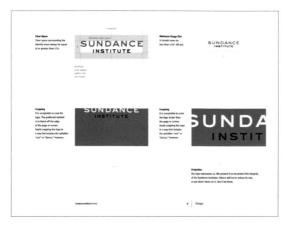

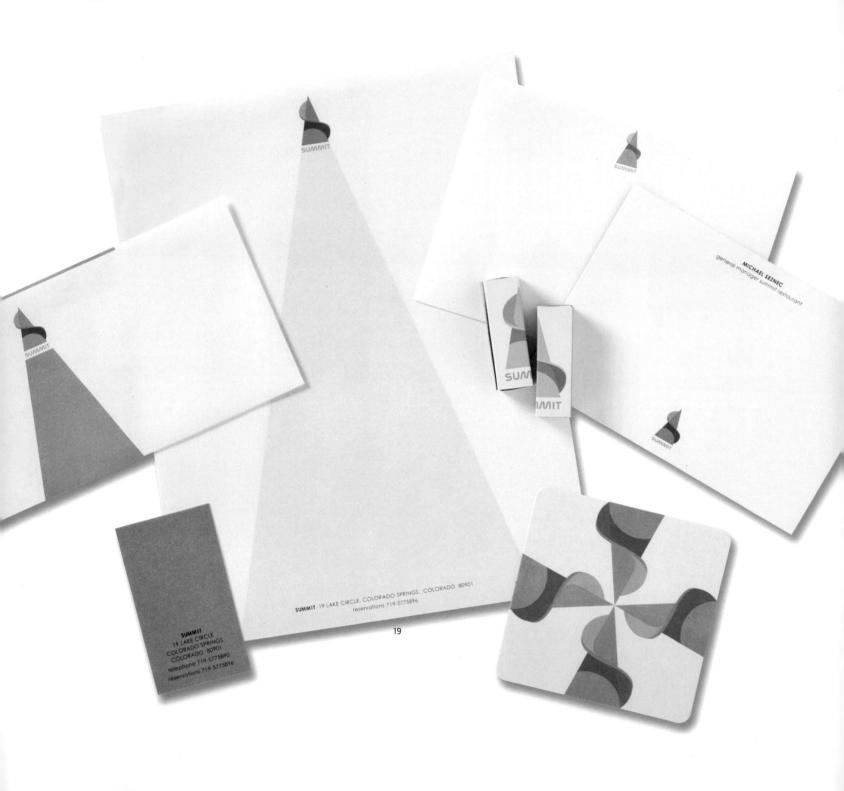

CLIENT: Summit DESIGN FIRM: Mirko Ilić Corp.

20

CLIENT: Goodman Theatre
DESIGN FIRM: Liska + Associates

21

CLIENT: ignition, Inc.
DESIGN FIRM: Timber Design Company

22

CLIENT: The Success Group
DESIGN FIRM: Sussner Design Company

23

CLIENT: Vocada, Inc.
DESIGN FIRM: Valiant Media, Inc.

24

CLIENT: Alta Pampa DESIGN FIRM: Emmi Salonen

25

CLIENT: Rancho Cordova Economic Development Corp. DESIGN FIRM: Taber Creative Group

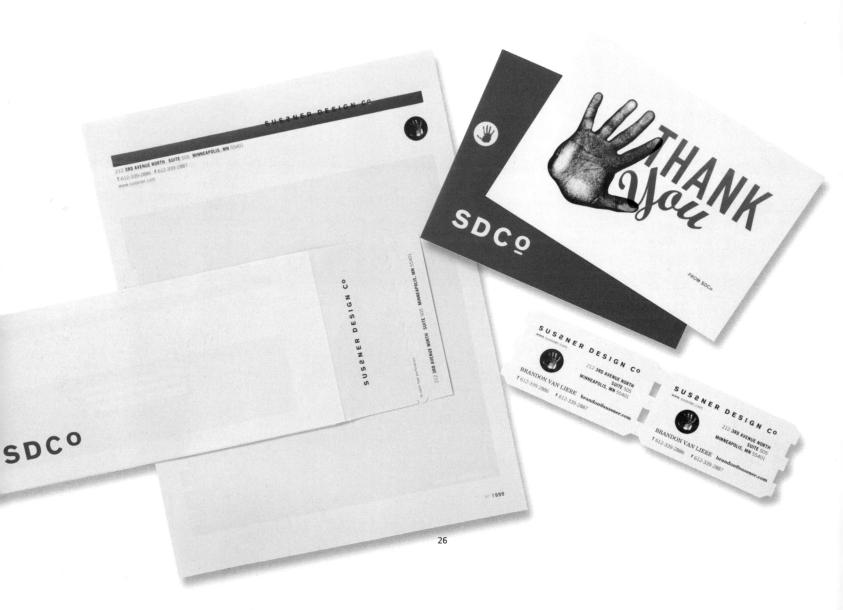

CATCH FIRE

ARE YOU ON FIRE?

26

CLIENT: Sussner Design Company
DESIGN FIRM: Sussner Design Company

27 CLIENT: The Energy Project DESIGN FIRM: 98pt6

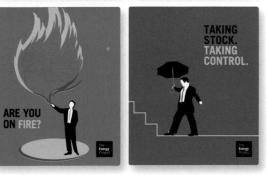

measure twice

YOU ONLY BUILD ONCE.

28

28
CLIENT: Measure Twice
DESIGN FIRM: 3

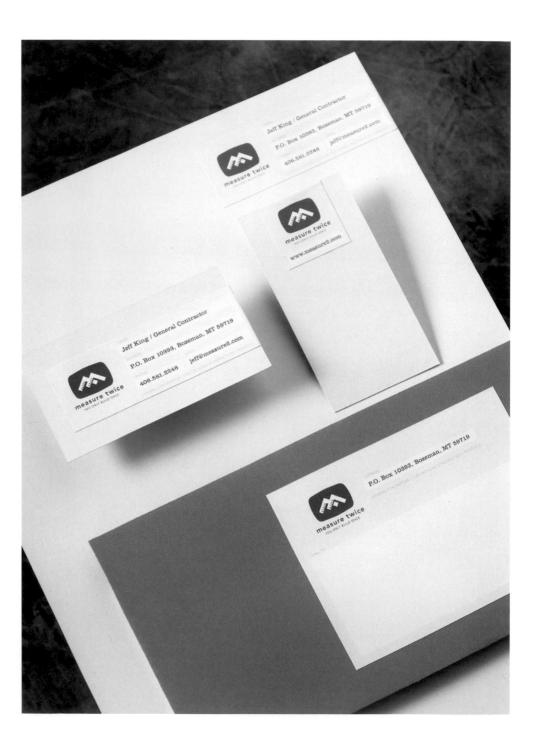

CALL US FIRST. OR CALL US LAS

GENERAL CONTRACTOR (OUSTON HOMES / REMODELS 581-2246

DON'T LET THIS HAPPEN TO YO

GENERAL CONTRACTOR (OUSTON HOMES / REMODELS 581-2246

CLIENT: Finnegan Erickson Associates
DESIGN FIRM: CDI Studios

30

CLIENT: Sapient Data Security
DESIGN FIRM: Ross Levine Design

31

CLIENT: The Grove Hotel
DESIGN FIRM: Oliver Russell

32

CLIENT: Vista Pathology DESIGN FIRM: Kinesis

33

CLIENT: West Corporation
DESIGN FIRM: Liska + Associates

34

CLIENT: Schnitzer NW
DESIGN FIRM: Hornall Anderson
Design Works

35

CLIENT: UrbanINFLUENCE
Design Studio
DESIGN FIRM: UrbanINFLUENCE
Design Studio

FINNEGAN ERICKSON ASSOCIATES

CONSULTING ENGINEERS

20

30

THE GROVE HOTEL

DOWNTOWN BOISE

31

e18ht

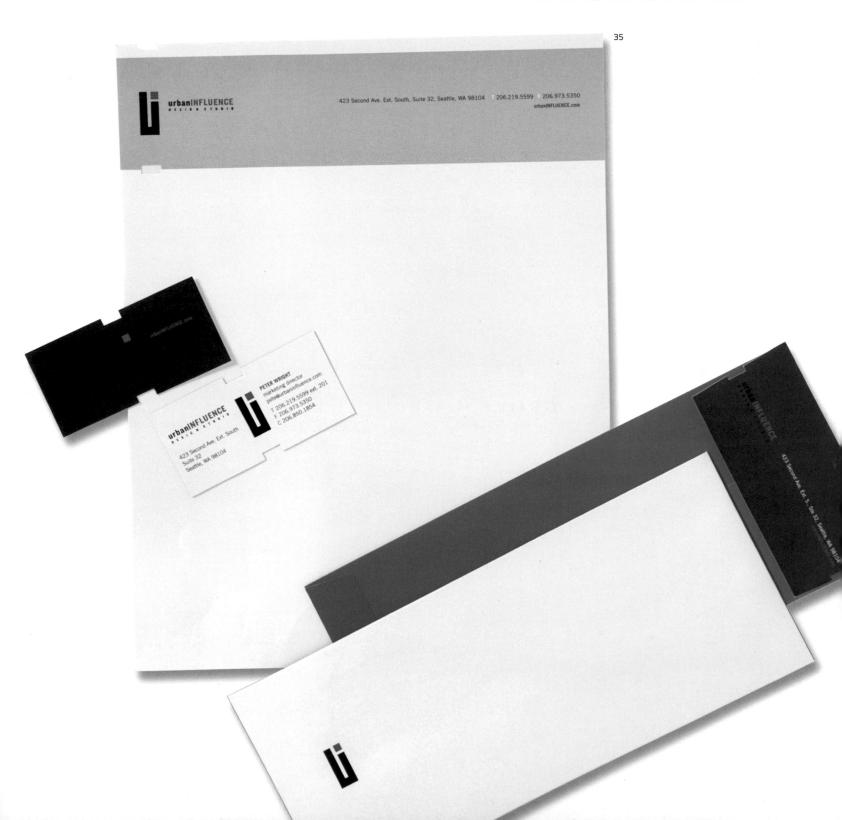

36 CLIENT: Bycor Limited DESIGN FIRM: p11 Creative

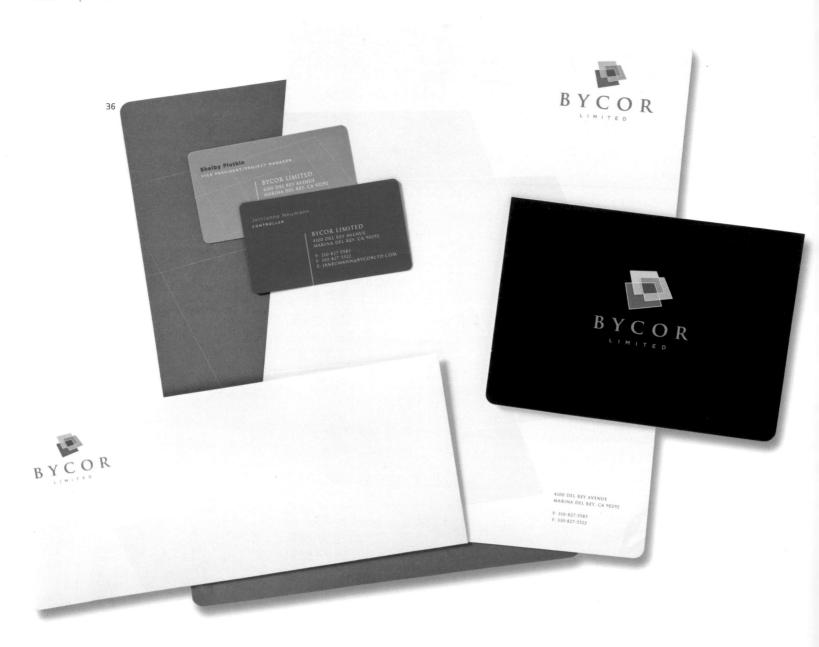

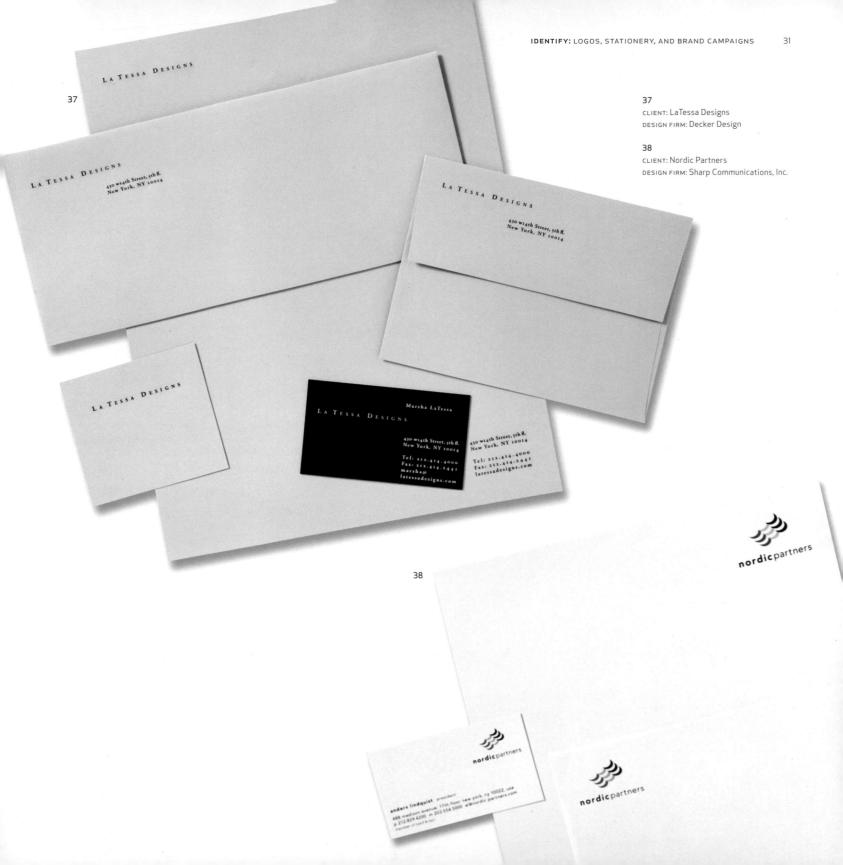

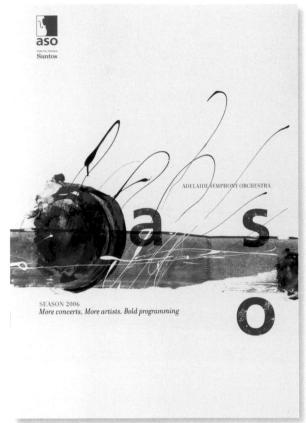

39
CLIENT: Adelaide Symphony Orchestra
DESIGN FIRM: Voice

BERNARDI

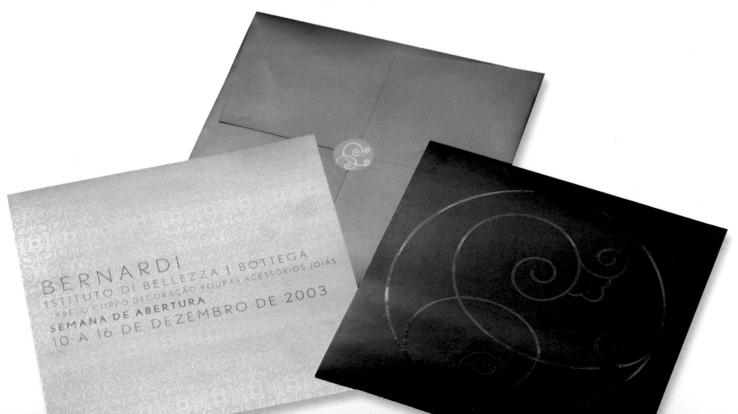

CLIENT: Widmer Brothers Brewery DESIGN FIRM: Hornall Anderson Design Works

43

CLIENT: 5 Gimnazija DESIGN FIRM: Bruketa & Zinic

44

CLIENT: Quadragen
DESIGN FIRM: Talisman Interactive

45

CLIENT: Tim Bieber: Director DESIGN FIRM: Liska + Associates

46

CLIENT: Three Below DESIGN FIRM: Spark Studio

47

CLIENT: Wet Paint
DESIGN FIRM: Hornall Anderson
Design Works

48

CLIENT: Incognito Sum
DESIGN FIRM: Octavo Design/
Spark Studio

GImnazija

Incognito Sum 3/50 Tanner Street Richmond 3121 Victoria Australia Telephone 03 9421 2025 Facsimile 03 9421 2026 info@incognitosum.com www.incognitosum.com

incognito sum

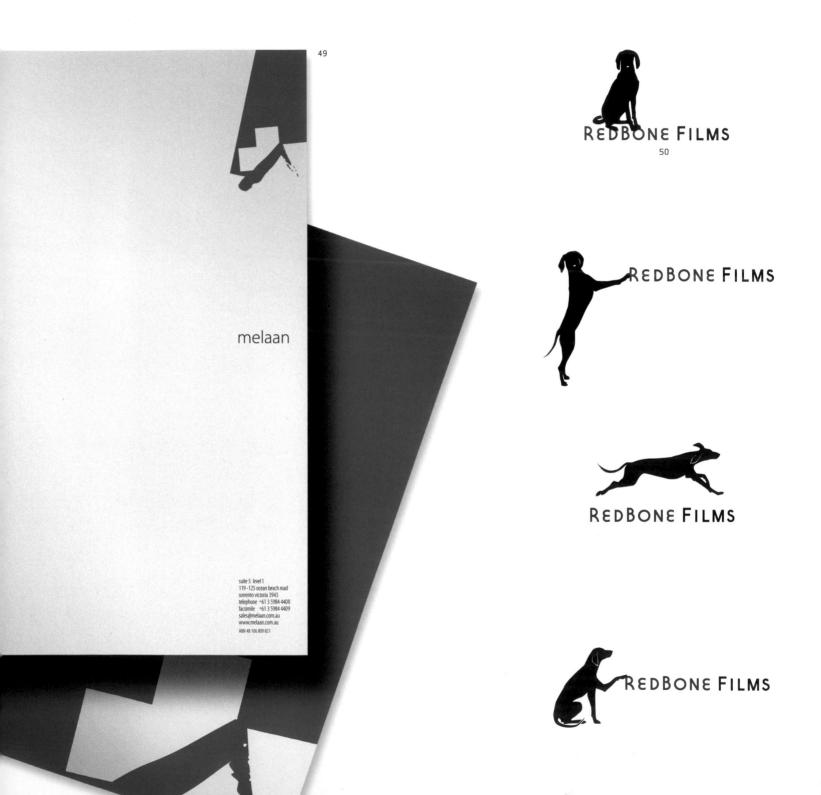

CLIENT: Melaan DESIGN FIRM: Spark Studio

50

CLIENT: Redbone Films DESIGN FIRM: AdamsMorioka

CLIENT: Brandoctor DESIGN FIRM: Brandoctor

52

сыемт: Metro Hi Speed DESIGN FIRM: UrbanINFLUENCE Design Studio

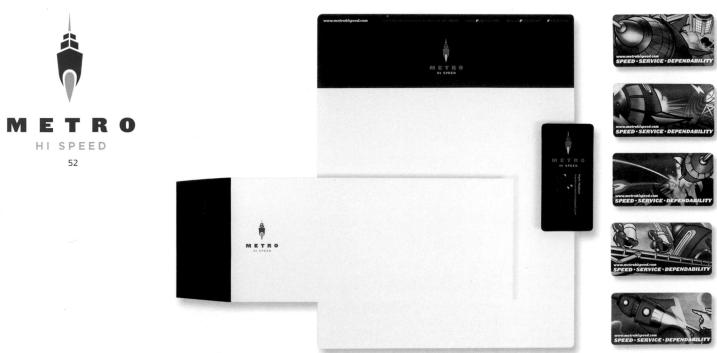

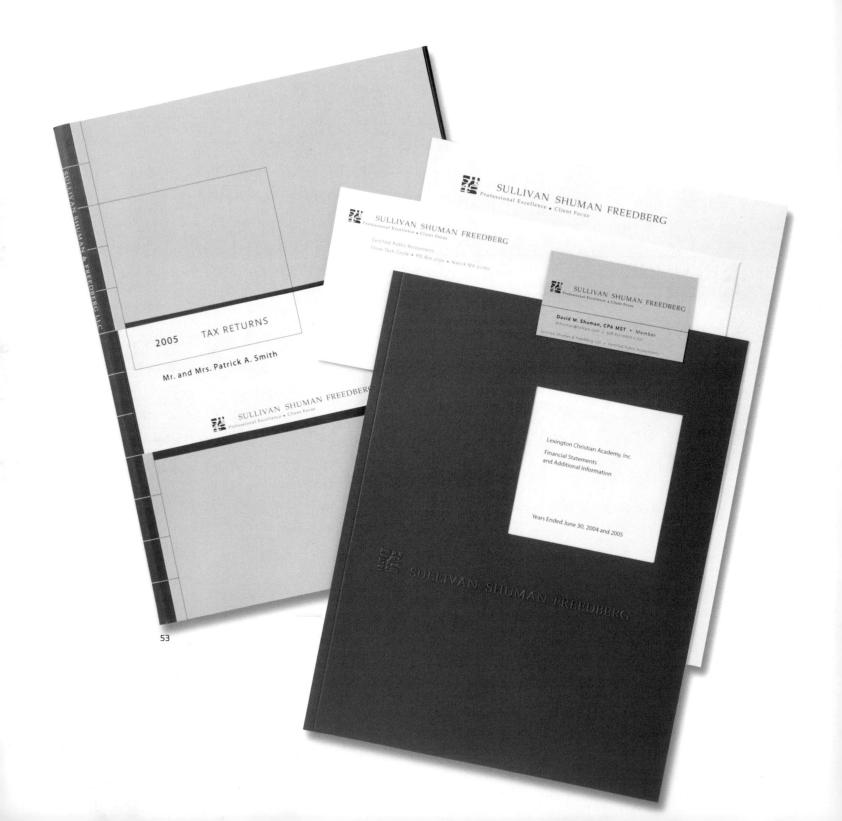

CLIENT: Sullivan Shuman Freedberg
DESIGN FIRM: Seltzer Design

54

CLIENT: Timber Design Company DESIGN FIRM: Timber Design Company

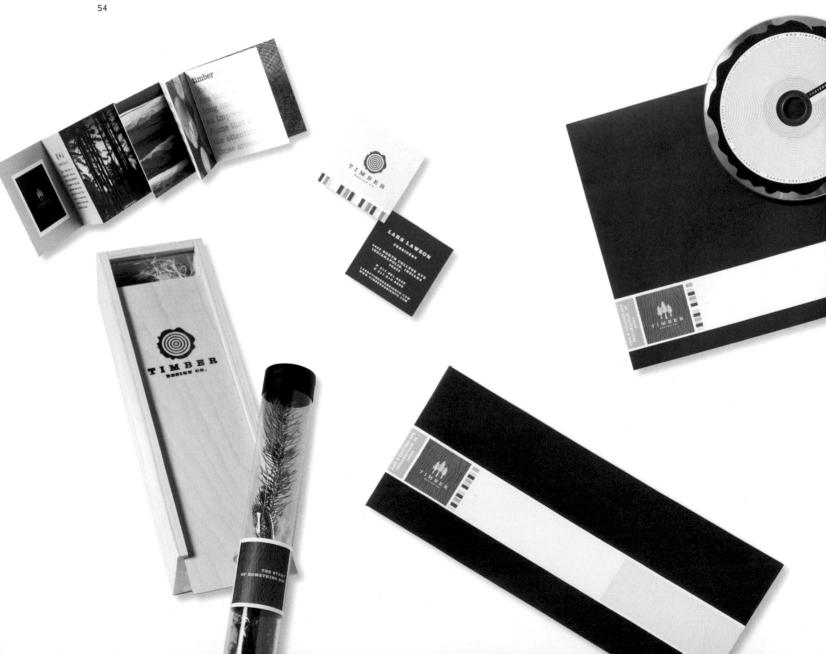

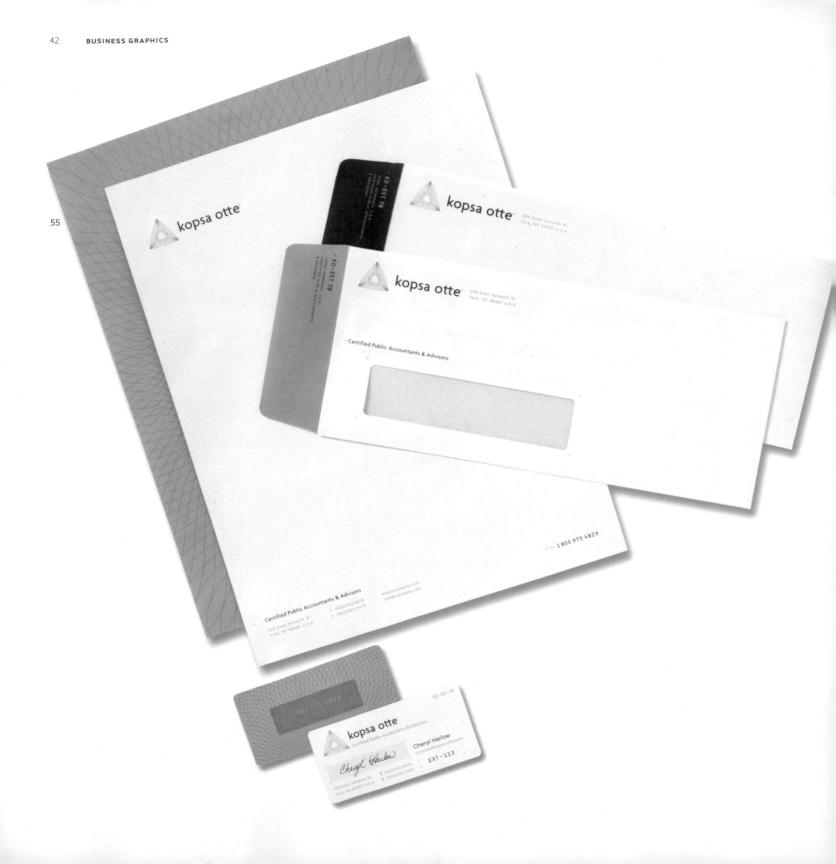

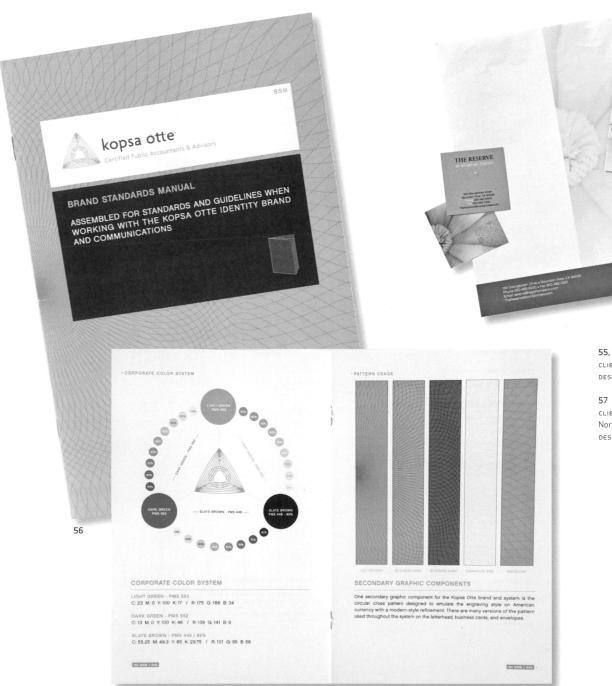

55, 56 CLIENT: Kopsa Otte DESIGN FIRM: Archrival

THE RESERVE

THE RESERVE

57
CLIENT: Regis Homes of
Northern California
DESIGN FIRM: p11 Creative

CLIENT: Tanya Dakin Photography
DESIGN FIRM: Talisman Interactive

59

CLIENT: Indiana Urban Forest Council DESIGN FIRM: Timber Design Company

60

CLIENT: Taleo
DESIGN FIRM: Addis Creson

61

CLIENT: Hudson Slaton Group DESIGN FIRM: Wages Design

62

CLIENT: Great Kitchens
DESIGN FIRM: Hartford Design

63

CLIENT: Protesa DESIGN FIRM: Diseño Dos Asociados

64

CLIENT: Wasserman Media Group DESIGN FIRM: AdamsMorioka

E0

INDIANA URBAN FOREST COUNCIL

59

60

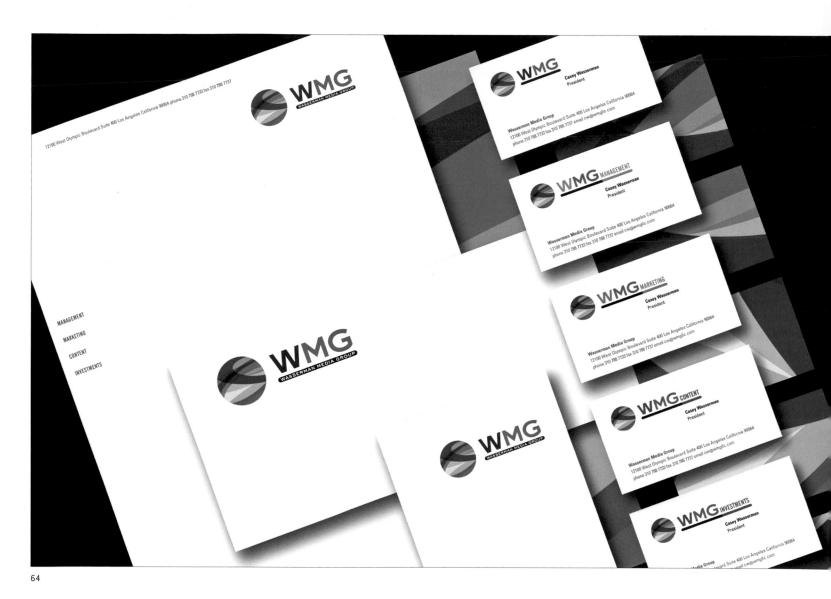

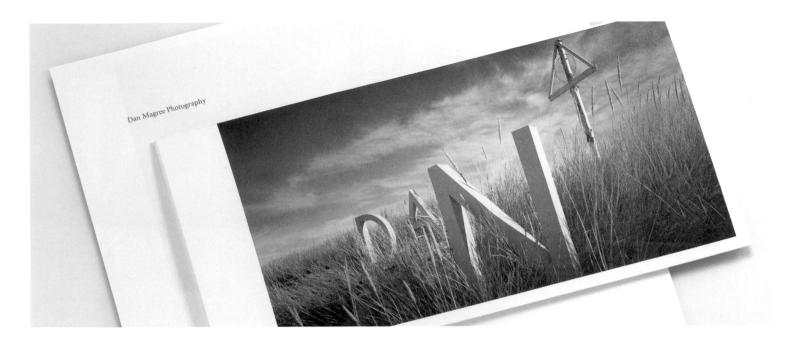

The Bakehouse Studio 2/133-135 Johnston Street Collingwood 3066 Victoria Australia

Mobile 0416 046 556 Telephone +61 3 9417 6448 Facsimile +61 3 9417 6442 dan@danmagree.com www.danmagree.com

Dan Magree Photography

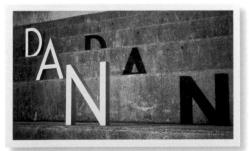

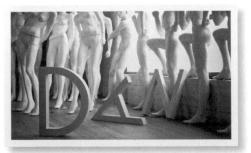

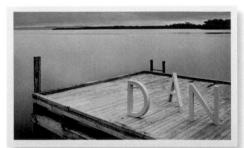

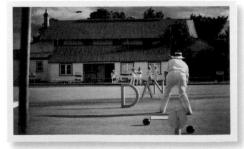

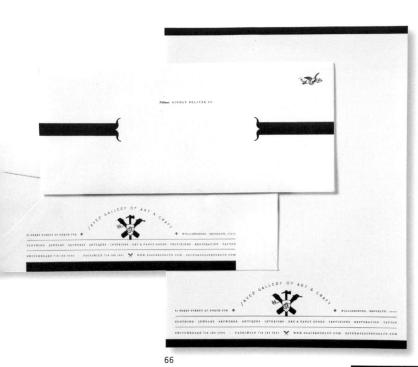

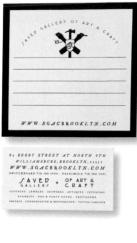

65 CLIENT: Dan Magree Photography DESIGN FIRM: Davidson Design

66
CLIENT: Saved Gallery of Art + Craft
DESIGN FIRM: Nothing: Something: NY

20 Z

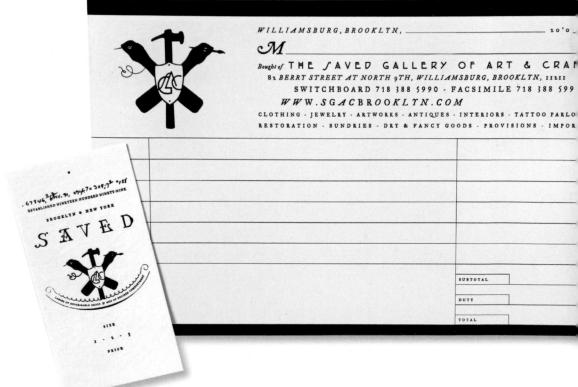

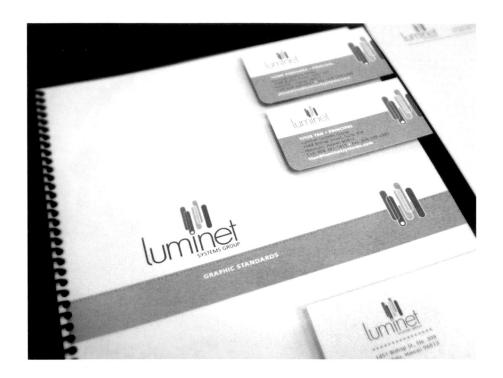

Nokia Global Games Summit

7

CLIENT: Luminet
DESIGN FIRM. John Wingard Design

68

CLIENT: Quba 3
DESIGN FIRM: Fluid Design Lab

69

CLIENT: Intel-Centrino
DESIGN FIRM: Addis Creson

70

CLIENT: Xhilarate
DESIGN FIRM: Talisman Interactive

71

CLIENT: Nokia
DESIGN FIRM: Valiant Media, Inc.

72

CLIENT: Outlink
DESIGN FIRM: Hartford Design

73

CLIENT: Tangerine Concepts
DESIGN FIRM: OneMethod Inc.

74

CLIENT: Agency Access
DESIGN FIRM: Matthew Schwartz
Design Studio

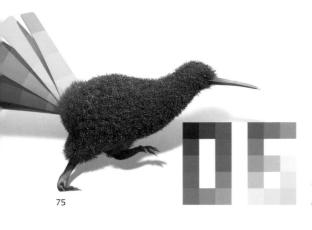

New Zealand International **Arts Festival**

24 February - 19 March

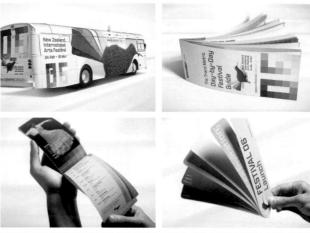

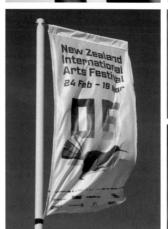

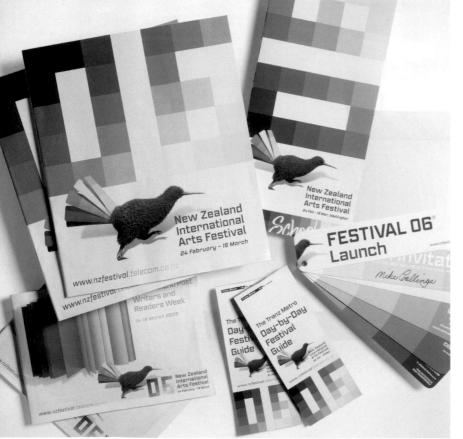

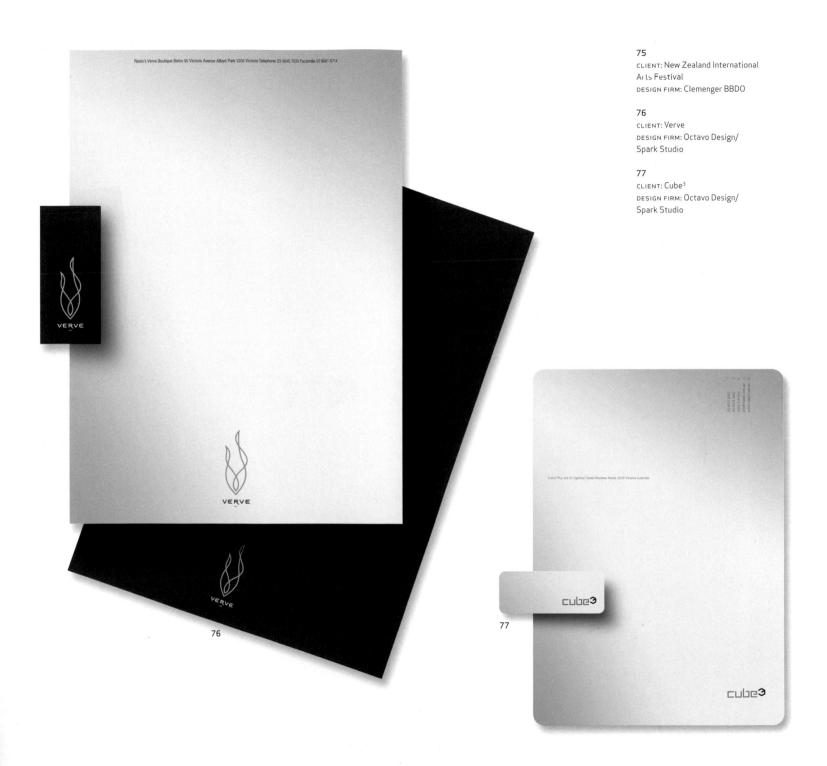

CLIENT: America Abroad Media DESIGN FIRM: Matthew Schwartz Design Studio

79

CLIENT: Regis Homes of Northern California DESIGN FIRM: p11 Creative

80

CLIENT: Food Bank of Alaska DESIGN FIRM: Mad Dog Graphx

81

CLIENT: Root Idea
DESIGN FIRM: Root Idea

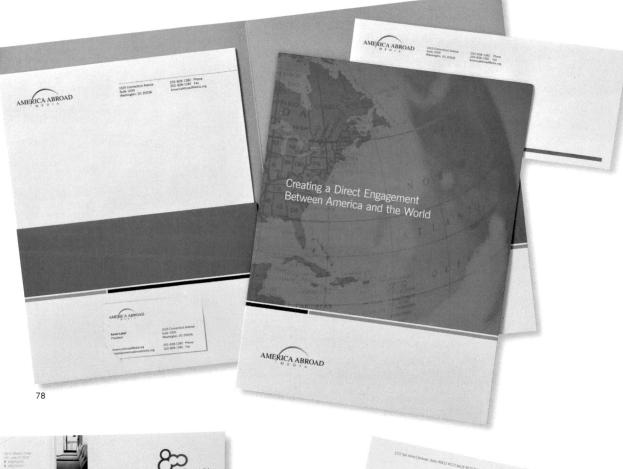

KENLEE AND THE STATE OF THE STA

ROOT

taxhelp

associates

CLIENT: Kitz DESIGN FIRM: Kinetic

83

CLIENT: Thomas Sweet DESIGN FIRM: 98pt6

21

CLIENT: Tax Help
DESIGN FIRM: UrbanINFLUENCE
Design Studio

85

CLIENT: Croatian National Tourist Board DESIGN FIRM: Studio International

86

CLIENT: Wenlop
DESIGN FIRM: Diseño Dos Asociados

87

CLIENT: Euroleague Basketball DESIGN FIRM: Sockeye Creative

88

CLIENT: Laporta DESIGN FIRM: Diseño Dos Asociados

RESIDENCIAL

89
CLIENT: Goodness
DESIGN FIRM: Clemenger BBDO

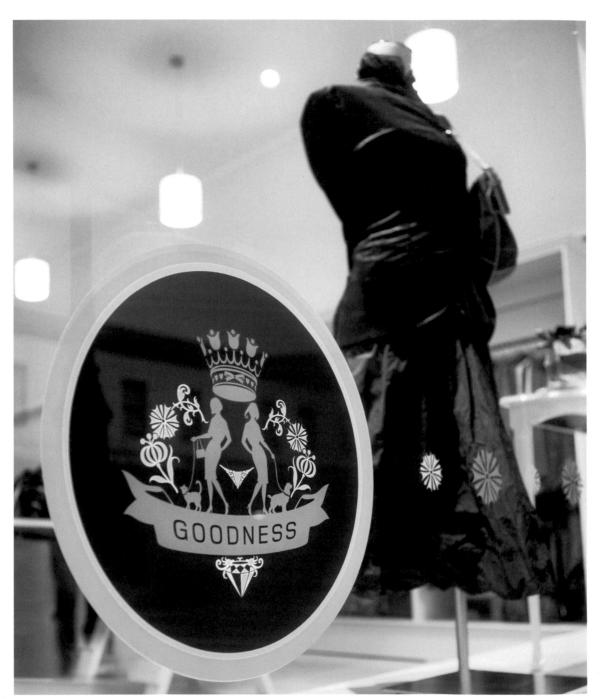

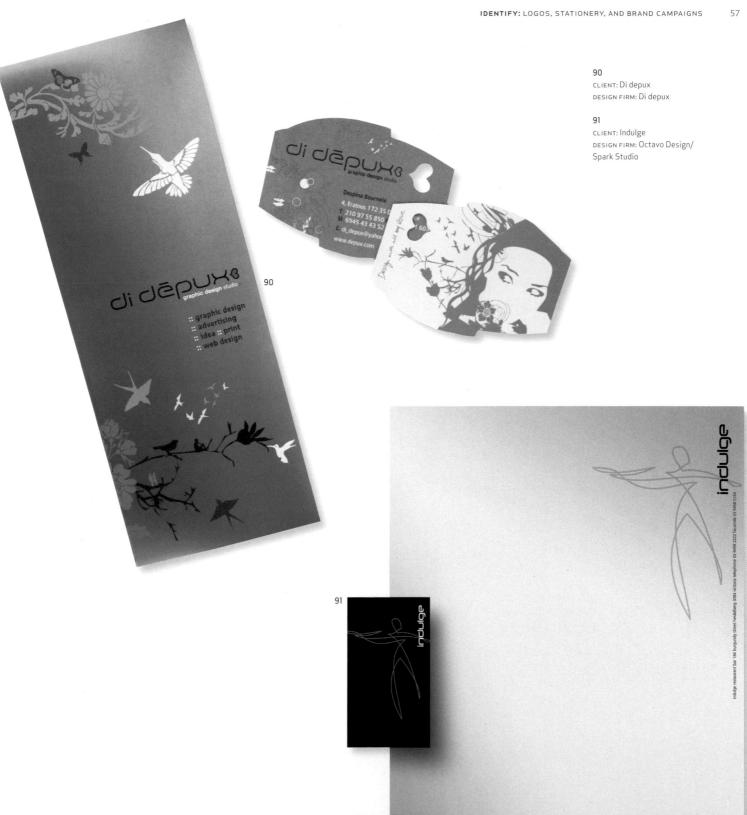

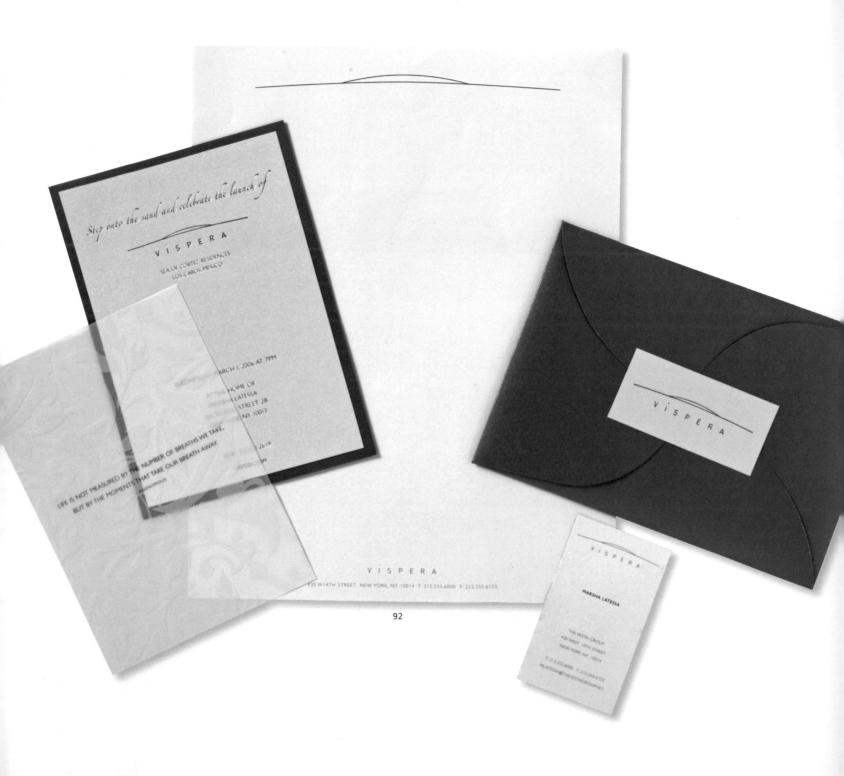

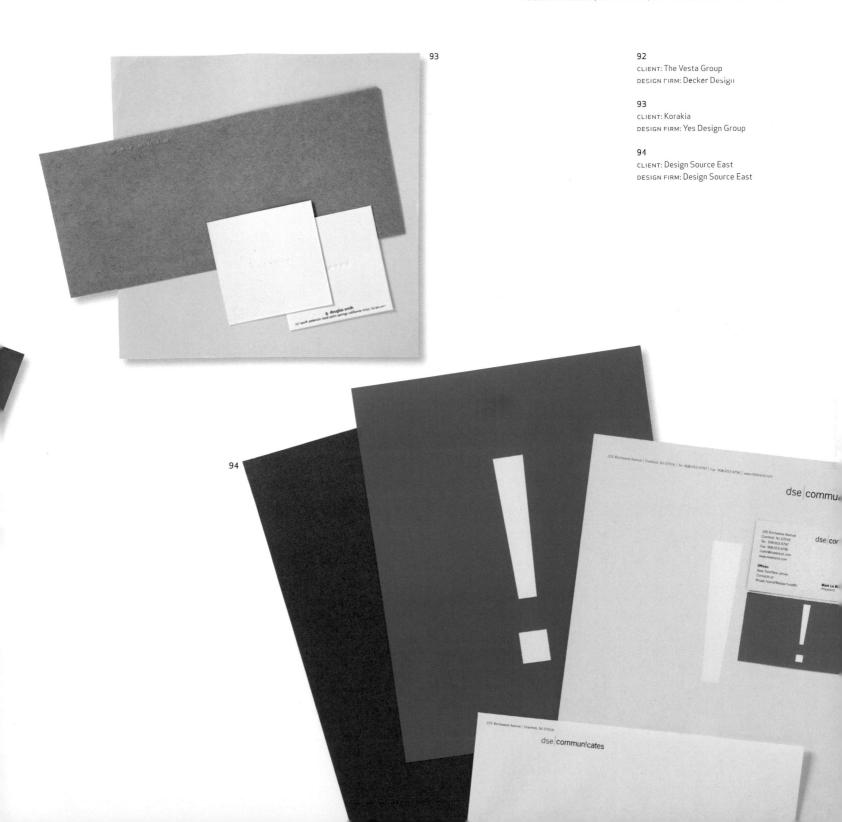

95
CLIENT: Bergen Street Studio
DESIGN FIRM: Poulin & Morris Inc.

96 CLIENT: Routledge Modise Moss Morris DESIGN FIRM: Enterprise IG

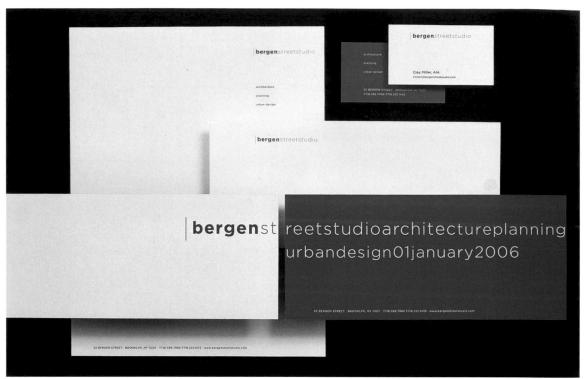

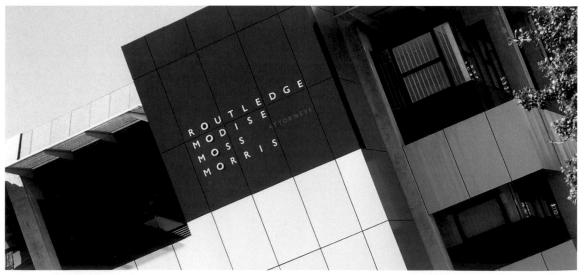

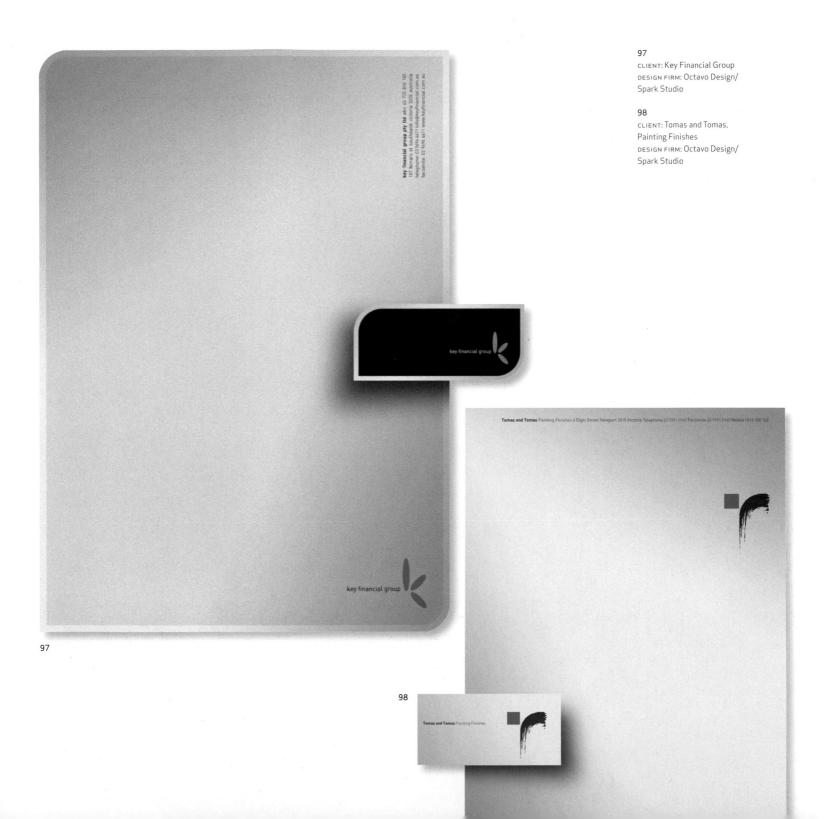

CLIENT: The Giles Agency
DESIGN FIRM: Timber Design Company

100

CLIENT: DIM
DESIGN FIRM: Manasteriotti
Design Studio

101

CLIENT: 16 Candles Bakery
DESIGN FIRM: Talisman Interactive

102

CLIENT: Riat Telecom
DESIGN FIRM: UrbanINFLUENCE
Design Studio

103

CLIENT: Alaska State Chamber of Commerce DESIGN FIRM: Mad Dog Graphx

104

CLIENT: The Handel Group DESIGN FIRM: AS|D Labs, Inc.

RIATTELECION

ALASKA STATE CHAMBER
OF COMMERCE
103

THE HANDEL GROUP

105

CLIENT: Newman International DESIGN FIRM: Davidson Design

106

CLIENT: Holmes Private Investigators DESIGN FIRM: Kinetic

107

CLIENT: Becky Lucas
DESIGN FIRM: Emmi Salonen

108 CLIENT: Truefitt & Hill DESIGN FIRM: 98pt6

TRUEFITT&HILL

EST. 1805 · ST. JAMES'S · LONDON

Grooming men for greatness.

108

Brian Jacobson Chief Fiancial Officer

216 W. Jackson Blvd. Suite 1040 Chicago IL 60606 www.truefittandhill.com Tel: 312 714 1011 Cell: 312 597 5138 Fax: 312 714 1059 brian.j@truefittandhill.com

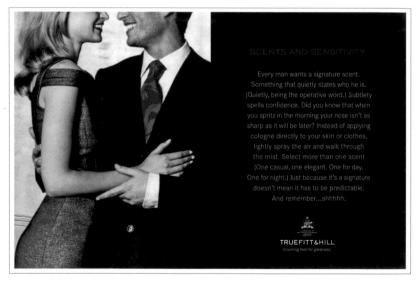

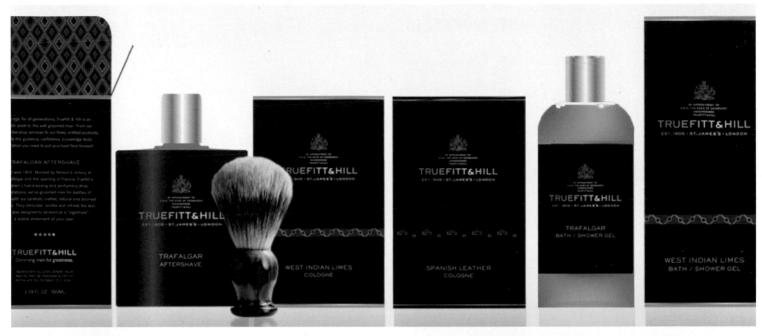

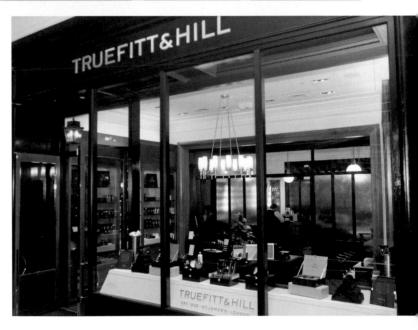

CLIENT: FNM Group DESIGN FIRM: Carré Noir Roma

110

CLIENT: Interior Resource DESIGN FIRM: Hollis Brand Communications

111

CLIENT: Thuma Works DESIGN FIRM: UrbanINFLUENCE Design Studio

112

CLIENT: The Jim Henson Company DESIGN FIRM: Michele Moore Design

113

CLIENT: Mohomine DESIGN FIRM: Hollis Brand Communications

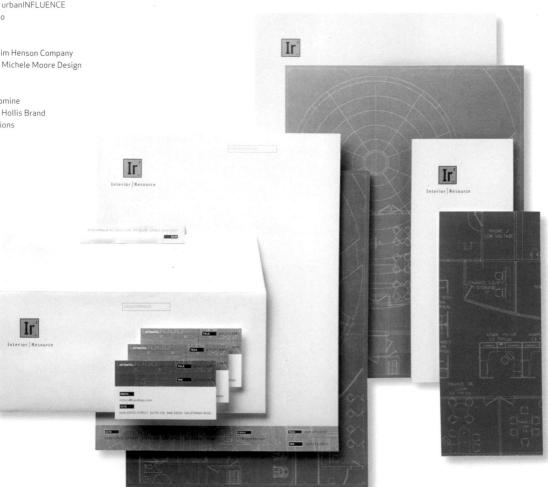

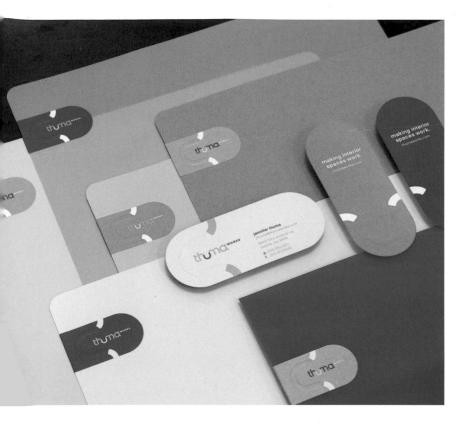

thomaworks

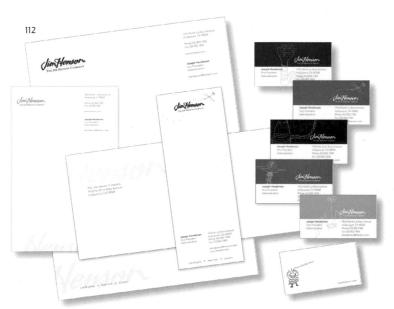

REFLECTIONS

114

CLIENT: Ulola DESIGN FIRM: Elevator

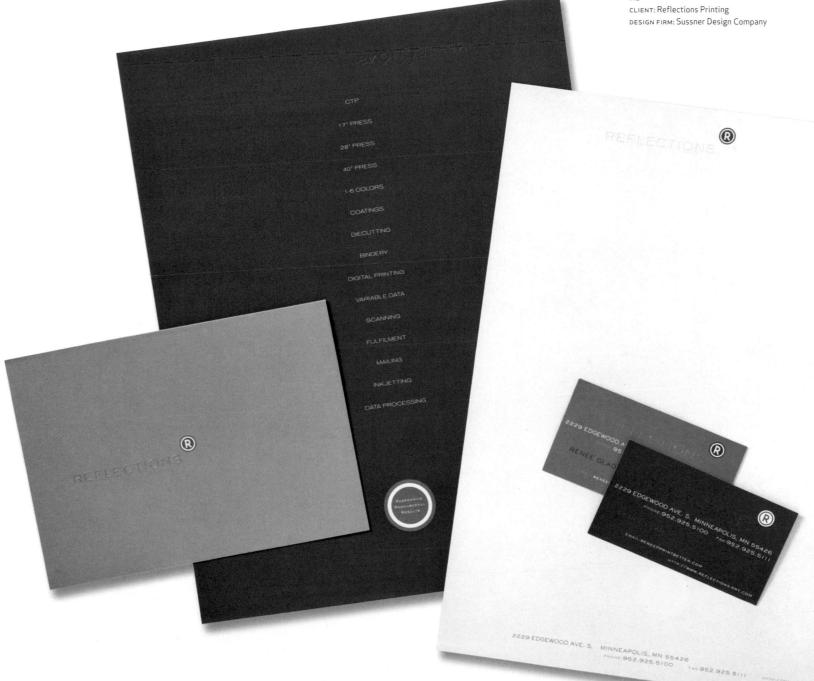

CLIENT: Lorenzo's Salon, Reflections Printing DESIGN FIRM: Sussner Design Company

117

CLIENT: Otsu DESIGN FIRM: JDAnthony

118

CLIENT: Kaleidoscope Information Services, Inc. DESIGN FIRM: Valiant Media, Inc.

119

CLIENT: Fantela Apartments DESIGN FIRM: Elevator

120

CLIENT: Marinanet DESIGN FIRM: Manasteriotti Design

CLIENT: Arlig Teckna DESIGN FIRM: Sussner Design Company

122

CLIENT: Axcelerator Home Loans DESIGN FIRM: Octavo Design/ Spark Studio

9rau

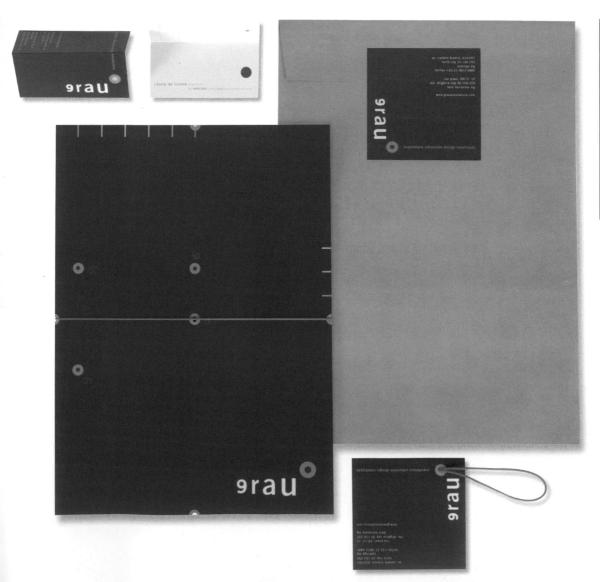

123 CLIENT: 9 Grau DESIGN FIRM: Hardy Design 124 124 CLIENT: Sender Legal Search Sender | LEGAL SEARCH DESIGN FIRM: Seltzer Design Sender | LEGAL SEARCH 100 Boylston Street Suite 1035 Boston MA 02116 Jane Sender President 100 Boylston Street Suite 1035 Boston MA 02116 617 426 5300 fax 617.426.0015 sender@jslegalsearch.com | slegalsearch.com Sender | LEGAL SEARCH 100 Boylston Street Suite 1035 Boston MA 02116 617 426 5300 fax 617 426 0015 sender@jslegalsearch.com jslegalsearch.com

125

CLIENT: The Moinian Group
DESIGN FIRM: The Valentine Group

ATELIER

635 WEST 42ND STREET new york, new york 10036

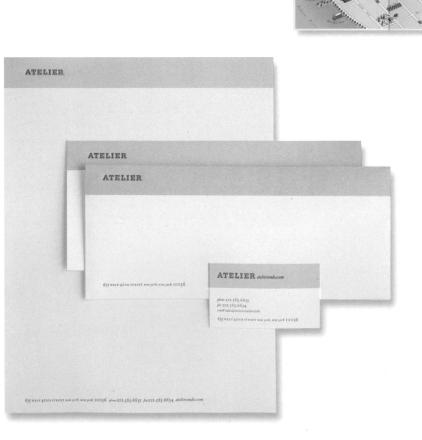

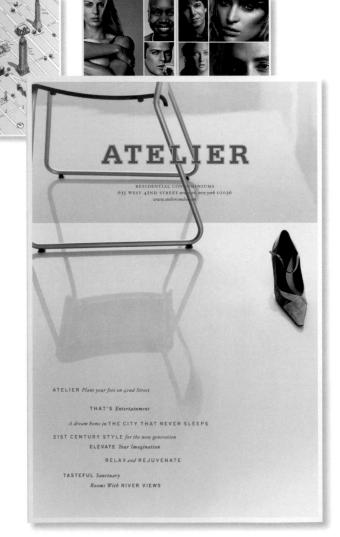

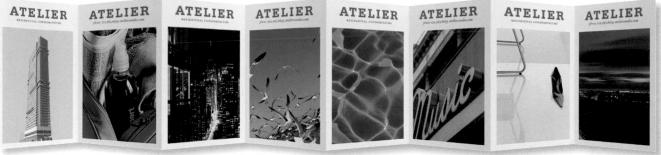

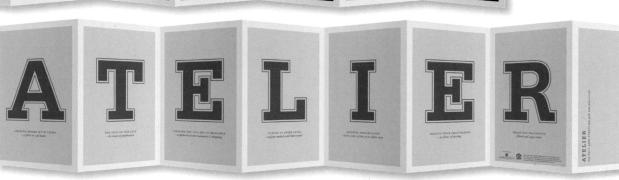

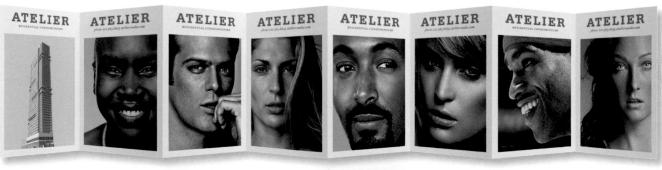

CLIENT: Everett Fenton Gidley DESIGN FIRM: Nazy Alvarez

127

CLIENT: Springboard Creative
DESIGN FIRM: Springboard Creative

128

CLIENT: Traffix
DESIGN FIRM: Lloyd's Graphic Design Ltd.

129

CLIENT: Ant Industrial Design Pte Ltd
DESIGN FIRM: Ant Industrial Design Pte Ltd

CLIENT: Fundação Biominas DESIGN FIRM: Hardy Design

131

CLIENT: ClariPath
DESIGN FIRM: JDAnthony

132

CLIENT: Galenski DESIGN FIRM: Elevator

133

CLIENT: Ljekarna Splitsko-dalmatinske županije DESIGN FIRM: Elevator

134

CLIENT: Dentos DESIGN FIRM: Diseño Dos Asociados

Ljekarna Splitsko-dalmatinske županije

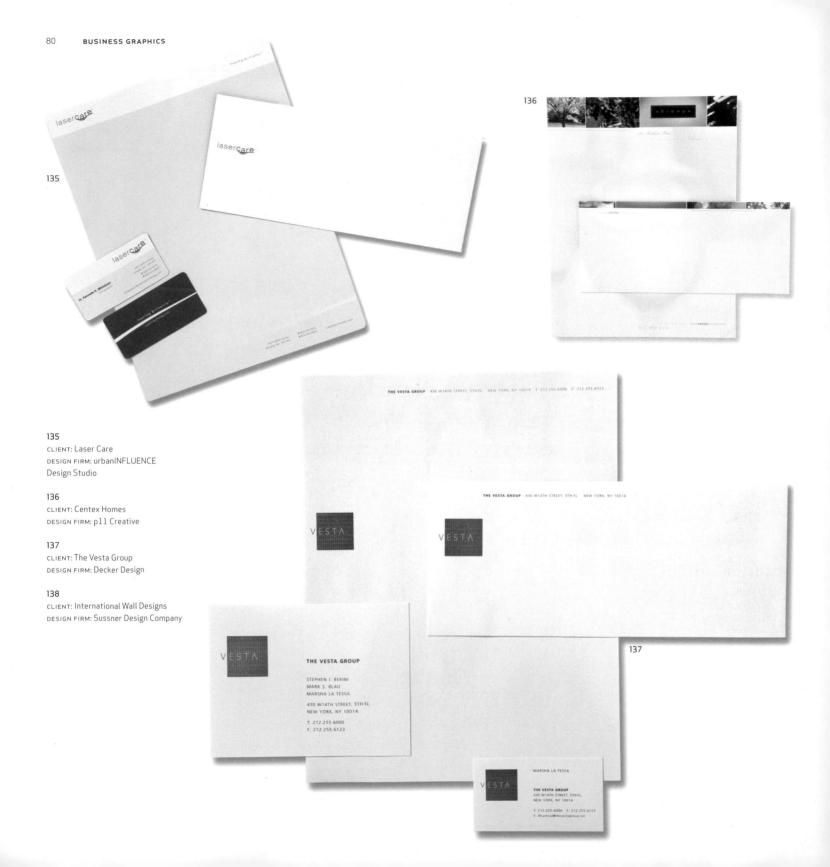

139 сыемт: Brigite DESIGN FIRM: Hardy Design

140

CLIENT: Consolidated Shoe Company DESIGN FIRM: The Republik

BRIGITE BRIGITE

BRIGITE BRIGITE

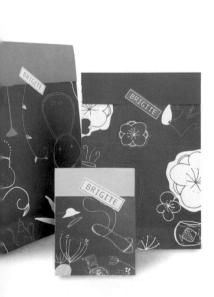

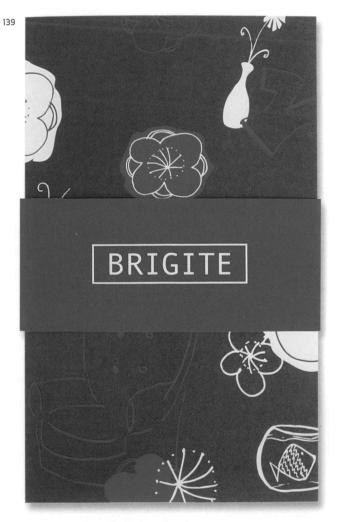

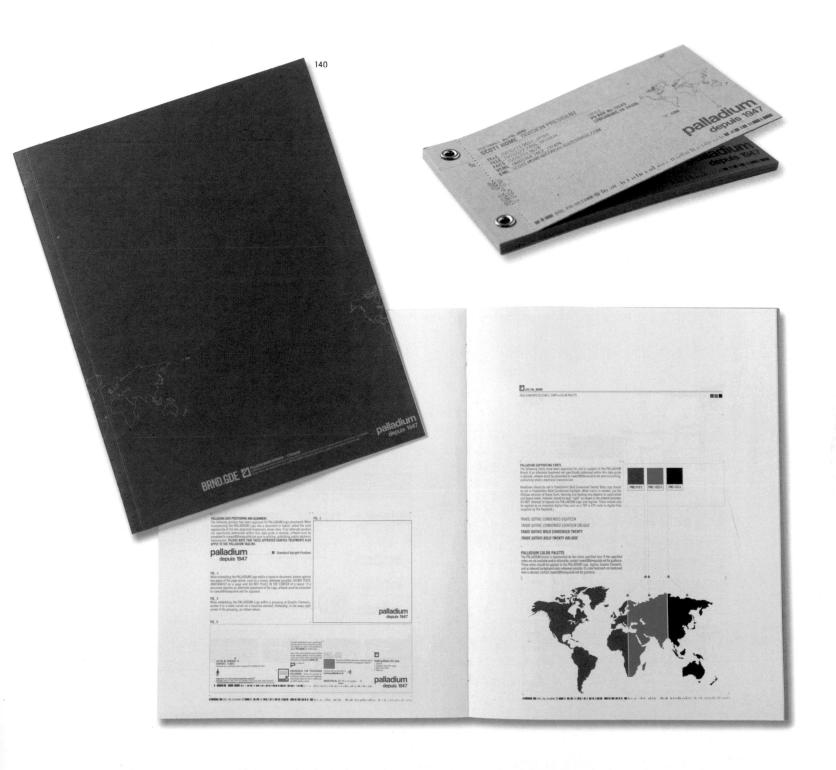

CLIENT: Pete's Mountain
DESIGN FIRM: Sockeye Creative

142

CLIENT: JDAnthony
DESIGN FIRM: JDAnthony

143

CLIENT: Mika Ohtsuki, Piano Technician DESIGN FIRM: Emmi Salonen

144

CLIENT: Cold Standard
DESIGN FIRM: Hornall Anderson
Design Works

145

CLIENT: Diamlink
DESIGN FIRM: Mindseye Creative

146

CLIENT: Črernelić-Business Interior Solutions DESIGN FIRM: Brandoctor

147

CLIENT: Mineral Image
DESIGN FIRM: Hardy Design

JDANTHONY

CREATIVE INTELLIGENCE GROUP

142

144

ČERNELIĆ Rješenja za poslovne interijere

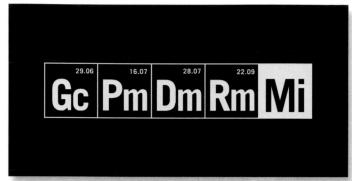

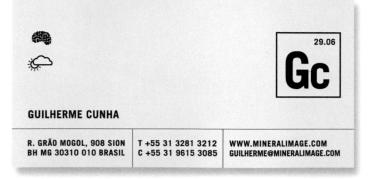

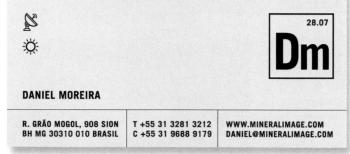

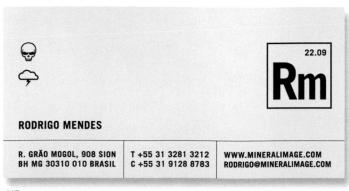

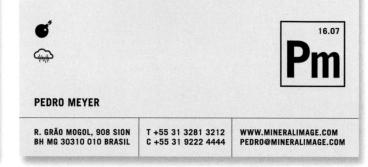

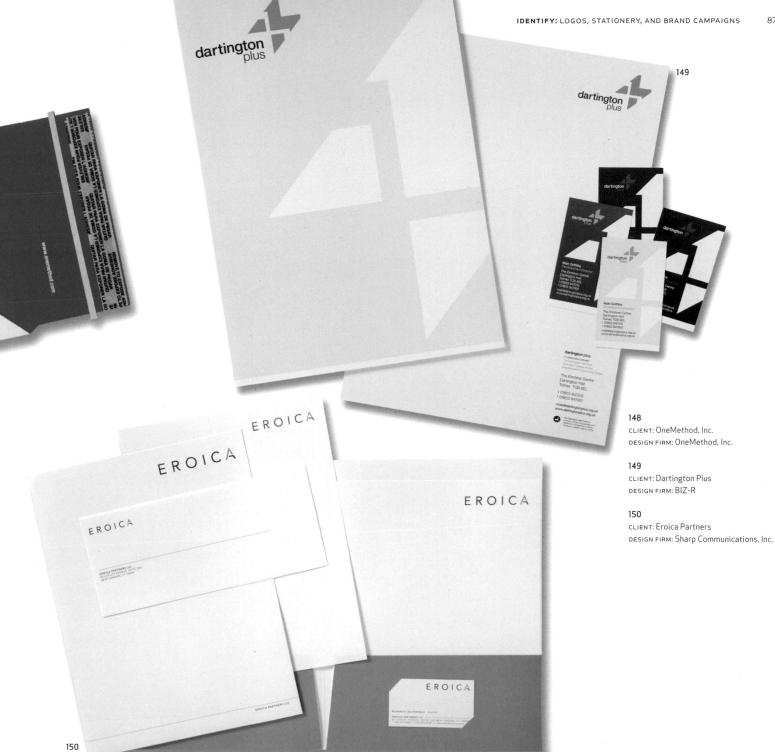

LANG NATURALS, INC. 20 Silva Lane Newport, RI 02842 T 401 848 7700 F 401 848 7701 www.langnaturals.com

DAVID LANG dave.lang@naturals.com

LANG NATURALS, INC. 20 Silva Lane Newport, RI 02842 T 401 848 7700 F 401 848 7701 www.langnaturals.com

stay.
a modern
dog hotel

LYRIS

CLIENT: Lang Naturals
DESIGN FIRM: Lowercase, Inc.

152

CLIENT: Jerry Adams Day Spa & Salon DESIGN FIRM: Liska + Associates

153

CLIENT: Vastu Commons
DESIGN FIRM: Lienhart Design

154

CLIENT: Stay. A Modern Dog Hotel DESIGN FIRM: Liska + Associates

155

CLIENT: Lyris
DESIGN FIRM: Hardy Design

156

CLIENT: Subject Wills & Company DESIGN FIRM: Talisman Interactive

157

CLIENT: Pier Sixty & The Lighthouse DESIGN FIRM: Sharp Communications, Inc.

nalh

nurturing growth in your bottom line.

112-8988 fraserton court burnaby, bc v5j 5h8

telephone 604.412.3885

web site www.nalh.ca e-mail info@nalh.ca nalh bookseeping services its joyce wishart managing director

12-8988 fraserton court ournaby, bc v5i 5h8

158

telephone 604.412.3885 facsimile 604.412.3888

www.nalh.ca

joyce@nalh.ca

nurturing growth in your bottom line.

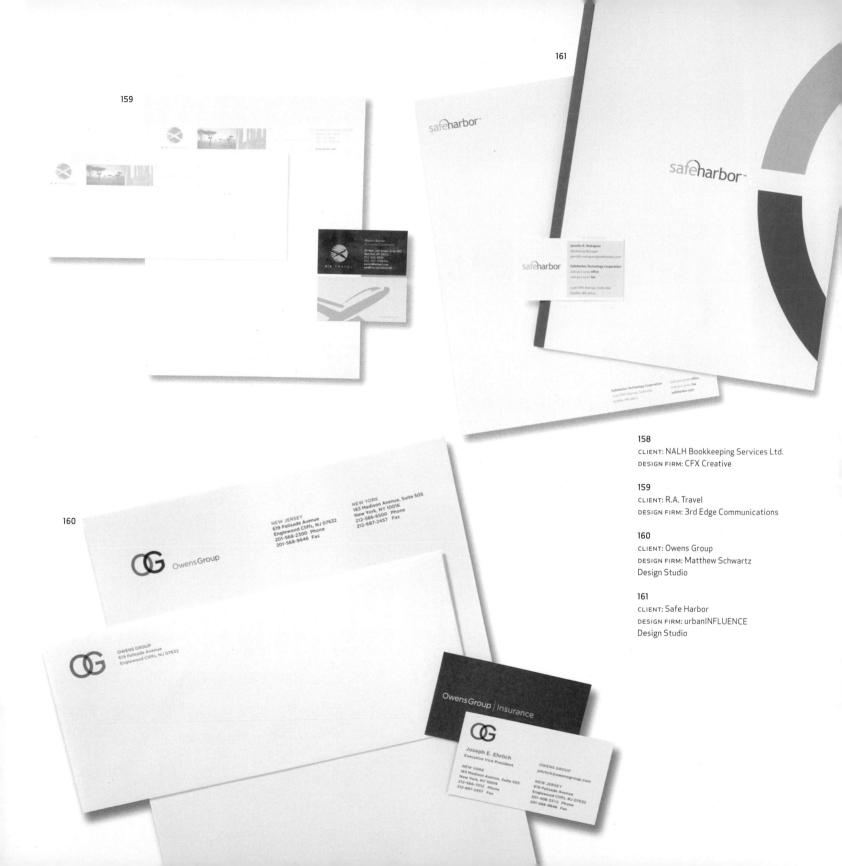

We started in 1986 as a regional office of the

San Francisco based Anshen+Allen. Ten years later

owned. While expressing our own identity in the

name Anshen+Allen Los Angeles, we continued

alliance with the Anshen+Allen organization.

we became a separate firm, autonomous and locally

to be linked to our origins by remaining in a working

that we were independently owned and operated. In a sense, we embraced what has been described as "devolu-tion," a concept that allowed us to operate independently, become even What was the reaction? The prin-cipals in the San Francisco office were very understanding of the need for our firm to embrace a unique identity. operate independently, become even more responsive to our clients needs and create challenging opportunities for young talented architects, while participating in a larger network known as Anshen+Allen.

Was the decision unanimous among the principals in Los Angeles? Absolutely.

When was Anshen+Allen in San Francisco notified? April 18, 2005

our irm to embrace a unique identity. They have been proactive in working with us to assure customers that this is a change in name only, and that the professional standards of both firms remain exceptionally high.

agreement involve any financial exchange? No.

How will the firms manage business they now work on jointly? We will work as partners toward a single, unified goal: to exceed our clients'expectations for the projects.

Our clients are paramount and we will do everything in our power to meet this goal.

Will the firms compete? As two wait the tirms competer as two completely independent firms workin in the same fields it is only natural thi we will be submitting for the same projects from time to time.

Will you continue to focus on the academic, science and technology, healthcare, and clvic practice areas? Yes. While these markets represent the majority of the projects the firm is awarded, the knowledge and skills amessed as a collaborative team is also fully transferable to any number of other markets. pragmatic standpoint, we will broaden our marketing base and submit propos als to clients that we have had an inter-est in working with. In addition, work-ing under our own name will lessen confusion among the public and our

Will you continue to maintain and expand your expertise in lab design and healthcare planning? Absolutely.

Who will serve as the managing principals of the firm? Will this change? No, our principals will remain the same and will serve in the same roles they did as Anshen+Allen

Will the firm maintain its present location? Yes, not only does Los Angeles provide a relatively central location for our clients, but it also gives our team we can leverage on behalf of our clients.

Are there plans to expand into new geographies with new offices? Not at this time.

Will there be any changes in personnel across the board? No.

Will you be hiring? If so, what positions? We are in a constant state of gradual and considered growth, and

How will this arrangement deliver better results for the employees? Our new name, CO Architects, for the first time creates a tangible sense of identity for the office and our team. This name will reinforce our values, fortify our culand what we are allows each member of our team to work toward a common set of ideals and gives us the freedom to become the firm we want to be.

Will the current Los Angeles clients be retained by CO Architects? Yes,

Who will "own" projects that have been completed by the Los Angeles office in terms of a portfolio of work? extensions in current projectare conducting business as us projects that exceed our clier tions in creativity, innovation, and functionality. Our clients They represent the body of expertise and success that our firm has built over the years; the passion and style of our team and our approach to creating lasting projects in a collaboraof timelines and integrity of p

people recognize the broad scope of

When did you notify your cla How will this change impact proposals that are in review? The basic substance beginning June 6, 2005. of the proposal does not change, only the name of the firm which submitted the work. We believe it is important that

Will this change cause any o

tinue to see the same discipli

are committed to consists

ABCDEFGHJKLMNOPQRSTUVWXYZabcdefghijklmnopqrstuvw ABCDEFGHJKLMNOPQRSTUVWXYZabcdefghijklmnopqrstuv

PRIMARY TYPEFACE: AVENIR (TOP) OR ARIAL (BOTTOM

FAX COVER SHEET (SINGLE)

PAX COVER SHEET (MULTIPLE)

LETTER OF TRANSMITTAL

Approach

We strive to design buildings that enrich the lives of the people who use them; buildings that gracefully fulfill functional and technical expectations, yet appeal as fully to the senses as to the intellect.

An inquisitive, skillful practice engaged in a collaborative process of discovery and immersed

in the craft and technology of building.

CO ARCHITECTS

ADAMSMORIOKA

DESIGN FIRM:

We pursue ideas that embody the timeless values of the institutions we serve. We believe good buildings reinforce the coherence of their surroundings and maintain their physical and cultural significance over time.

persistent search for the solution that best fits the needs of the program and site. Design emerges through a creative, iterative process of discovery.

Our senior staff share a common store of knowledge and experience, developed over nearly two decades, that informs every project. Principals actively lead project teams in a practice founded on a structure of participation.

we couple our depth of experience with a genume delight in the craft and technology of building. We seek to rise above the exigencies of the program and budget to make memorable places that build community and celebrate the experience of being in a particular place at a particular time.

· · · · · · www.coarchitects.com

COMPANIES GROW AND CHANGE. WHEN A NAME CHANGES, A COMPANY NEEDS A VISUAL SYSTEM TO INTRODUCE, CLARIFY, AND ESTABLISH THE CHANGE.

DESIGN FIRMS OFTEN FACE THE CHALLENGE OF DEVELOPING AN IDENTITY

SYSTEM AND REBRANDING PROGRAM THAT PROVIDES A CONNECTION TO THE

BEST ATTRIBUTES OF THE OLD COMPANY, WHILE INFUSING THE IMAGE WITH

FRESHNESS AND VITALITY. THIS CASE STUDY PRESENTS AN INNOVATIVE AND

ENERGETIC DESIGN SOLUTION THAT POSITIONS CO ARCHITECTS AS BOTH

NEW AND ESTABLISHED.

CO ARCHITECTS

CLIENT After several years in business, Anshen+Allen renamed itself CO Architects. CO Architects specializes in large architectural projects in the academic, healthcare, and science/technology fields. Its roster includes some of the most well-known and experienced architects in the United States.

With the name change, CO Architects needed to reintroduce itself to current and future clients and its approximately 110 employees. Company officials have long understood that graphic design is a complex and specialized profession, and looked to AdamsMorioka, the company that created the original identity system for Anshen+Allen in 1999, to rebrand the firm.

PROJECT AdamsMorioka chose a bold and simple visual system for CO Architects. They celebrated and emphasized the unique name wherever

possible and focused on communicating the client's attributes of energy and strength.

Designers developed a new logotype, a color palette, a custom font, stationery, project sheet templates, proposal covers, announcement cards, a book cover, merchandise giveaways, and even company wrapping paper.

Feedback from employees and existing clients was overwhelmingly positive, and the rebranding program generated significant interest from potential clients. Recruitment efforts also improved; CO Architects saw a thirty percent jump in new applicants in the year following the rebranding effort.

INTERNAL AUDIENCE Current employees are a critical target audience for any corporate identity and rebranding program. If engaged, informed, and proud of their company's brand,

The logo communicates a brand anchored in strength and infused with energy.

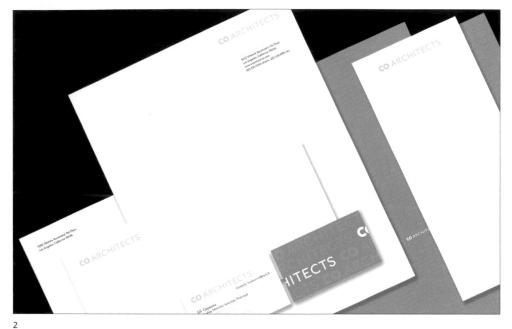

Drucker Graduate Management Center

Grave

Grave Graduate Descript

Management Graduate Descript

2

employees function as brand ambassadors. AdamsMorioka made sure that the rebranding program included creative and thoughtful ways to introduce the system to employees. They paid careful attention to the design of the employee handbook, internal style guidelines, and the "packaging" of the rebranding program.

At the launch of the rebrand, each employee received a unique bamboo desktop organizer that included business cards, employee handbook, notecards, merchandise, and a coffee mug. This attention to detail and understanding of the important internal audience further established the brand among the firm's most important brand ambassadors—the employees.

systems accurately reflect the client's attributes. CO Architects had long been known for being consistent, stable, collaborative, and dedicated to excellence. AdamsMorioka emphasized these elements and designed a new corporate identity and rebranding program that communicates a brand anchored in strength and infused with energy.

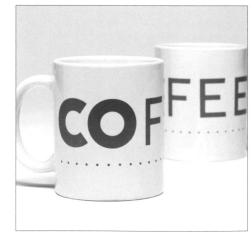

COARCHITECTS

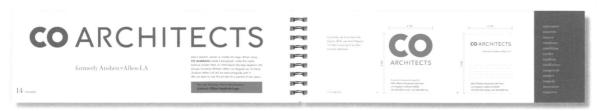

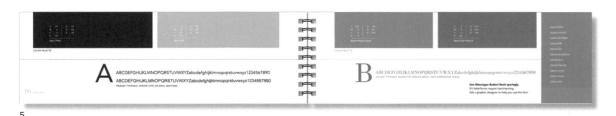

AdamsMorioka used color and style to convey both vitality and stability.

AdamsMorioka designed templates that the client could easily adapt to show a variety of projects.

4

3

Functional office items reinforce the brand.

5

AdamsMorioka extended the rebranding program to the design of the style guidelines.

6

The unusual name lends itself well to a variety of communication pieces.

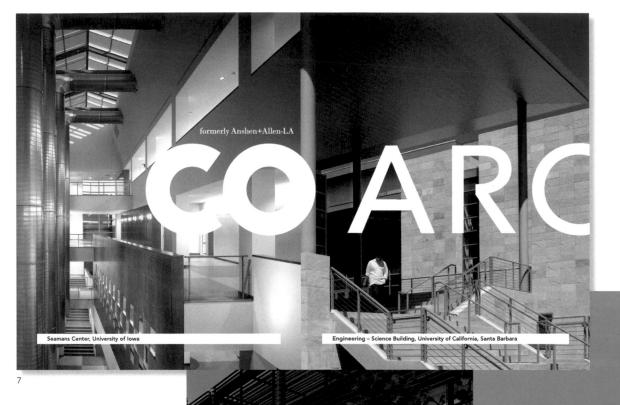

COARCHITECTS

5055 Wilshire Boulevard, 9th Floor Los Angeles, California 90036 323.525.0500 phone, 323.525.0955 fax

ECTS

Santa Monica College Library

To find out more, visit

www.coarchitects.com

Postcards are printed in a way that allows for customized imprinting for featured projects.

8

The design team created wrapping paper to communicate the brand in an unexpected and intriguing way.

C

The interior, in this case, is the brand.
AdamsMorioka designed the entrance to
the client's office to provide immediate
introduction to the new visual language.

10

To introduce and generate excitement about the rebranding program, each employee received a bamboo desk tray filled with branded materials.

CLIENT: CO Architects
DESIGN FIRM: AdamsMorioka
ART DIRECTORS: Sean Adams,
Volker Dürre
DESIGNER: Volker Dürre

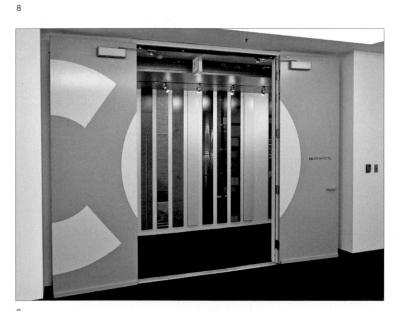

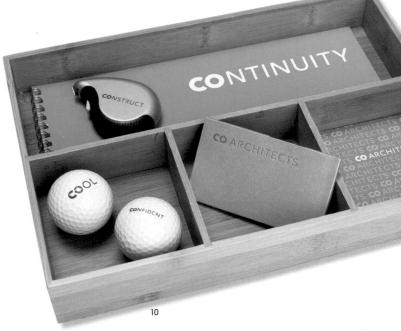

THOUGHTFUL AND HOLISTIC BRANDING INCREASES AWARENESS AND BUILDS RECOGNITION AMONG A COMPANY'S INTERNAL AND EXTERNAL AUDIENCES. BRANDING DIFFERENTIATES ONE COMPANY FROM ANOTHER AND UNIFIES AND FOCUSES CORPORATE VALUES. THIS THOROUGH, SYSTEMATIC, AND WELL-ARTICULATED IDENTIFICATION AND BRANDING PROGRAM CREATED FOR INTERNATIONAL LAW FIRM SACHNOFF & WEAVER ACHIEVES THE PERFECT BALANCE OF CONSISTENCY AND FLEXIBILITY.

Sachnoff&Weaver

CLIENT Sachnoff & Weaver employs more than 140 lawyers and offers a remarkably large array of legal services. The legal industry has undergone corporate consolidation and commoditization of services over the past fifteen years. Business once based on long-term relationships has become more consumer-driven and product-oriented. These changes caused Sachnoff & Weaver to grow in size and scope and face stiffer competition. It needed visual language to support its efforts toward client retention, attorney recruitment, and marketplace differentiation. The company approached Crosby Associates with a request for a consistent corporate identity and a system of communicating its brand across a variety of communication pieces.

PROJECT Crosby Associates developed a strong visual language that emphasizes consistent messaging and flexibility of use. The expansive

program includes the logo design, a typeface, a color palette, stationery, a website, annual reviews, environmental graphics, report covers, notecards, and more. Even with the size of the program, the visual style is brilliantly simple and distinctive. The designers wisely chose a variety of photography, typography, and wellestablished editorial illustrators to communicate a personality that reflects the law firm's progressive, yet business-oriented style.

VISUAL VARIETY The best branding programs allow for visual variety rooted in consistent messaging-no small task for a design firm. Colors may change, techniques may be combined, and written language may differ in an effort to keep the audience engaged. The corporate website does not have to look exactly like the advertising, and the annual report need not look like the employee holiday party invite. What

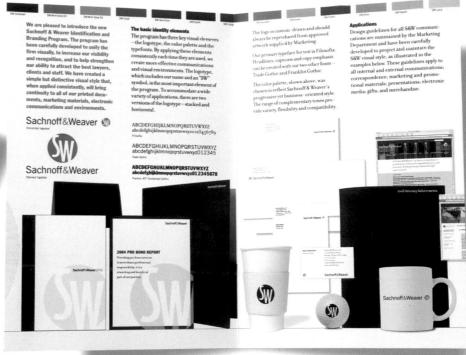

does need to be consistent throughout all the communication media is the core message of the company.

Crosby designed a varied visual language for Sachnoff & Weaver that enhances the depth of the core values of the company. The website looks hip and urban, while the notecards look elegant and refined. However, both indicate that the company is smart, accomplished, significant, and contemporary.

consistent flexibility One of the greatest challenges for any midsize to large company is to develop an identification and branding program that will be implemented by any number of departments, in multiple locations, and by

several vendors. Regardless of what an approved set of style guidelines may require, people will customize presentations, report covers, and corporate coffee cups.

Crosby's designers understood this penchant for customization and designed with it in mind. They developed a program that offers consistency and flexibility through the use of extremely detailed templates with built-in ways of customizing color and adapting the design to various print techniques. Accounting for the way people really use program components ensures that the company's core values are always communicated, even when an employee prefers SW Curry over SW Indigo.

SW

SW

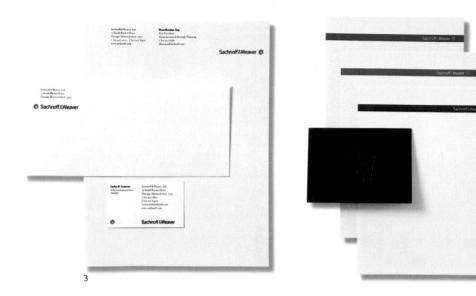

To introduce the branding initiative to employees, Crosby created a quick reference guide that details the flexibility and breadth of the program.

2
Crosby explored several logo options.
The process helped refine ideas and focus concepts.

3 Crosby created a comprehensive stationery system including an embossed notecard and printed or engraved sheets for imprinting.

4
Highly detailed templates provide consistency across all corporate communications.

Editorial illustrations added a level of creative sophistication and personality to the Annual Review.

6

The photography and color palette support the brand, while giving the website an intuitive and progressive feel.

Securities Litigation and Regulation

In high-stakes securities litigation, Sachnoff & Weaver's trial lawyers obtained a settlement that astounded a federal district judge.

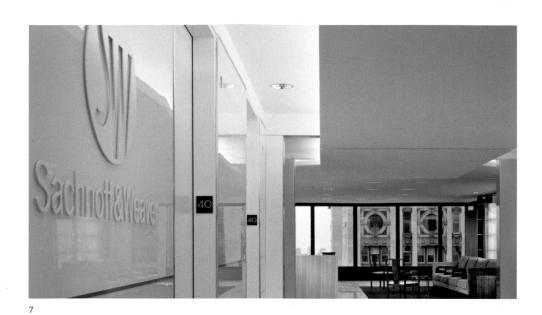

The identity and branding program is used throughout the company, from the lobby of the corporate offices to the business cards.

8

Crosby chose textured paper and specialty printing techniques to communicate Sachnoff & Weaver's depth and attention to detail.

CLIENT: Sachnoff & Weaver
DESIGN FIRM: Crosby Associates
ART DIRECTOR: Bart Crosby
DESIGNERS: Carl Wolht, Gosia Sobus

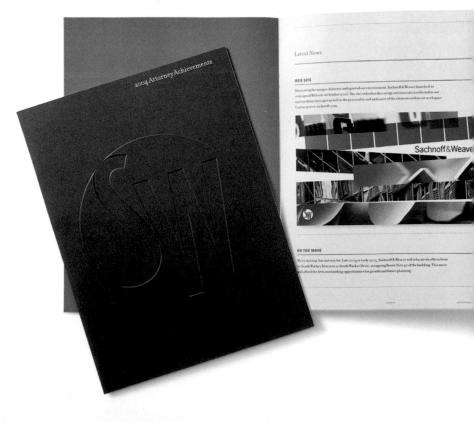

CLIENT

AMSTERDAM PARTNERS

DESIGN FIRM

KESSELSKRAMER

Lamsterdam

DESIGNERS CREATE BRAND PROGRAMS; AUDIENCES CREATE BRANDS. THIS MAKES
THE PROCESS OF BRAND DEVELOPMENT BOTH STRATEGIC AND SERENDIPITOUS.

DESIGNERS USE COLOR, TEXTURE, SHAPE, AND TEXT TO GUIDE AN AUDIENCE
TOWARD PERCEIVING CERTAIN THINGS, BUT THE ULTIMATE INTERPRETATION IS
UP TO THEM. HOW PEOPLE INTERPRET A DESIGN DEPENDS ON SEVERAL FACTORS—
SOME THAT THE DESIGNERS CAN MANAGE, AND SOME THAT DEPEND ON A PERSON'S
OVERALL EXPERIENCE WITH THE PRODUCT, SERVICE, OR COMPANY BEING
BRANDED. THE MULTIPLICITY OF FACTORS BRINGS A SURPRISE ELEMENT INTO

I amsterdam.

This case study showcases a visual system that was designed to harness audience participation in brand development. The client, Amsterdam Partners, engaged KesselsKramer to develop a branding program for the city of Amsterdam. The design solution encourages open and varied interpretations of what Amsterdam represents and how best to express the essence of the city.

CLIENT Amsterdam has a strong reputation as a hub for international business and a destination for vibrant culture. The region competes with cities such as Barcelona and Berlin for both commerce and tourism. Amsterdam Partners is an initiative comprising government entities, cultural institutions, and local businesses, including Heineken, Philips, and Shell, that works to increase Amsterdam's international appeal.

PROJECT KesselsKramer approached the project by treating the city of Amsterdam like it would any other branding project. The "thing" to be branded in this case happened to be less tangible than a single service or company. While attempting to understand the essence of such a diverse city, KesselsKramer concluded that in the end, a city is its people. From this strategic conclusion, the design team created the central theme for the brand program, I Amsterdam. Deliverables included the I Amsterdam name, a book, photography, an exhibition, and a brand manual directing use for outdoor advertising, posters, merchandise, a website, and co-branded material.

LONG RUN KesselsKramer chose to execute the I Amsterdam concept by letting the people of Amsterdam speak for the city. The design firm

I Amsterdam allows the people of Amsterdam to speak for the city.

«Рното: Martijn van de Griendt

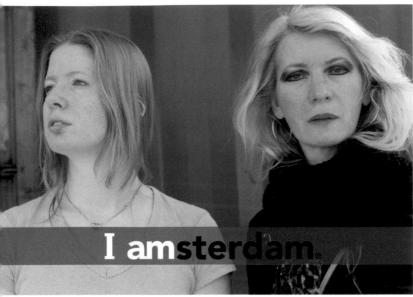

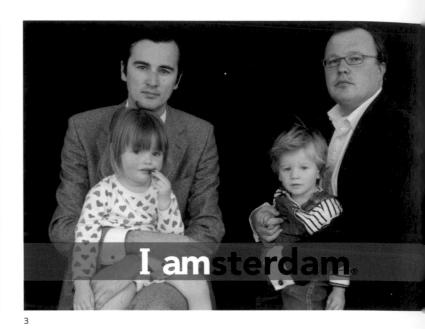

commissioned portraits of the city from twenty Amsterdam-based photographers, which became part of a book and an exhibition. The book is sold throughout the world, and the exhibit travels to city museums and international conventions. The book and exhibit provide a compelling solution to the client requirement that the branding program be long lasting and of universal understanding.

FOREIGN LANGUAGE Although the primary language of Amsterdam is Dutch, KesselsKramer chose to communicate the brand message in English. Using English makes the program more universal in scope, and increases the commercial power of both the book and the exhibit. The theme, I Amsterdam, allows both local and international people to define their own experience of the city.

PEOPLE POWER Amsterdam Partners will promote the city internationally using the visual language of I Amsterdam. However, KesselsKramer designed the program to belong primarily to the wider public rather than to the client; I Amsterdam is intentionally left open to interpretation. What it means and how it is used will vary from person to person or company to company. People are free to use the theme for personal or commercial use in whatever settings they choose. The openness of the branding program reflects the diversity and creative spirit that makes Amsterdam such a remarkable and culturally significant city.

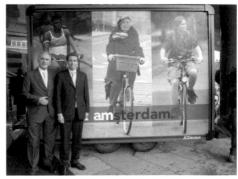

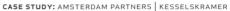

2, 3, 4

Images from the I Amsterdam book and exhibit are also used for posters and advertising. PHOTOS: Maaike de Koning (2), Diana Monkhorst (3), KesselsKramer (4)

5, 6, 7, 8

The I Amsterdam book fulfills the client's requirement that the branding program be long lasting and of universal understanding.
PHOTOS: Martijn van de Griendt (6),
Henk Wildschut (7), Gerard Wessel (8)

9
I Amsterdam is meant to be defined by—and belong to—the wider public.
PHOTO: Peter Verduin

10

The brand manual helps ensure consistency. This is particularly important since the brand program will be executed by several different government agencies and businesses.

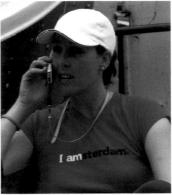

THE RESERVE THE PARTY OF THE PA

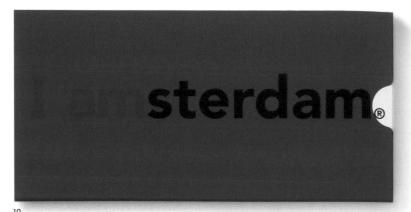

I amsterdam.

Lamsterdam.

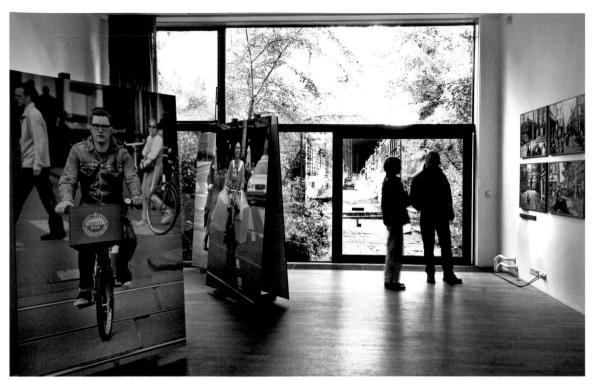

11, 12

The I Amsterdam exhibit launched the compaign and travels internationally to conventions and museums to promote the city and region.
PHOTOS: KesselsKramer

13

The I Amsterdam campaign found expression on city vehicles and in other municipal venues. PHOTO: Peter Verduin

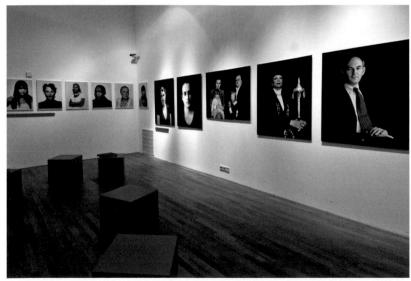

14, 16

The giant 3D version of the logo is used throughout the city, encouraging people to interact with the brand program. рнотоs: Peter Verduin (14), Matthijs de Jongh (16)

15

I Amsterdam applies not only to the people, but also to the cultural institutions of the city. рното: Peter Verduin

CLIENT: Amsterdam Partners DESIGN FIRM: KesselsKramer

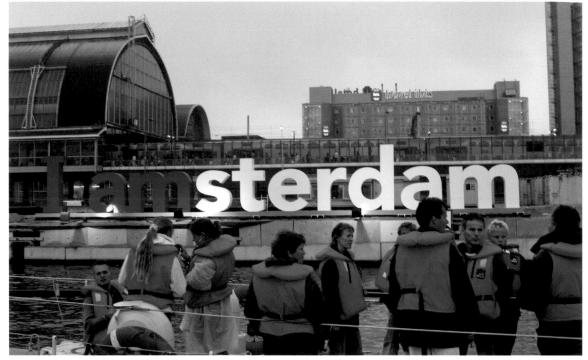

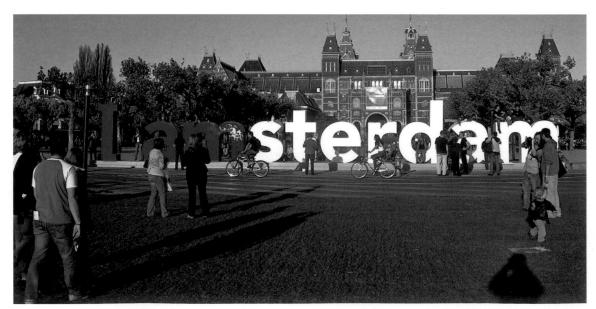

CLIENT: Tekstilpromet
DESIGN FIRM: Brandoctor

2 CLIENT: Emmi Salonen DESIGN FIRM: Emmi Salonen

3 CLIENT: OrangeSeed Design DESIGN FIRM: OrangeSeed Design 4 CLIENT: Step Wines Australia DESIGN FIRM: Voice

5 CLIENT: Alexander, Berkey, Williams & Weather, LLP DESIGN FIRM: Stoller Design Group

6
CLIENT: Ian Kelly Landscaping
DESIGN FIRM: Spark Studio

7 CLIENT: Sorrento Hotel DESIGN FIRM: UrbanINFLUENCE Design Studio In the parameter of the parameter that parameter the parameter that parameter the parameter of the parameter

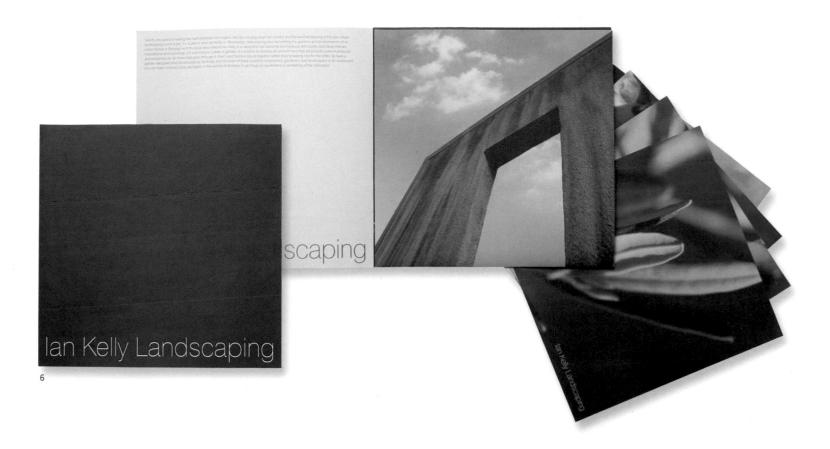

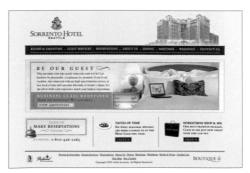

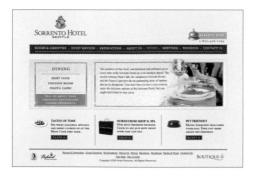

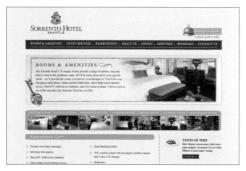

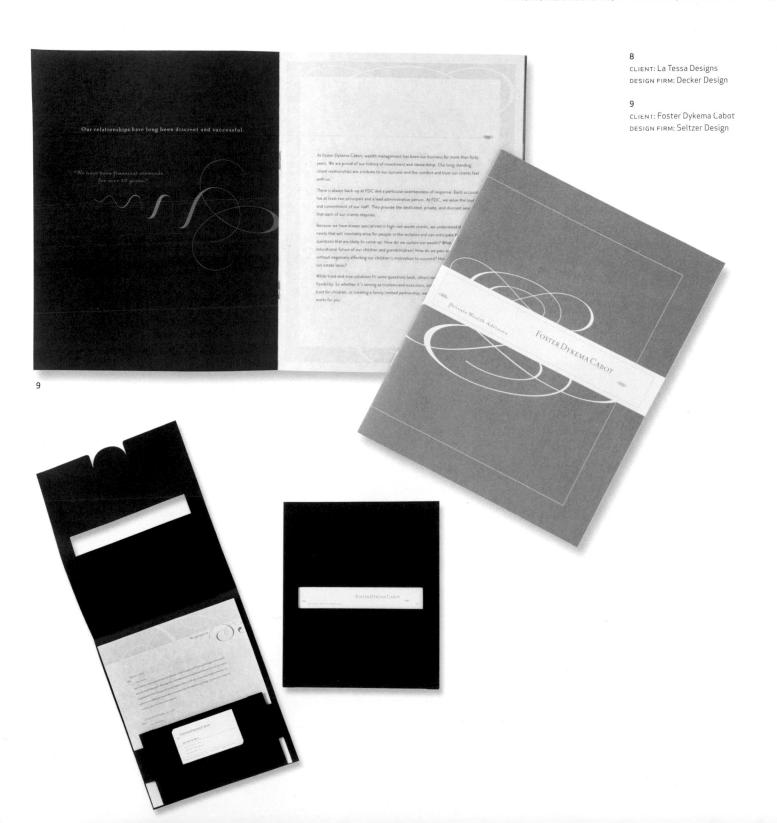

Projection of the 18 to the large Properties Apparatus 2005

10
CLIENT: Interface
DESIGN FIRM: The Valentine Group

11
CLIENT: AEI Digital
DESIGN FIRM: Talisman Interactive

12 CLIENT: Film Visions Funding, L.L.C. DESIGN FIRM: Lain Livingston Marketing Studio

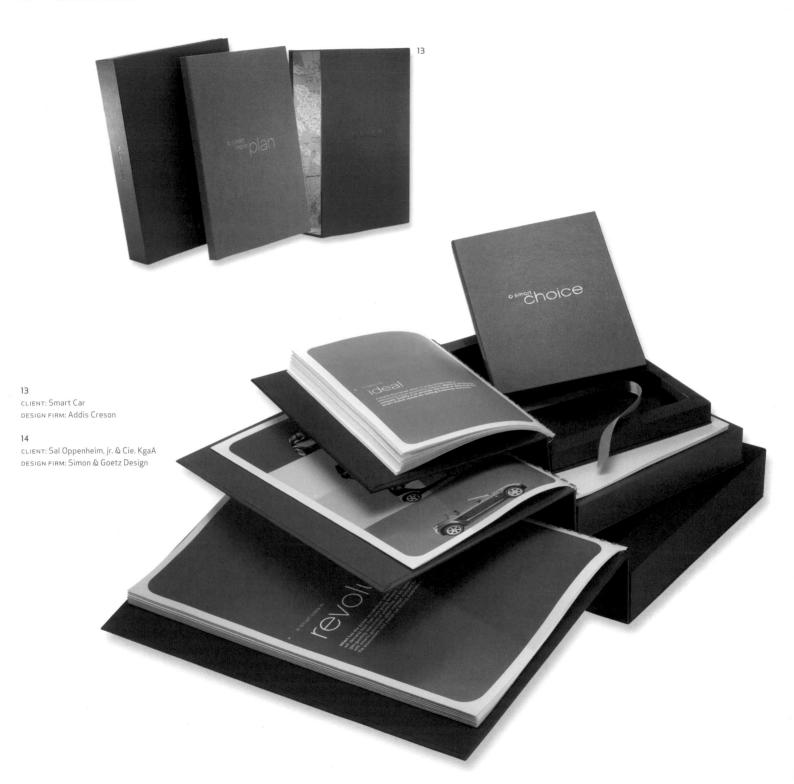

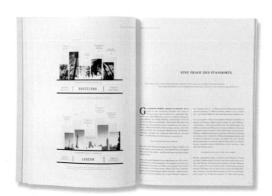

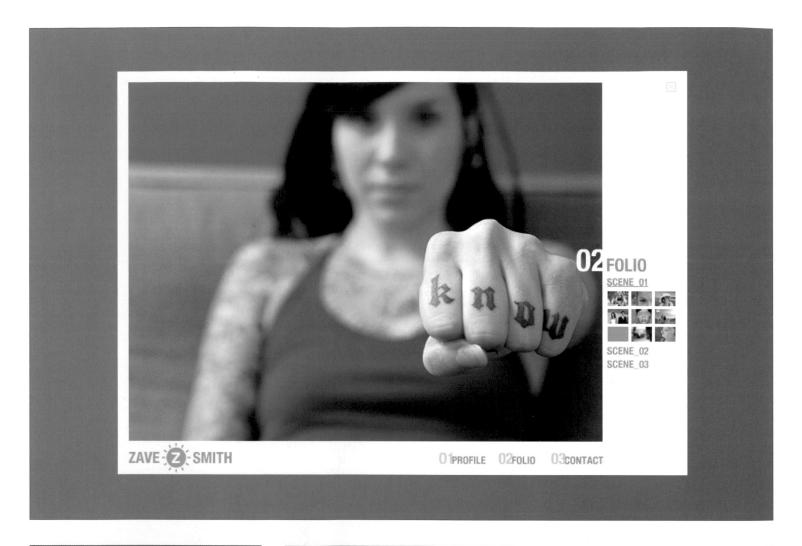

15 CLIENT: Zave Smith Photography DESIGN FIRM: Talisman Interactive

16 CLIENT: Gold Cafe DESIGN FIRM: Go Welsh

17
CLIENT: Emmi Salonen
DESIGN FIRM: Emmi Salonen

CLIENT: Health Net
DESIGN FIRM: The Valentine Group

Agust a sear Health Net Openion Flast Turniqueting Perocher Organization, or two plan. It sidence you the fraction to seek care from may be declare health care provider in the cinama. Hong spectre aways by wang to northwell periodics or you get the fraction to seek care from may be declare health care provider or the cinama. With dispace there is virually no paperweek or or otherwise) to some of the Neth With dispace there is virually no paper week or or otherwise, has more than the control of th

THE PLAN THAT AFFORDS YOU MORE

If you're shopping for a separate prescription drug coverage, then *Orange*, the Prescription Drug Plan from Health Net, is just for you. And if you're comparing drug pricing for a Prescription Drug Plan, then you'll find Health Net to be one of the least expensive.

One of the most critical components of good health care is a common sense Prescription Drug Plan that's tailored to your needs — a plan that's reasonably priced and easy to use. That's why thousands of people have chosen Health Net Medicare plans. We've based our business on the specific needs of the individuals we serve. Plus, our vast network of nationwide pharmacies means you can probably get your prescriptions filled at your neighborhood drug store.

Medicare is Olasgoig, Medicare is undergoing one of ing greatest change in weenty years. Beginning January 1, 2006 the new Medicare Program will include a Prescription Drug Plan, called Par D. Vinder Part D. you'll be able to Drug Plan, called Par D. Vinder Part D. you'll be able to souther insurance coverage to help up for drugs prescribed to you by a physician. The program is open to anyone whole already receiving Medicare, or is eligible for a Medicare Advantage Plan. But remember, Part D is not provided by the government like Parts A and B— it's a government-mandated plan that you can only access through a qualified plan aponsor like Health Net. This benefit will be made available in a number of ways either integrated with a variety of full coverage plans, or as a separate Precipiono Drug Plan to supplement a negolar Medicare or Medigup plan.

acting the Marke processor, we can transport on an impartitable acting the required qualities have becomes a few control of the importance as a state of the control of the distribution of the control of the contro

COPATMENT

The size of year experiment depend on which four the days or of the white. Our from Health New other new or these (experiment health white a three the days year of the white. Our from Health New other the experiment. These is the device the experiment. The house the street of the size of the white point of the property of

Four decision tituellist. To take advantage of these new drug plans, most people must select and eritol in a plan during the enrollment period, which begins November 15, 2005 (see enclosed cumillamin from). Once you're enrolled in a plan, if you should decide that another plan would hearify you better, you heare you have only 100, 2006 to switch. To avoid late face, you must enroll in a plan by May 15, 2006, 501l, no matter which plan you choose, or when you choose it, you're still owned by Medicare.

DATES TO BEHINDE

November 13, 2005.
This is the free day Medicase eligible radioviduals can coroll in a Medicase Fort D P Drug Plot. Your effective due will be January 1, 2006.

December \$1, 2005

This is the first day Medicare eligible individuals can enroll in any plan for medical or drug oversee to be on an Issuage 1, 2006.

This is the law day that people who are digible for Mullicust one tentil in a Part D Proceiption
Dong Film without incoming a late immiliation for, unless their qualify for an exception. Possible
on this day, the excitoring Medicines appeared Dang Disconnet Card Fragram ends, and in
replaced by the Medicine Dort D Proceiption Drug Plan.

This is the fast day people what have already entrolled in a plan can smuch to a new plushor they fiel will better unit their stoods.

CLIENT: Los Medanos College DESIGN FIRM: Stoller Design Group

23

CLIENT: Maurice Blackburn Cashman
DESIGN FIRM: Octavo Design/
Spark Studio

24

CLIENT: Los Medanos College DESIGN FIRM: Stoller Design Group

25

CLIENT: Gravica Design DESIGN FIRM: Talisman Interactive

bio experience/pecsion/secolades

I offer a complete rute of services binduring identify, print and
interactive to load and approxy our communications strategy.
Transpip powerful results communications, there have been of the
investment, offerendiate them from the competition, but bulled
investment, offerendiate them from the competition, but bulled
from the past 3 byets 1 services.

For the past 3 byets 1 services and 5 them for past of the competition of automatically investment and them to the competition of the services are been polyphotole and
investment of the services and the forest of automatically investment of the services are serviced based for the bulled of the services are serviced by the competition of the services are serviced by the services are serviced by

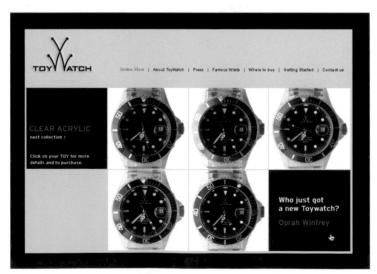

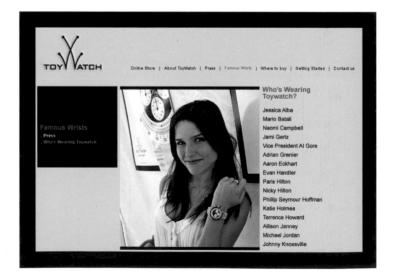

Foundation seeks to improve education. Looking for leading-edge thinkers to collaborate on solutions to tough questions.

26

CLIENT: ToyWatch USA
DESIGN FIRM: Liska + Associates

27

CLIENT: The Spencer Foundation DESIGN FIRM: Kym Abrams Design

28

CLIENT: Australian Ballet School DESIGN FIRM: Spark Studio

What can help them collaborate to produce educational improvements?

29 CLIENT: Sal Oppenheim, jr. & Cie. KgaA DESIGN FIRM: Simon & Goetz Design

30 CLIENT: Postspeed DESIGN FIRM: Spark Studio

31 CLIENT: Target Commercial Interiors DESIGN FIRM: Sussner Design Company

Postspeed pushing the envelope

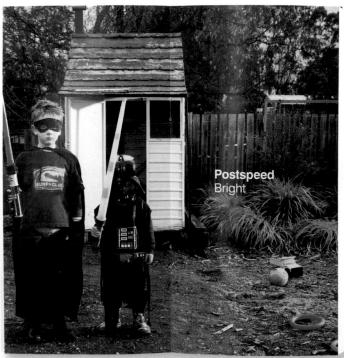

Premium quality, for promotional envelopes and direct mail.

 quality you can see and feel when image is paramount.
 compliments your brand
 makes a good first impression
 clean, sharp fold.

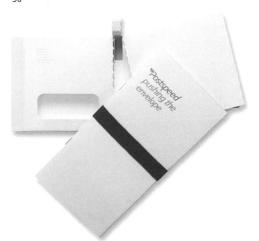

CLIENT: The Buzz Company DESIGN FIRM: Faust Associates

CLIENT: Swanson, Martin & Bell DESIGN FIRM: Liska + Associates

34

CLIENT: California Council for Humanities DESIGN FIRM: Stoller Design Group

Hey, The Buzz Company desperately wants you to work

Really. For crying out loud, just talk to them. What would with them. it hurt you?

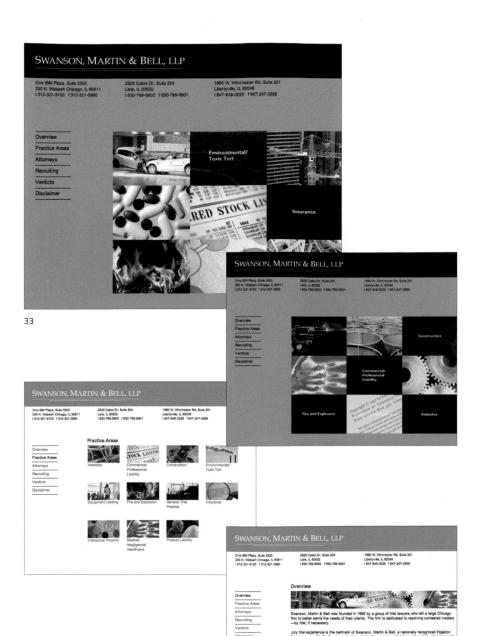

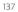

CLIENT: Square Gain DESIGN FIRM: Curious

36

CLIENT: IntraSpec Solutions
DESIGN FIRM: Sussner Design Company

37

MUTUAL OF AMERICA 2005 Community Partnership Award

> CLIENT: Axcelerator Home Loans DESIGN FIRM: Octavo Design/ Spark Studio

38

CLIENT: Mutual of America DESIGN FIRM: Decker Design

MUTUAL OF AMERICA

Jernig is need the next hapithin to qualitative the sections of plan or discontinuous for the condition times to be conditionated to the condition times to the condition times to the condition times to the condition times of the condition times of the condition times of the condition times of the condition times to the condition times the condition time at \$40 times are motioned period times the condition time of the plant is particularly among districts for entirely one of plant is particularly among times the condition times are for the plant in the condition times are the condition to the condition time and the condition times are the conditio

whether the second section is the second section of the second section in the second section is section in the second section in the second section is section in the second section in the second section is section in the second section in the second section is section in the second section in the second section is section in the second section in the second section is section in the second section in the second section is section in the second section in the second section is section in the second section in the second section is section in the second section in the section is section in the second section in the second section is section in the section in the section in the section is section in the section in the section in the section is section in the section in the section in the section is section in the section in the section in the section is section in the section in the section in the section is section in the section in the section in the section is section in the section in the section in the section is section in the section in the section in the section is section in the section in the section in the section is section in the section in the section in the section is section in the section in the section in the section is section in the section in the section in the section is section in the section i

ir the past servical years, Easter Seals and our partners in operated vide by soft serving people with dissilation and commits agricultural commission." Self-Bill Laterian, discipof Easter Seals" FARM Program, "Suided by a commitment recepts and commissions, in 2004–2000 we have halped 1-200 Servines and farm workers coalistate files Servin and or way of 100."

CLIENT: City Bay Developers
DESIGN FIRM: Design Source East

40

CLIENT: Skanska USA Building, Inc. DESIGN FIRM: Design Source East

41

CLIENT: Oxiana Limited
DESIGN FIRM: Octavo Design/
Spark Studio

42

CLIENT: Martin Architectural
DESIGN FIRM: Front Media Studio

nagement Offer Clients the st in the Industry

chitects Working in Construction

the name at most construction minagement forms, Shamka USA is employed most efforted exclusion of the exolit is more value to the shock. Viewed as a positive differentiation is bringe out-citizen body the perconstruction and the designer. As construction management firms along gain recognition as collaborative partners with construct, the institutions to see that the property assumption is to five more smoothy and efficiently located and prospers astimutate tents to flow more smoothy and efficiently the property of the property of the contraction of the property of the contraction of the property of the pro

CLIENT: Seva Foundation
DESIGN FIRM: Stoller Design Group

44

CLIENT: Continental Warranty
DESIGN FIRM: UrbanINFLUENCE
Design Studio

45

CLIENT: America Abroad Media DESIGN FIRM: Matthew Schwartz Design Studio

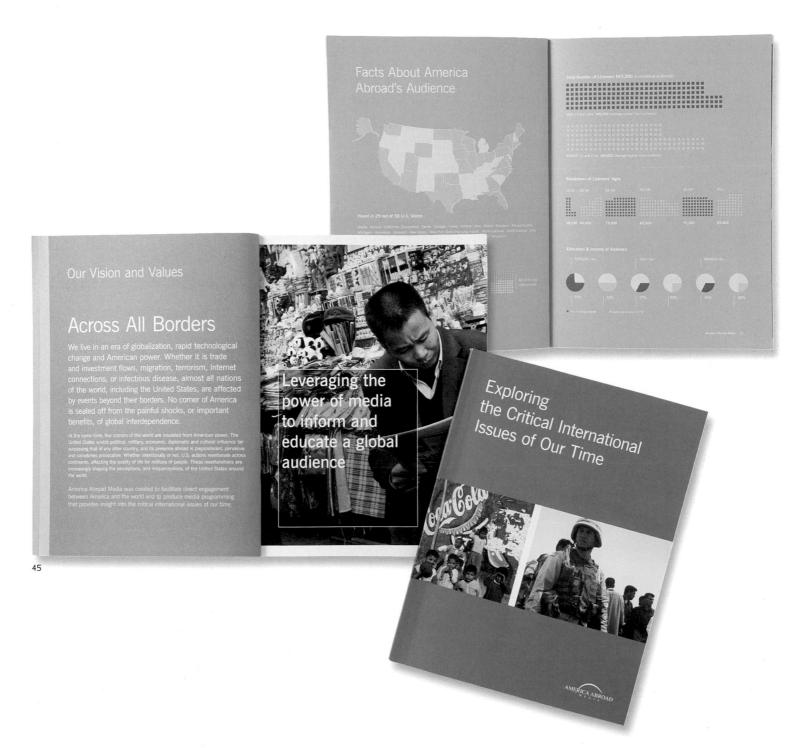

CLIENT: International Wall Designs
DESIGN FIRM: Sussner Design Company

47

CLIENT: Dual Immobiliare
DESIGN FIRM: Fluid Design Lab

48

CLIENT: GFa, Architects
DESIGN FIRM: TD2, Identity & Strategic
Design Consultants

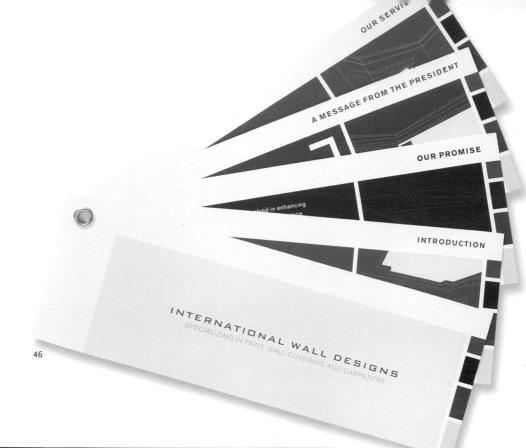

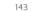

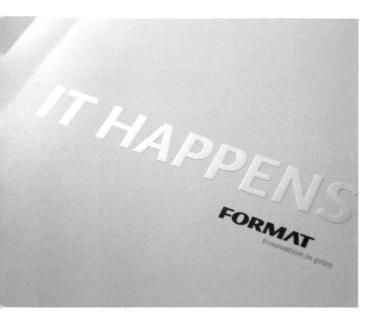

CLIENT: John Michael Kohler Arts Center DESIGN FIRM: Liska + Associates

DESIGN FIRM: Ayse Celem Design

51

CLIENT: FORMAT Printers

DESIGN FIRM: Clemenger BBDO

CLIENT: Organik 29

52 CLIENT: Marge Casey + Associates DESIGN FIRM: Liska + Associates

53 CLIENT: Fluent DESIGN FIRM: Monderer Design

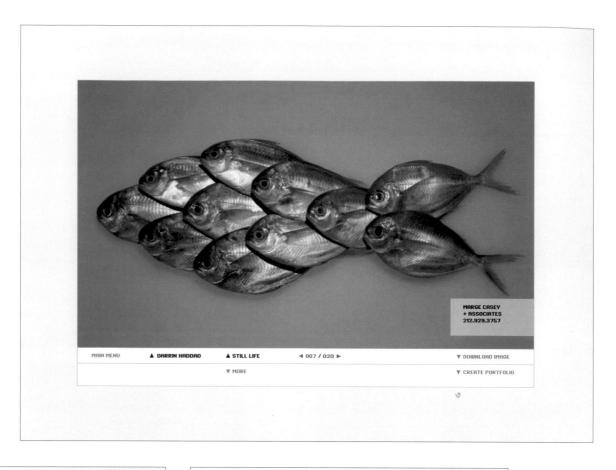

A Brand needs to come from somewhere,

stand for something and have a story to tell.

54 CLIENT: Mainland DESIGN FIRM: Clemenger BBD0

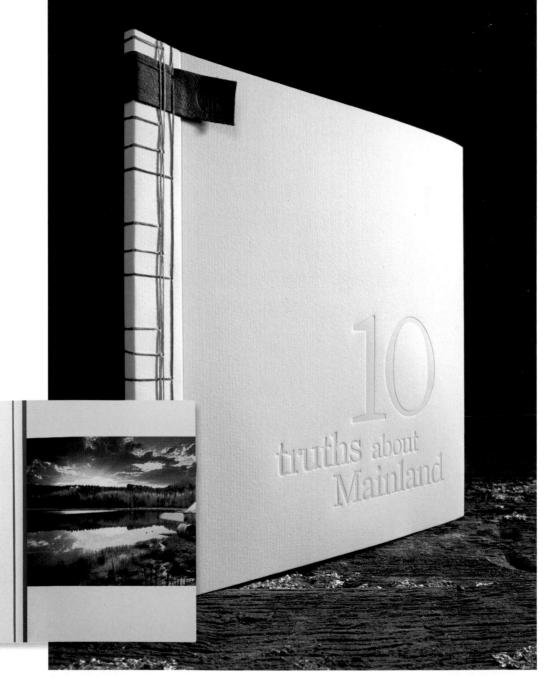

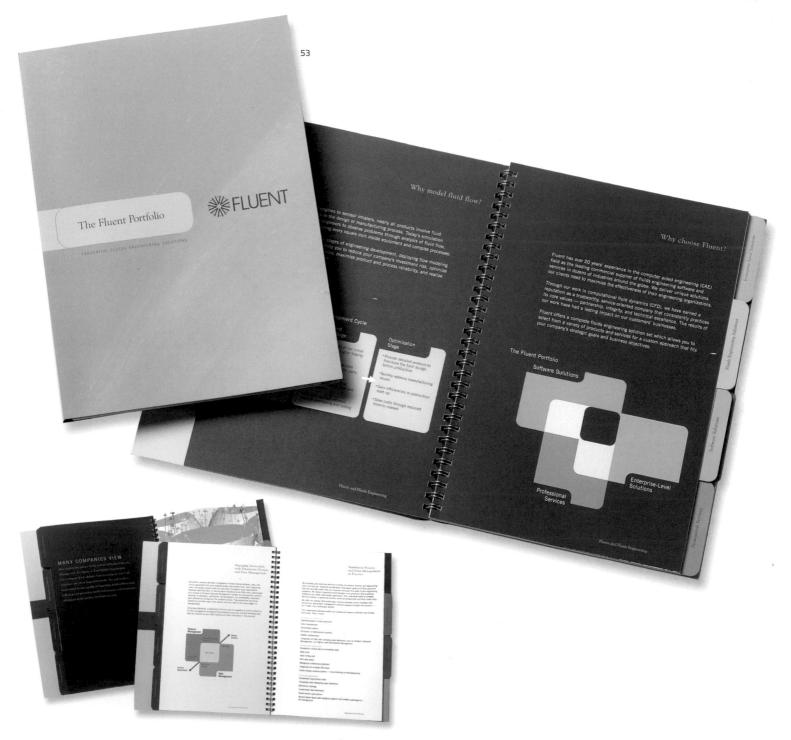

CLIENT: PIC
DESIGN FIRM: Jason and Jason

56

CLIENT: Securing America's Future Energy DESIGN FIRM: Matthew Schwartz Design Studio

57

CLIENT: Hudson Highland DESIGN FIRM: Lowercase, Inc

58

CLIENT: Davies Collision Cave DESIGN FIRM: Davidson Design

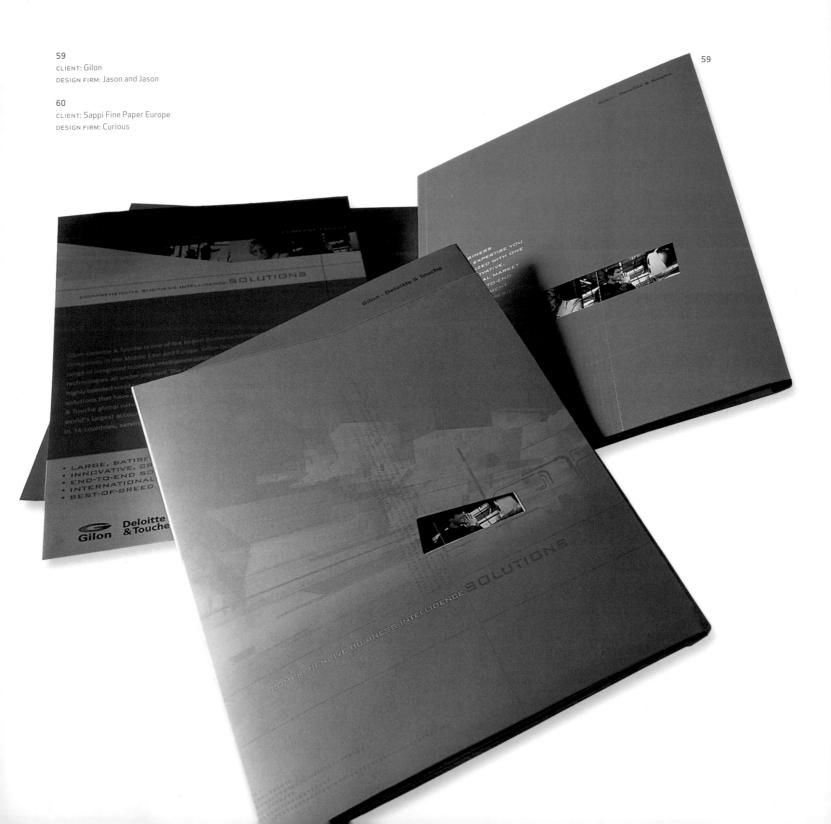

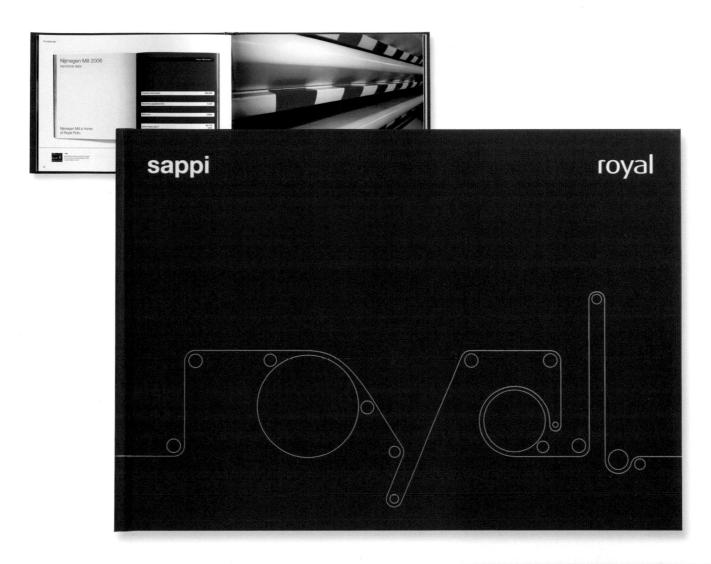

CLIENT: Motorola DESIGN FIRM: Liska + Associates

62

CLIENT: Sydney College of the Arts DESIGN FIRM: Boccalatte

63

CLIENT: Cooper, Robertson & Partners DESIGN FIRM: Poulin + Morris Inc.

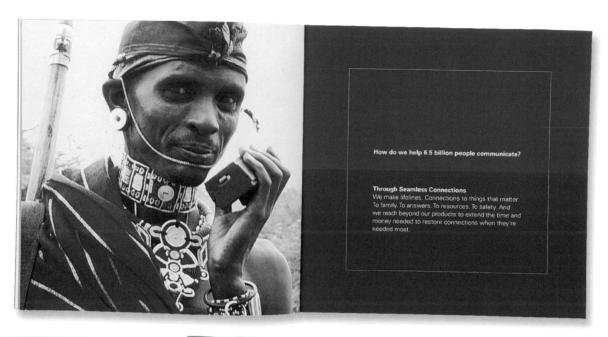

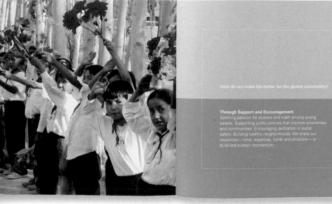

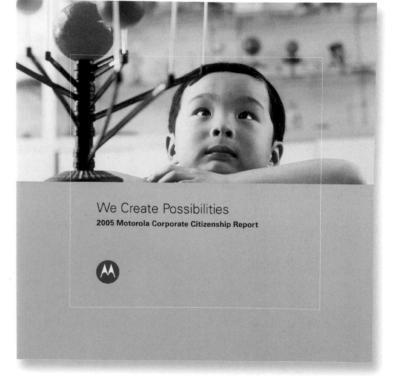

61

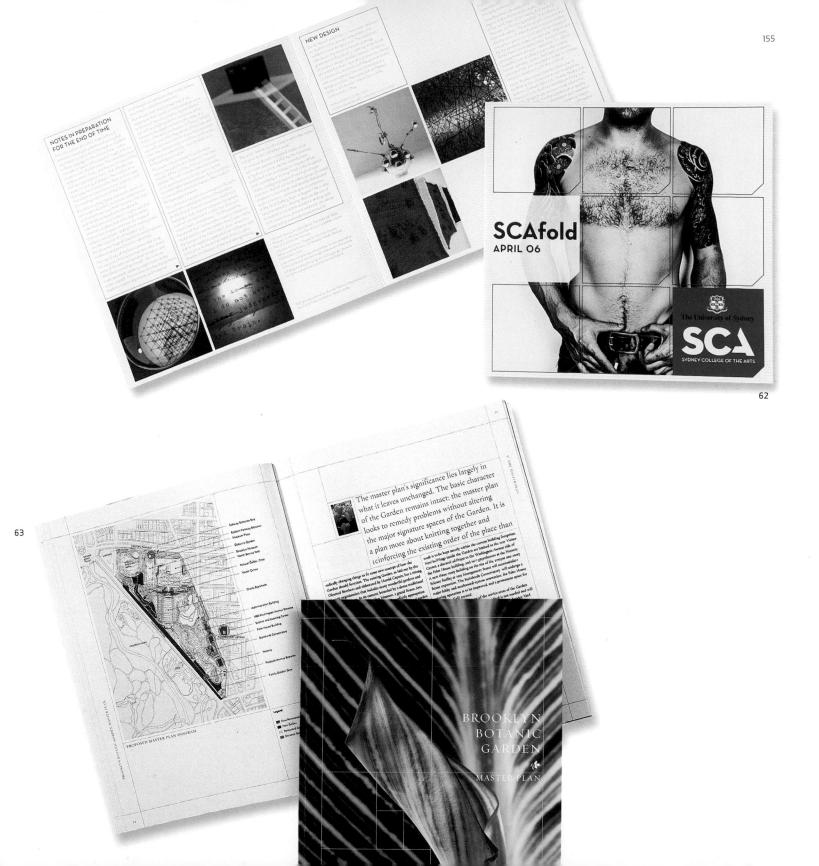

64 CLIENT: Adobe DESIGN FIRM: AdamsMorioka

65 CLIENT: Brininstool + Lynch DESIGN FIRM: Liska + Associates

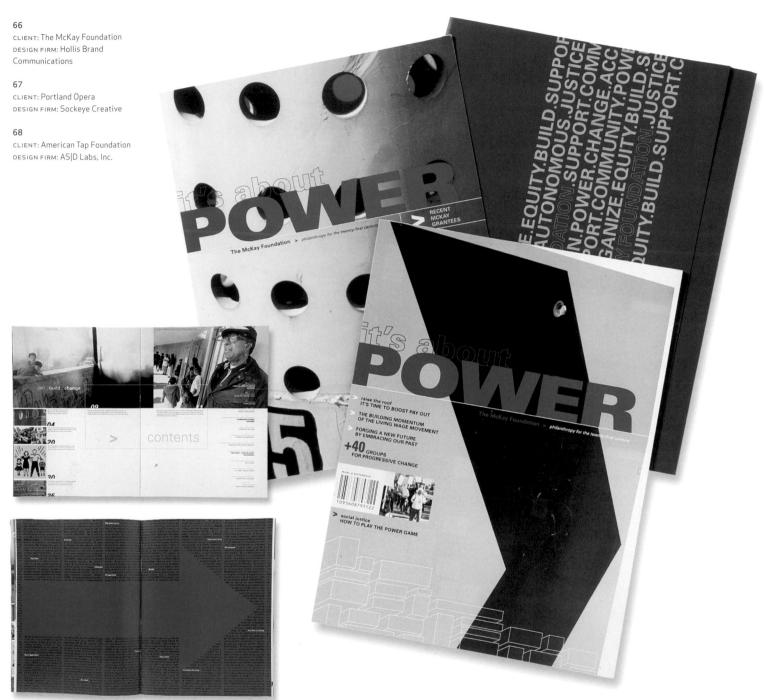

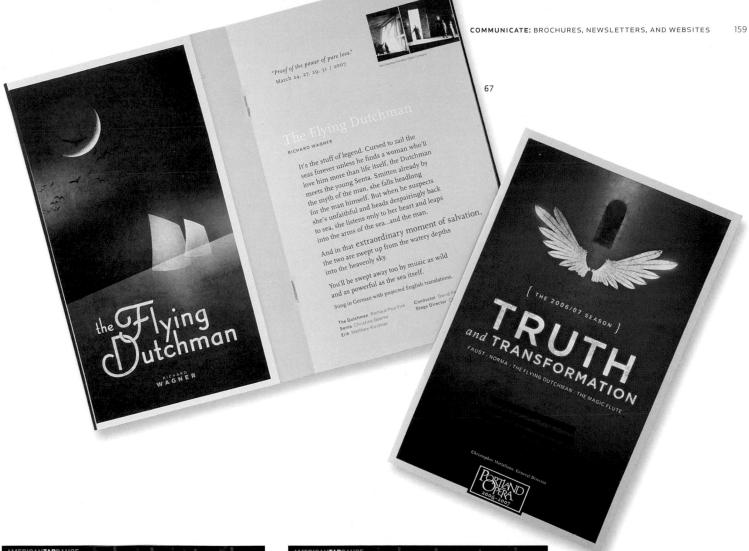

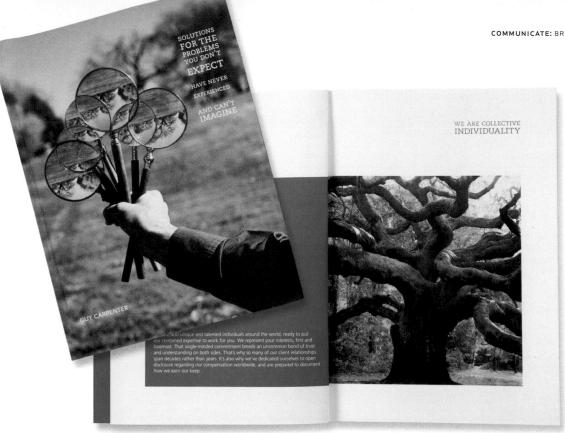

CLIENT: Hudson Highland DESIGN FIRM: Lowercase, Inc.

70

сыемт: Karinca Design DESIGN FIRM: Ayse Celem Design

71

CLIENT: Guy Carpenter DESIGN FIRM: And Partners

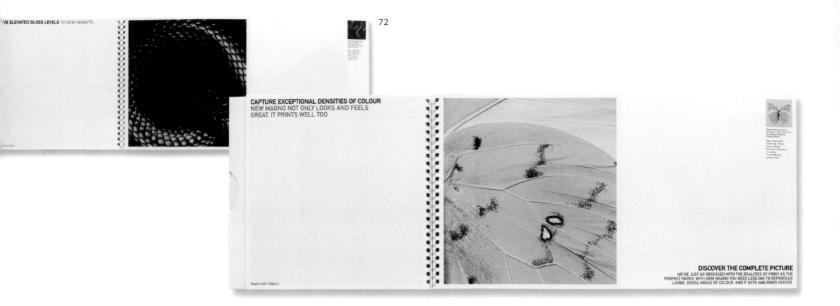

72 CLIENT: Sappi Fine Paper Europe DESIGN FIRM: Curious

73
CLIENT: Via Donau
DESIGN FIRM: KASHI_design

74
CLIENT: Design Within Reach
DESIGN FIRM: Morla Design, Inc.

75 CLIENT: Vovovod-Kanalizacija, Ljubljana DESIGN FIRM: KROG, Ljubljana

CLIENT: O.n - G.D. Review DESIGN FIRM: Carrè Noir Roma

77

CLIENT: Zilio Ecologia DESIGN FIRM: Fluid Design Lab

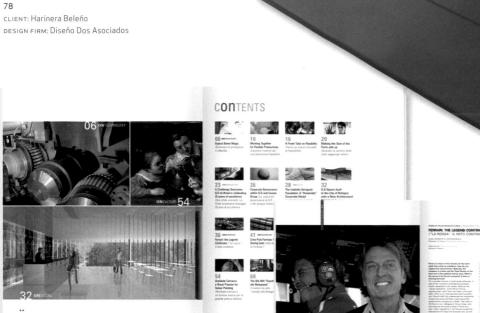

EOLICA

rerche!

Luomo ha imparato a volare, ha applicato le leggi della fisica, ha capto che l'aria ed il vento possori essere al suo servizio, trendo da esse moltepio cherefici. Basta persare all'aviazione civile e militaro ad uno Shuttle in orbita sila Terrio a la sinuttamento energetico della forza che sprigiona.

Questo crazir a il ferre della forza che sprigiona.

orza che sprigiona.

Questo grazie al fatto che
l'atmosfera genera un carico sulla
superficie terrestre chiamato
pressione atmosferica. Questa
pressione può essere più o meno
forte e creare desgli postamenei
dell'aria de zone ad alta pressione
a zone a bassa pressione dive el
carico e minore. Il Vento e uno
spostamento daria tra puntal in
condizioni di pressione differenti.

Why?

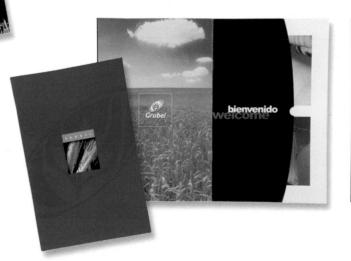

78

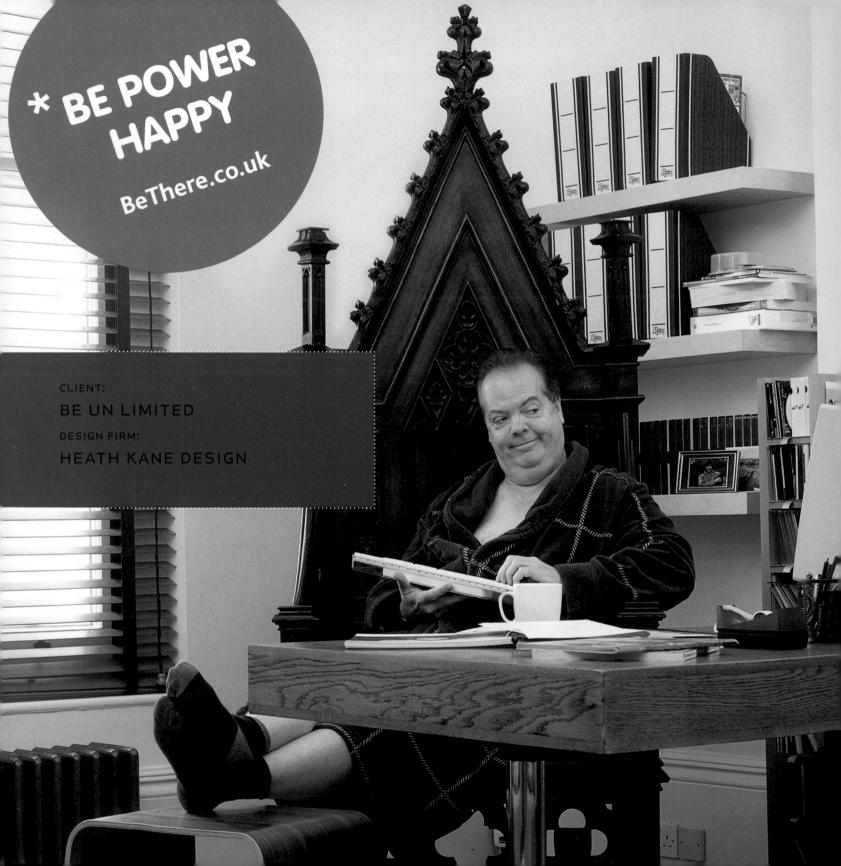

BE UN LIMITED (BE) OFFERS AN EXAMPLE OF BUSINESS DESIGN THAT

COMMUNICATES THROUGH UNEXPECTED IMAGES AND VOICE. THE VISUAL

SYSTEM DESCRIBES A HIGHLY TECHNICAL PRODUCT IN A FRIENDLY WAY

THAT FOCUSES ON END-USER BENEFITS. THE BRAND COMMUNICATES

PROFESSIONALISM, COMPETENCY, AND QUALITY IN A MORE INVIGORATING

AND CLEVER WAY THAN MOST COMPANIES DO. THE RESULT IS A

DIFFERENTIATED AND UNMISTAKABLE BRAND IDENTITY.

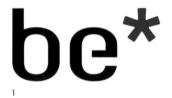

CLIENT Founded in 2004, Be was the UK's first Internet Service Provider (ISP) to harness the latest ADSL2+ technology and maximize phone line capacity at a highly competitive price. Be grew rapidly—from zero to 10,000 customers in little more than a year—and was acquired in 2006 by a larger telecom, 02.

Be understood the benefit of strategic design from the very beginning. Heath Kane helped Be define and communicate the company's values in a branded way. Using the name as a lead-in, they articulated the values: Be challenging, Be efficient, Be inspirational, Be the best, and Be cool. The brand attributes derived from the values include engineered, clever, invigorating, and responsive.

PROJECT In addition to naming the company, deliverables for Be included all internal and external communication design and collateral:

advertising (print, radio, and online), direct marketing, Web and online media, display and exhibition design, packaging, presentation and corporate branding.

FOCUSED VISION Big-picture vision often comes across as "we want to reach everyone and be the best at everything." Laudable as that may be, a broad scope makes it difficult to deliver a clear message to anyone about anything in particular. Heath Kane developed a series of short-term and long-term advertising objectives that focused initial advertising and marketing efforts on specific market segments. As the brand became more established and the company had a successful story to tell, the message was extended to additional audiences.

JUXTAPOSE Heath Kane helped define the initial target market as predominantly male, well-educated, early-technology adopters,

The asterisk is part of Be's logo and acts as a metaphor representing connotation and connection (e.g. Be* Online, Be* Active, Be* Informed, Be* Entertained).

and peer-influenced. The last color that may come to mind when imagining what appeals to this audience is pink—the exact color Heath Kane chose as the backbone of the Be brand. However, pink works perfectly well with the company values and brand attributes. It vastly differentiates Be from the dozens of competing telecom companies and contributed to Be becoming a widely recognizable brand almost overnight.

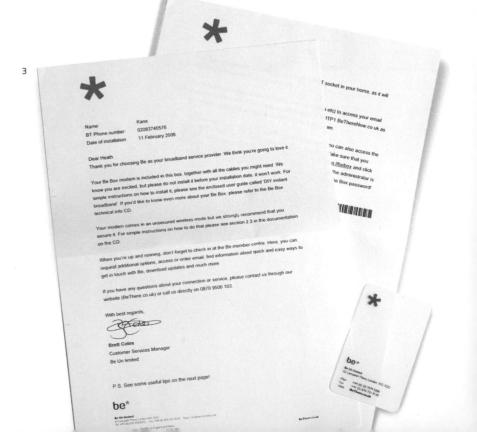

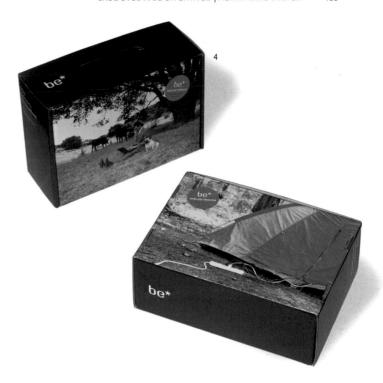

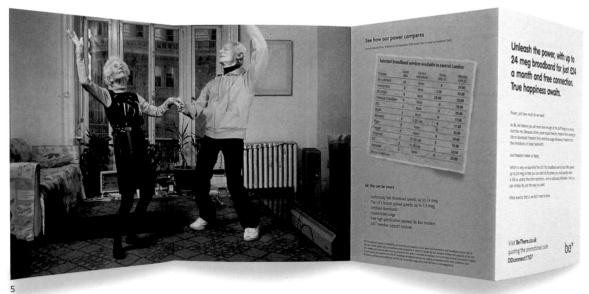

Even the instruction manual received branding attention. Friendly, helpful, and entertaining, it clearly differentiates Be from other telecom companies.

3

The asterisk at the top, anchored by the logo at the bottom, communicates that Be is transparent and straightforward, without small print or unwelcome clauses.

4

The welcome pack is the familiar size of a lunch-box and includes everything the user needs to get online.

5

Direct mail pieces need to have visual stopping power. This piece uses Be's quirky, unexpected style to capture attention and engage the reader.

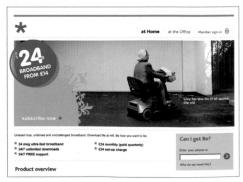

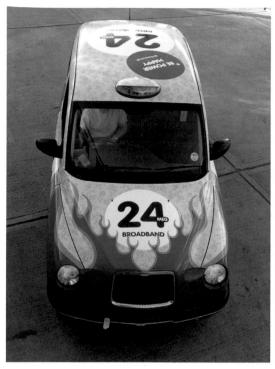

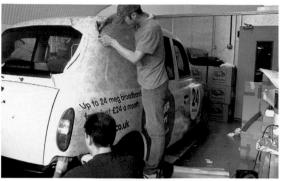

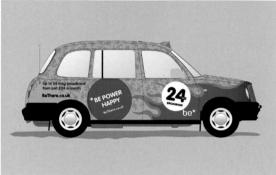

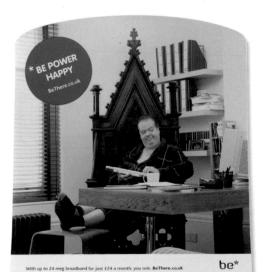

Isn't power wonderful?
Go on, admit it. You don't have to be a budding dictator to think that power absolutely rocks.

Take this cab journey, for example.

You could ask your driver to take you anywhere. Right now. Penzance, for instance. Or the liste of Skye. Of course, there are a few hindrances to consider: that slight matter of cost, the distance to travel and, hey, this raffet isn't going to help. But what if the cost was negligible? What if the distance could be covered instantaneously? What if there were no barriers in your way whatsoever?

Well, welcome to broadband from Be. With download speeds up to a staggering 24 meg, upload speeds up to a of the standard of the standard speeds up to a staggering 24 meg, upload speeds up to a necond-breaking 1.3 meg, unlimited usage (subject to fair usage policy), a free wireless modern and all for just £24 a month, you finally have the power you need to simply be, online – just the way you want.

c

The CD-ROM containing technical information reflects the Be brand. The label reads: "Warning: Contains nerdy information ubout your modem."

7

The launch party reinforced the idea that Be is a different kind of communication company. The theme was "Something Different, Something Pink."

8

The website avoids typical clichés and opts for vibrant, witty images of people being liberated and inspired by the potential of online capabilities.

9

More than fifty pink Be branded taxis hit the streets of London in 2005, helping to make the company an instantly recognizable brand.

10

In addition to branding livery exteriors, designers created branded messages that were placed on the backs of taxi cab seats.

CLIENT: Be Un Limited
DESIGN FIRM: Heath Kane Design
ART DIRECTOR: Heath Kane
DESIGNER: Heath Kane

CLIENT:

MACQUARIE TELECOM

DESIGN FIRM:

LANDINI ASSOCIATES

THE MOST EFFECTIVE DESIGN COMES FROM A STRATEGIC AND METHODICAL APPROACH. THIS CASE STUDY PROVIDES A BRILLIANT EXAMPLE OF THE DIFFERENCE IT MAKES WHEN DESIGN FIRMS TAKE TIME TO LOOK STRATEGICALLY INTO THEIR CLIENT'S BUSINESS AND CREATE VISUAL SYSTEMS THAT FUNCTION AS BUSINESS COMMUNICATION SOLUTIONS. IN THIS CASE STUDY, LANDINI ASSOCIATES DEVELOPED A BRAND IDENTITY THAT REFLECTS CLEARLY THE BUSINESS STRATEGY OF ITS CLIENT, MACQUARIE TELECOM.

CLIENT Macquarie Telecom provides information and communications technology for business and government clients throughout Australia and Singapore. The company develops and implements a range of voice, mobile, and data networks, as well as hosting and security products. Macquarie is the challenger to the top two telecom providers in their market. The company positions itself as a "business only" telecom, pursuing medium- to large-scale businesses and not serving consumer markets.

taking a strategic look at Macquarie's business. Designers developed a logo to reflect the four key business areas and overlayed them to show the client's expertise in convergent communications systems. Project deliverables included the brand platform, identity and identity

guidelines for all customer touch points, a launch party, and third-party-sponsored branding guidelines.

LOGO AT WORK The logo is designed to work as a visual communication tool for several communication pieces. Each of the four atoms represents a key business area: voice, data, mobile, and hosting. The four business areas often converge and are connected by accountable service and a high level of security.

By designing the logo to reflect Macquarie's business strategy, the logo serves as a visual cue for employees and customers. Employees can use the logo as a talking point to describe their key business functions to customers. Then, when customers see the logo, they experience a visual reminder of Macquarie's business areas

The logo represents Macquarie's four key business areas; the overlay shows their convergence within the brand.

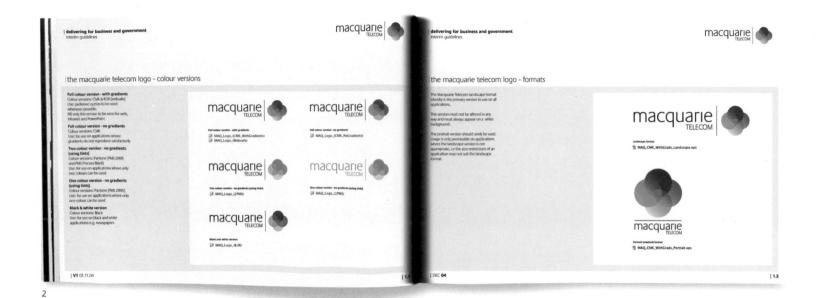

and attributes. The strategic design also works as a versatile visual reference within several communication pieces.

NICE APPROACH A strategic approach to design involves studying the attributes that differentiate clients from their competitors. It also involves asking questions about any communication barriers faced by the client. The designer then has the challenge of developing a visual system that addresses each of these (and other) issues.

Landini learned that Macquarie has a surprisingly approachable nature. This approachability clearly differentiated Macquarie from its competitors and addressed a major obstacle for customers. That is, most people assume that telecom companies are high-tech and low-touch; that telecoms speak another language, and are neither easy to communicate with nor friendly.

Landini designed the visual system to reflect accurately the client's approachable nature and commitment to providing highly accountable service. The designers did this through the four overlaid atoms, rounded typeface, and with added attention to the website design. To counter the perception of telecom businesses as unapproachable and difficult to communicate with, Landini designed the website to be very easy to navigate and to reflect the core attributes of the company: approachable, secure, and highly accountable.

ADDED DIMENSION Corporate offices provide tremendous opportunities to reinforce brand identity among employees and customers.

Landini extended the reach of the brand identity to the Macquarie corporate office in Sydney, providing depth and dimension through reception signage, wayfinding, and ambient art pieces.

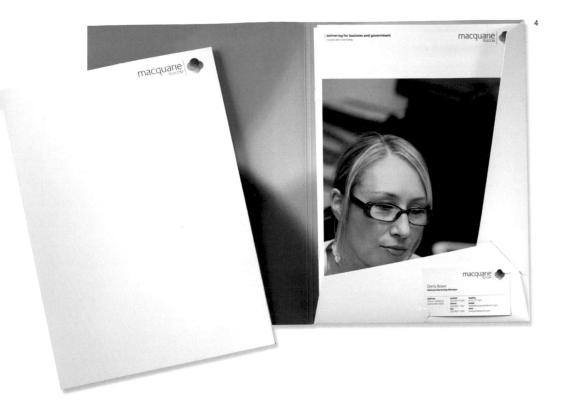

Style manuals help internal staff and external contractors support the brand values effectively and consistently.

3

The website communicates Macquarie's core attribute of being a surprisingly approachable technology company.

1

The corporate brochure gives internal staff and customers an overview of the brand elements, key messages, and company products and services.

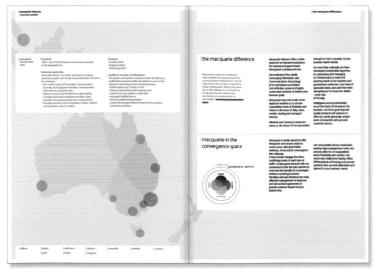

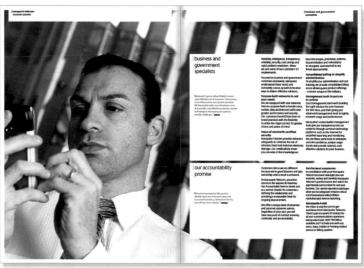

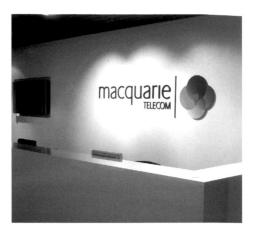

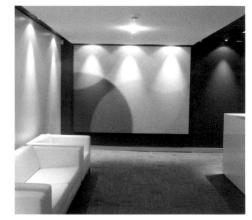

5
Macquarie hosted a launch party for key staff and customers to introduce the new brand.

6
Corporate offices provide an opportunity to extend the brand with added depth and dimension.

7 Landini set up digital, in-house printing to be consistent with preprinted material.

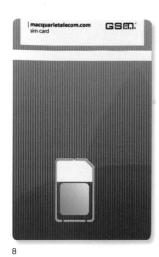

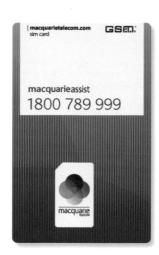

Landini reinforced the brand by adding the logo to a variety of products and business items.

CLIENT: Macquarie Telecom DESIGN FIRM: Landini Associates ART DIRECTOR: Mark Landini DESIGNER: Clayton Andrews

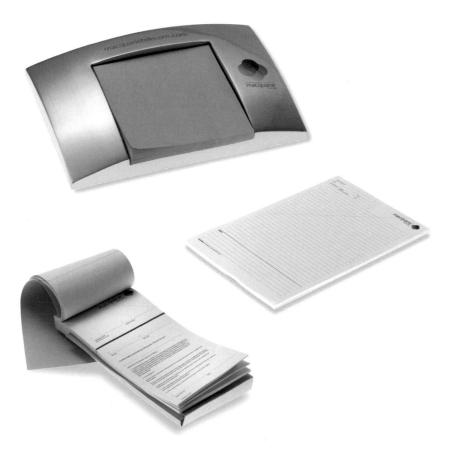

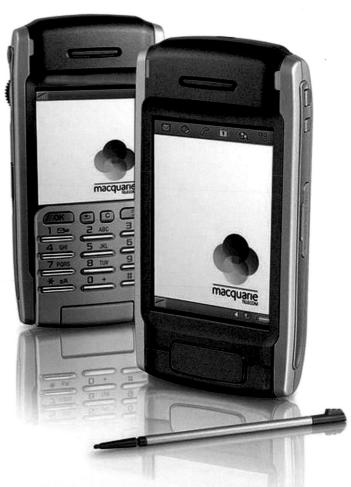

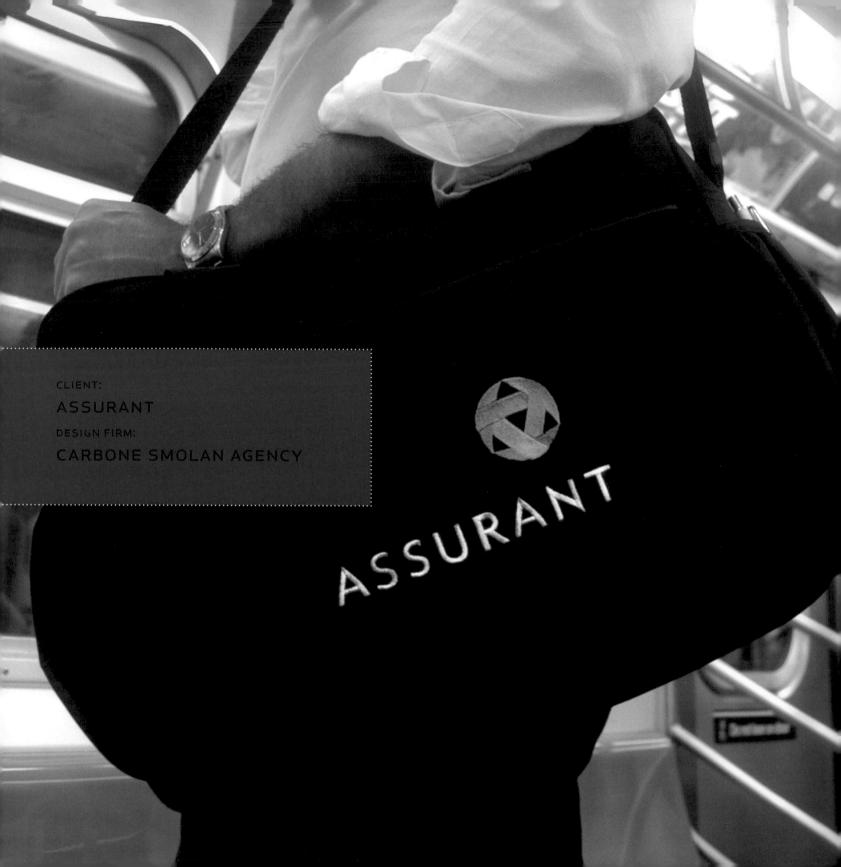

DESIGNERS USE AESTHETICS TO HELP BUSINESSES SOLVE COMMUNICATION ISSUES. THROUGH STRATEGIC COMBINATION OF ELEMENTS SUCH AS COLOR, SHAPE, TEXTURE, PHOTOGRAPHY, ILLUSTRATION, AND ANIMATION, THEY DEVELOP VISUAL AND VERBAL SYSTEMS THAT COMMUNICATE THE ATTRIBUTES AND BENEFITS OF A PRODUCT, SERVICE, OR COMPANY. THIS CASE STUDY FEATURES A VISUAL SYSTEM THAT HELPS ASSURANT COMMUNICATE ITS ABILITY TO BRING CLARITY TO THE INCREDIBLY COMPLEX BUSINESS OF SPECIALTY INSURANCE.

CLIENT Assurant, a Fortune 500 company, provides specialty insurance and insurance-related services through five subsidiaries: Assurant Employee Benefits, Assurant Health, Assurant Preneed, Assurant Solutions, and Assurant Specialty Property. The company prides itself on communicating complicated ideas in accessible and understandable ways.

PROJECT Fortis changed its name to Assurant to coincide with the company's initial public offering (IPO). Company officials engaged Carbone Smolan Agency (CSA) to develop a new identity system to support the name change. CSA worked in tandem with Assurant's in-house communications team to develop the brand. Deliverables included brand identity, a stationery system, advertising, and a style guide.

GOOD TIMING By launching a branding program simultaneously with its IPO, Assurant was able

to capitalize on the press coverage already garnered by the IPO. The branding program provided Assurant with a visual tool with which they could discuss the attributes that differentiate it from competitors.

DEFINING IDENTITY CSA designed Assurant's brand identity to communicate two key concepts. First, the use of three colors illustrates Assurant's three key businesses: risk management, customized technology, and long-term partnerships. Second, the logo demonstrates that the three are interwoven to provide a rich range of integrated services.

SAME BUT DIFFERENT Assurant needed to develop an identity that allowed subsidiaries to retain independence while also creating a unified brand presence. The design solution involved maintaining the various subsidiary names and treating them with a shared logo and typeface.

The loosely woven symbol and use of three colors in the logo represent the integration of Assurant's three key business areas.

2
The ad campaign used simple and familiar items such as a kite and a yo-yo to communicate
Assurant's ability to bring clarity to complex issues.

3Strategic branded items included USB drives and luggage tags.

4 The use of brilliant color makes Assurant stand out from competitors in the more traditional and conservative insurance industry.

CLIENT: Assurant
DESIGN FIRM: Carbone Smolan Agency
ART DIRECTOR: Ken Carbone

3

for the loosely woven logo sphere. The colors for the loosely woven logo sphere. The colors communicate vibrancy, dynamism, and interconnection. The colors help Assurant stand out in an industry dominated by conservative, corporate "suits." The rounded type follows the spherical shape of the logo and communicates approachability and warmth, suggesting that Assurant is a different type of insurance company.

OBJECT LESSON Full-page ads introduced the new name and brand identity. In each ad, a simple image connects with a complex idea to communicate the core strengths of the company. For example, the design team used the symbol of a kite to illustrate aerodynamics and interrelationships. Another ad features the logo sphere to express the company's attributes. The campaign demonstrates Assurant's ability to communicate complex concepts in clear ways.

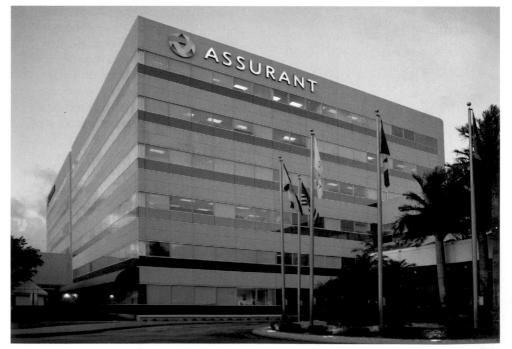

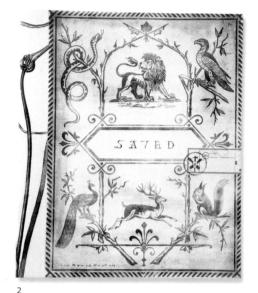

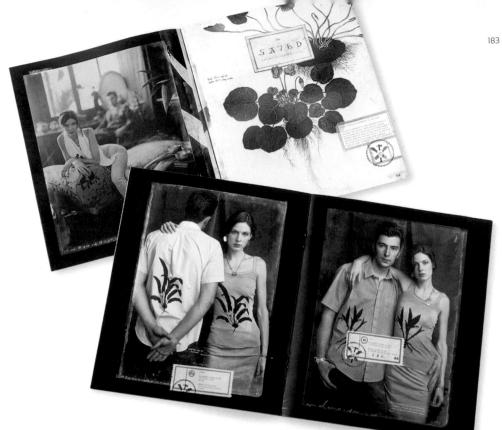

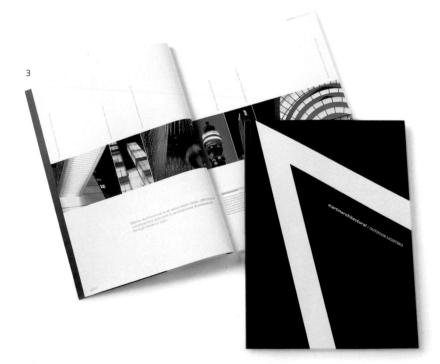

4 CLIENT: Essenciale DESIGN FIRM: Hardy Design

5 CLIENT: Wong Co Co (Jubes) DESIGN FIRM: Kinetic

CLIENT: Montville Sales
DESIGN FIRM: Sussner Design Company

7

CLIENT: Made Her Think
DESIGN FIRM: Nothing: Something: NY

8

CLIENT: Robert K. Futterman & Associates (RKF)
DESIGN FIRM: Liska + Associates

Meredith Kahn PRESENTS MADE HER THINK

PROCESSION of OBSESSIONS.

SENSETTE L. Skull Mala-champagne & white, 24" / 2. Skull Mala-green & black, 34"

9 CLIENT: Nebraska Book Company DESIGN FIRM: Archrival

10 CLIENT: Grupo Daca DESIGN FIRM: Diseño Dos Asociados

11 CLIENT: Millennium DESIGN FIRM: Hornall Anderson Design Works

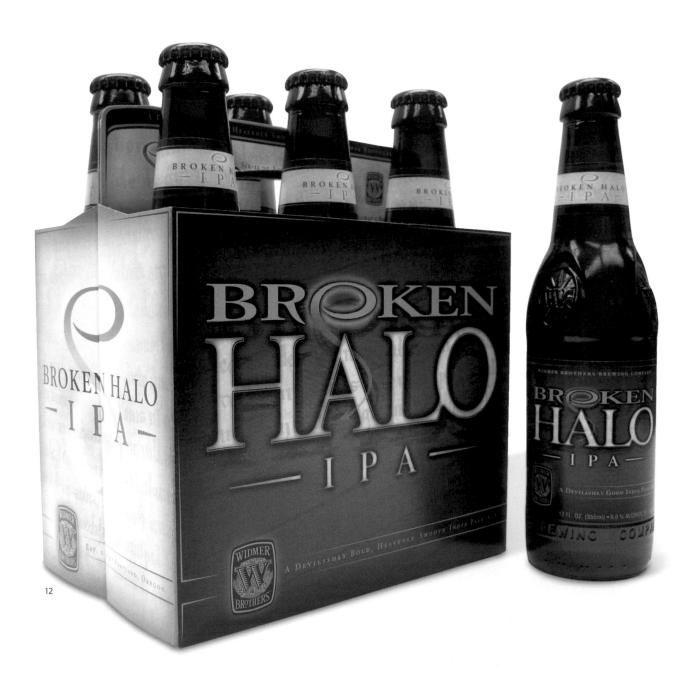

12 CLIENT: Widmer Brothers Brewery DESIGN FIRM: Hornall Anderson Design Works

13
CLIENT: Wells
DESIGN FIRM: Curious

Hibernate: Bedding and linen We look for value — whether it's a polycotton sheet or Egyptian cotton percale sheet; wool blanket or bedspread; manmade pillow (for allergy sufferers) or Hungarian goose down duvet. Our linen workshop can also make most things to most sizes. Our range includes bathrobes and towels.

Manufacturers include: Brinkhaus. Dougners Guild, Pater Reed and Yves Delorme. Kenzo and Pierre Frey Shown opposite: Brinkhaus fine durests and phone granularal maleration.

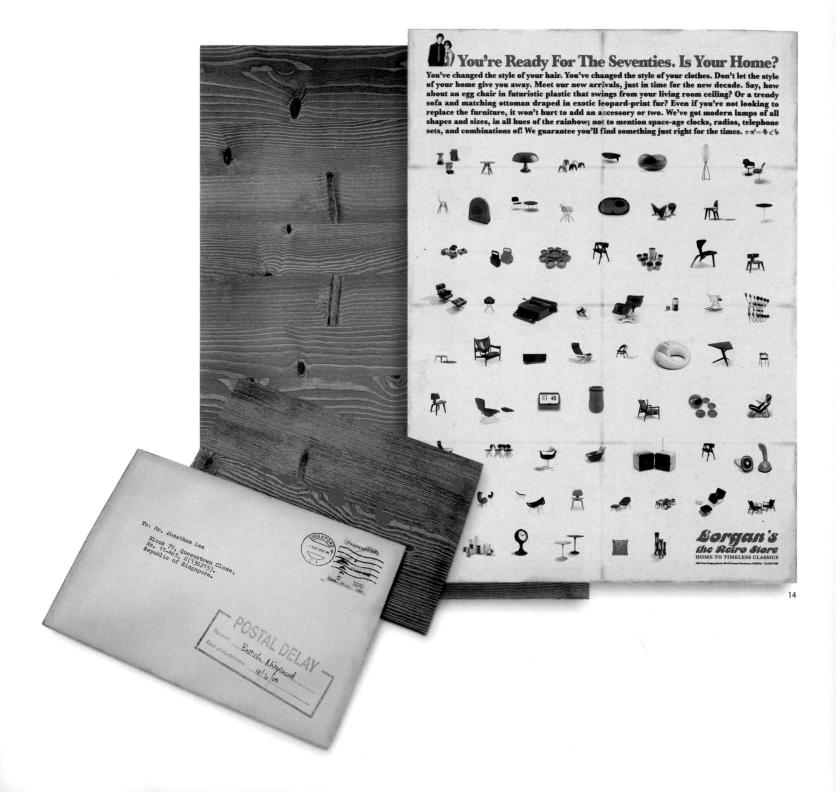

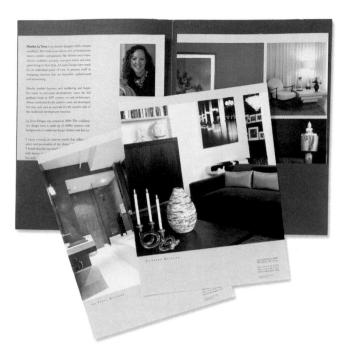

CLIENT: Lorgan DESIGN FIRM: Kinetic

15

CLIENT: La Tessa Designs DESIGN FIRM: Decker Design

16

CLIENT: OC Tanner
DESIGN FIRM: Hornall Anderson
Design Works

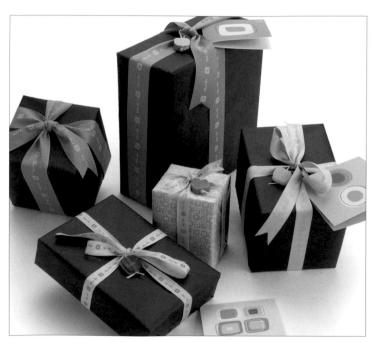

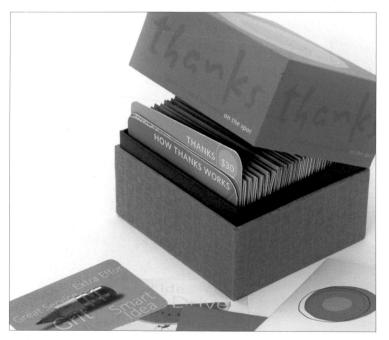

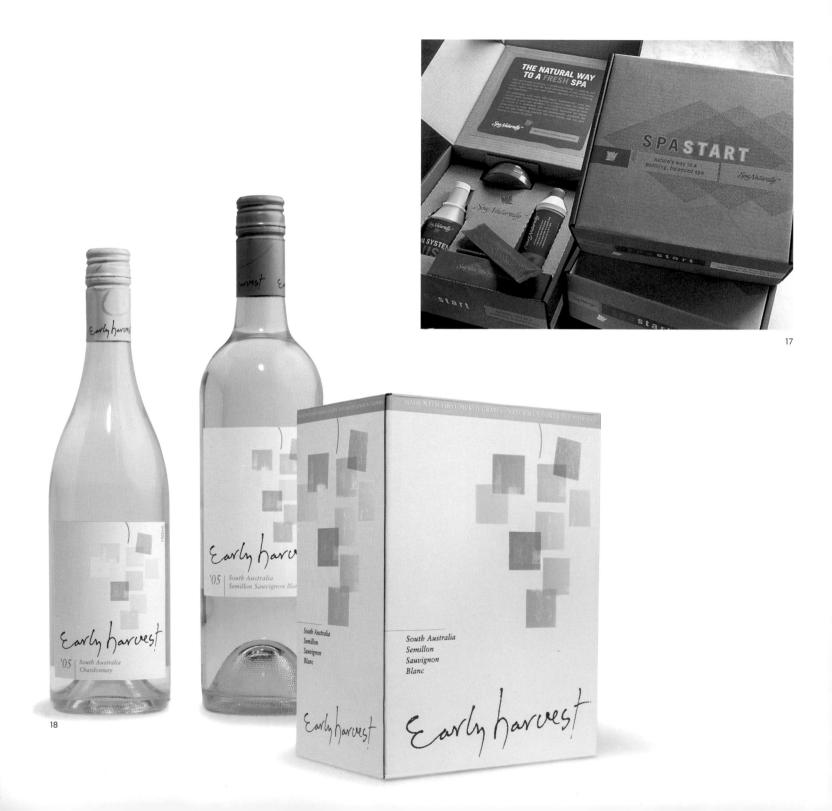

CLIENT: Spa Naturally
DESIGN FIRM: Sussner Design Company

18

CLIENT: Foster's Australia DESIGN FIRM: Davidson Design

19

CLIENT: Rebecca Taylor DESIGN FIRM: Liska + Associates

21

CLIENT: Made Her Think DESIGN FIRM: Nothing: Something: NY

CLIENT: Beringer Blass Wine Estates DESIGN FIRM: Davidson Design

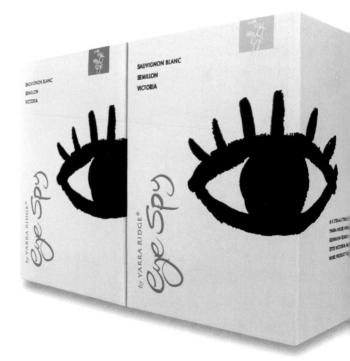

Shouldn't your workspace function as capably as you do?

22

CLIENT: Piquant Blue DESIGN FIRM: Perks Design Partners

23

CLIENT: Benjamin Moore DESIGN FIRM: Hornall Anderson Design Works

24

CLIENT: WorkRite Ergonomics DESIGN FIRM: Wages Design

Get a clear line of sight from any angle.

(And a cleaner desk top, too.)

BIFMA G1-2001 Sections 8.3.4 (page 6

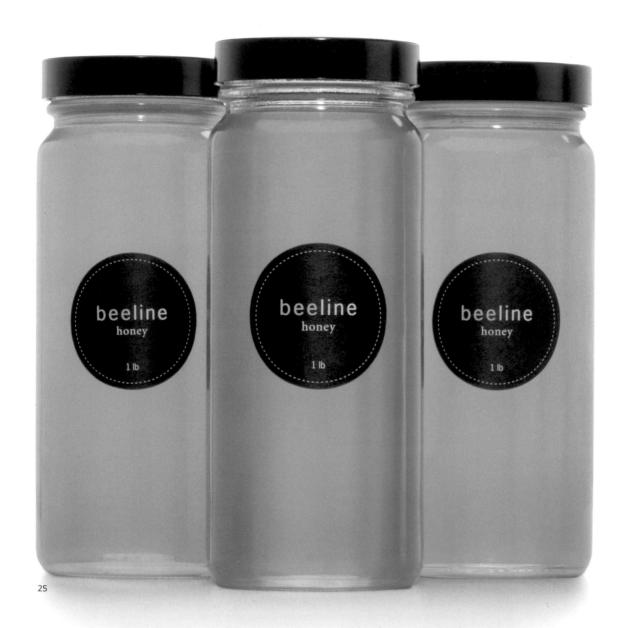

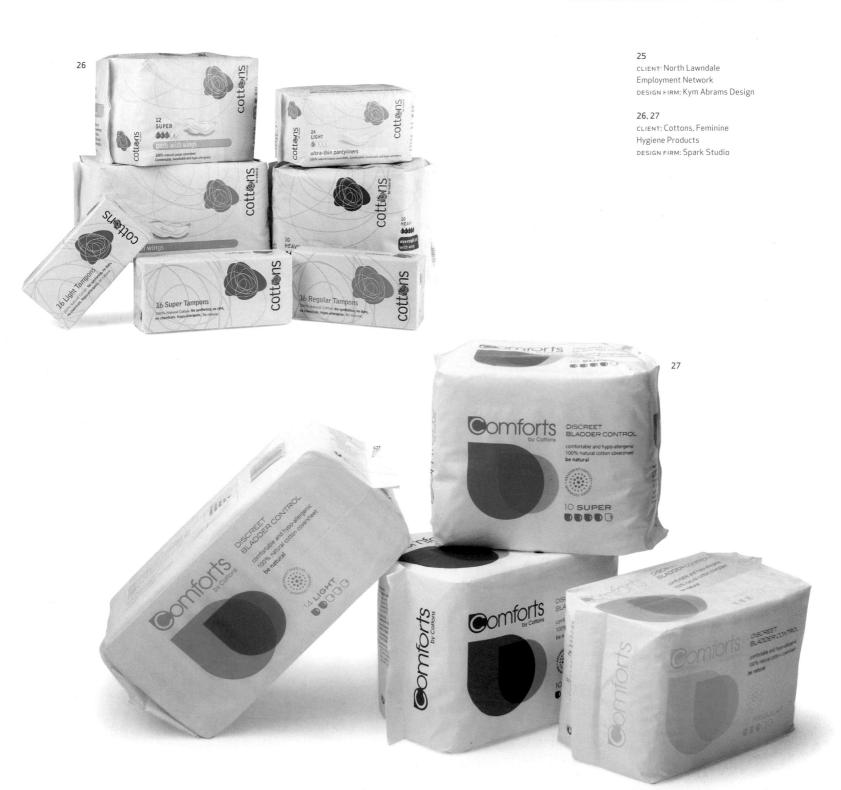

CLIENT: Reflections
DESIGN FIRM: Sussner Design Company

29

CLIENT: Bally's DESIGN FIRM: Addis Creson

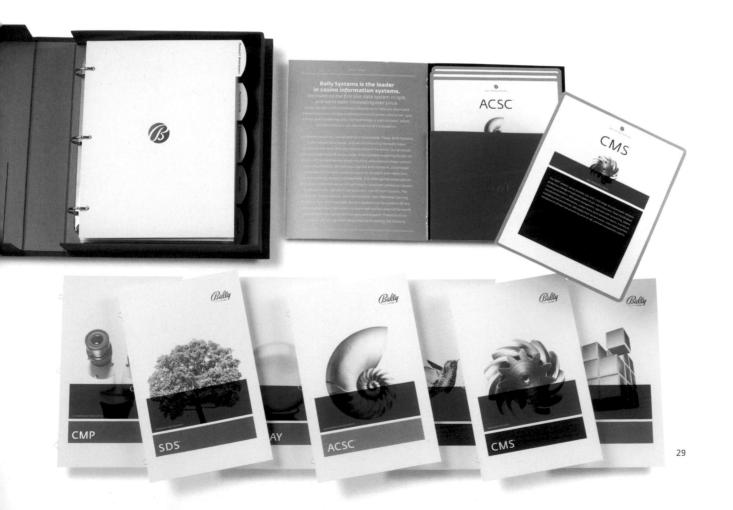

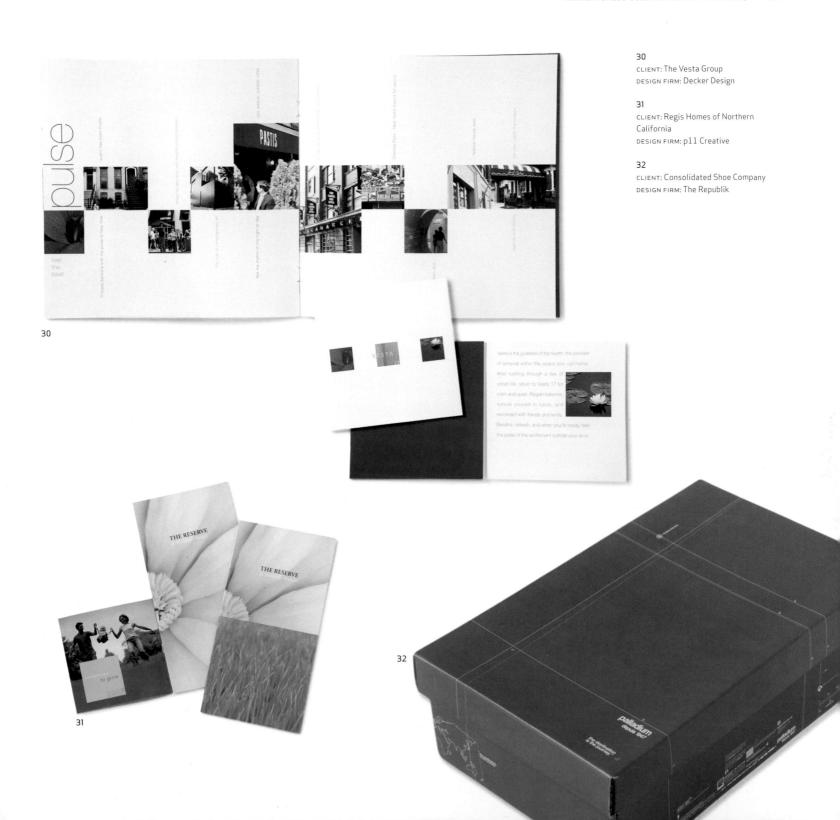

33
CLIENT: Wingara Wine Group
DESIGN FIRM: Perks Design Partners

34
CLIENT: Centex Homes
DESIGN FIRM: pl1 Creative

35 CLIENT: Ryco Filters DESIGN FIRM: Octavo Design/ Spark Studio

36 CLIENT: Posestvo Črni kos, Rošpoh DESIGN FIRM: KROG, Ljubljana

37 CLIENT: Ljubljanski grad DESIGN FIRM: KROG, Ljubljana

33

WOOLSHED

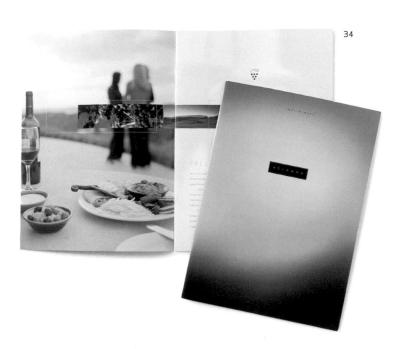

CLIENT: J. Boag & Son DESIGN FIRM: Perks Design Partners

39

CLIENT: Cold Standard
DESIGN FIRM: Hornall Anderson
Design Works

40

CLIENT: Bing Bang
DESIGN FIRM: Nothing: Something: NY

41

CLIENT: Lyon Capital Ventures
DESIGN FIRM: p11 Creative

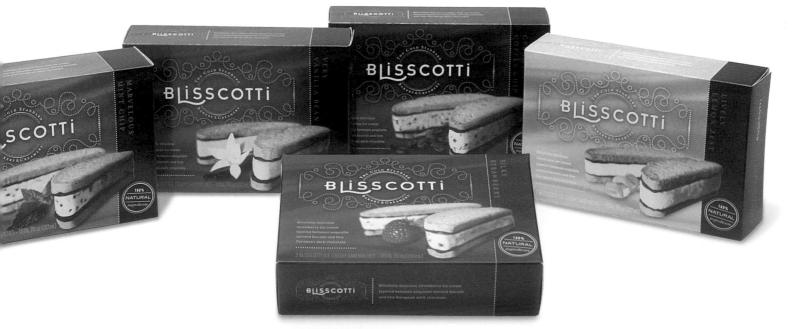

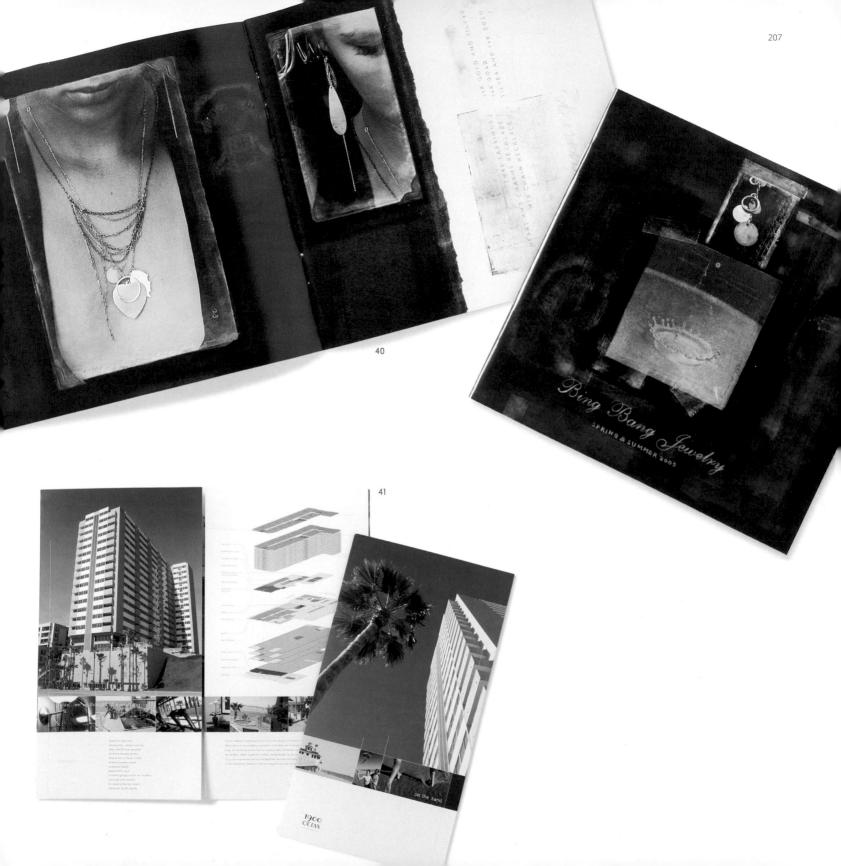

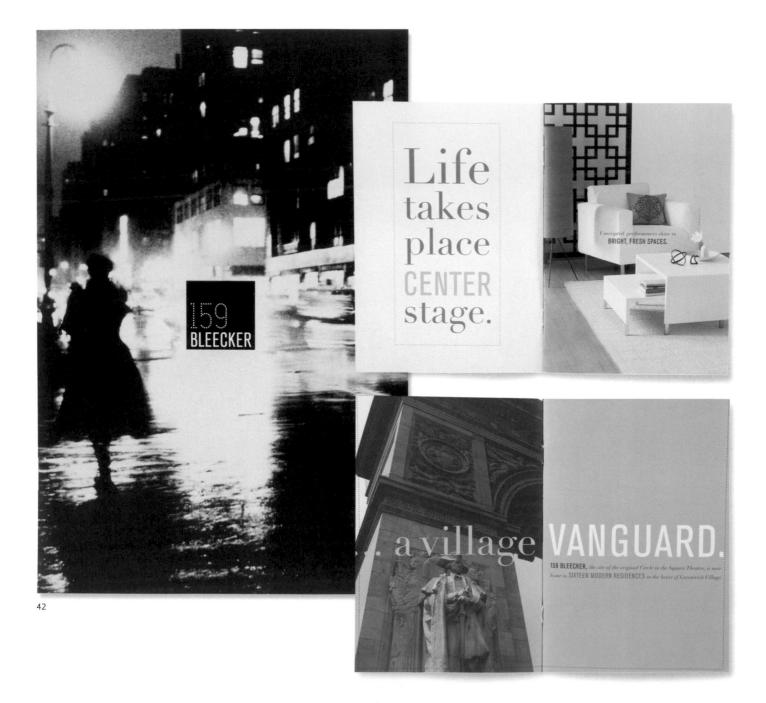

CLIENT: Coldwell Banker Hunt Kennedy
DESIGN FIRM: Liska + Associates

43, 44, 45

CLIENT: Tahitian Noni DESIGN FIRM: Hornall Anderson Design Works

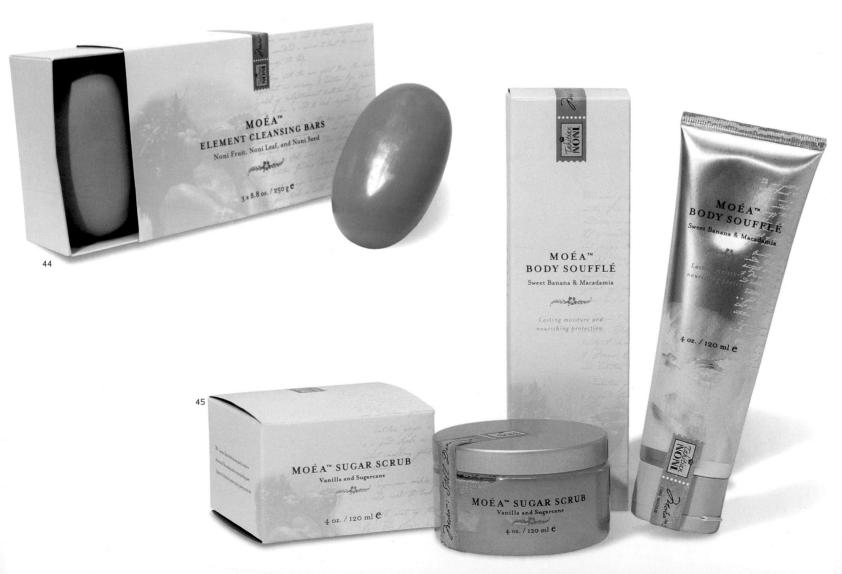

THE MOST IMPORTANT COMPONENT OF THE DESIGN PROCESS TAKES PLACE BEFORE ANY SKETCHING BEGINS. THE WORK OF INTERVIEWING THE CLIENT, ASSESSING THE EXISTING BRAND PROGRAM, RESEARCHING THE INDUSTRY, AND UNDERSTANDING THE COMPETITION ESTABLISHES AND DEFINES THE BRANDING STRATEGY FOR BOTH THE DESIGN TEAM AND THE CLIENT.

THIS CASE STUDY SHOWS HOW THE INITIAL WORK HAD AN IMPACT ON THE PROJECT SCOPE AND RESULTED IN A VISUAL SYSTEM THAT REFLECTS

ANKASA'S CORE ATTRIBUTES AND PRODUCT BENEFITS.

CLIENT Based in New York and Mumbai, India, Ankasa designs and manufactures high-end, luxurious home-furnishing couture collections. Its sister company, ANK International, sources, designs, and manufactures fabrics and rare finishes for fashion designers including Oscar de la Renta, Armani, and Escada.

visual system that reflects and highlights the luxurious quality of the Ankasa brand. Wherever the design interacted with the product line (either physically or through imagery), the designers chose to keep design elements to a minimum and let the product textiles, patterns, and textures speak for themselves. The use of color and the simplicity of design were particularly valuable for the product tags and packaging, since Ankasa's product line involves multiple colors and continually evolves. Deliverables for the project included a company and industry

analysis, an identity system, a stationery system, a press kit, invoices, tags, invitations, packaging, and website design.

A GOOD FIT Ankasa originally approached mCube to create product tags. When mCube's designers began working with the logo, they realized the mark didn't match the company's brand values or business objectives. As mCube extended its creative review to other branded elements, they found similar discrepancies. mCube approached the client and presented their findings. Ankasa agreed with mCube's analysis and charged them with the larger task of designing a visual system that would differentiate Ankasa from its peers and more clearly reflect the luxury of the product line.

A IS FOR... Ankasa required that the new logo incorporate the letter 'A' from its existing logo. mCube transformed the letter A into a symbol

The symbol for the logo represents a softened, stylized letter A and hints at a piece of furniture.

that references multiple aspects of the company. The logo represents the company name and the home decor industry by hinting at the types of furniture on which Ankasa's products are used. The choice of an earthy brown as the primary logo color reflects the natural source of Ankasa's products.

PRODUCT FEATURES mCube paid particular attention to how the logo and other elements would function with the physical products. The tags, for example, needed to reflect the high-end nature of the products and also work well with a wide variety of colors and textures. mCube chose brown partly because the neutrality works well with the range of product colors. The tags are sewn with silver thread to highlight the richness of the products. Similar thought went into the packaging design. The signature brown strip is large enough to highlight the silver logo and small enough to allow for easy viewing of the package contents.

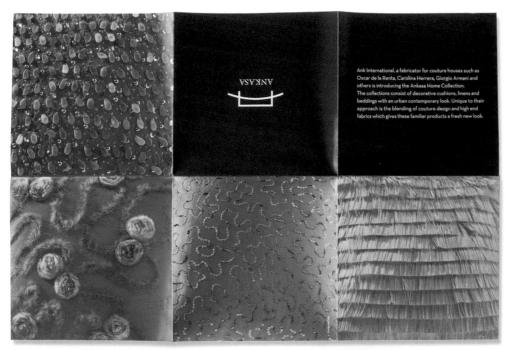

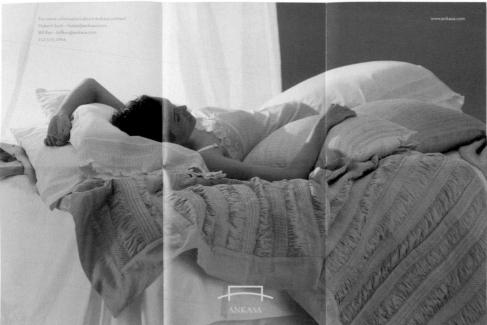

The stationery system communicates brand attributes of elegance and attention to design detail.

3

In most cases, the logo is foil-stamped in silver against brown to add a distinctive quality and elegance to the brand image.

4

Each element of the business system, including mailing labels and purchase orders, is consistent with the brand standards.

5

The cropped details from textured cushion covers and the lifestyle image communicate attributes of sophistication and luxury.

6

The website follows the simple, elegant, and product-driven strategy.

6

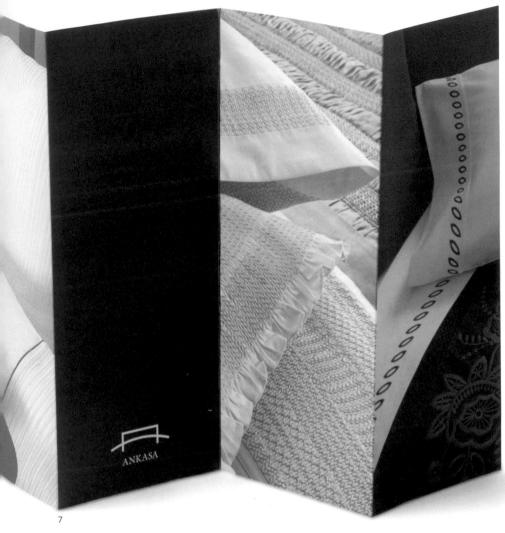

Following the overall brand strategy, the trade-show invitation allows the product to speak for itself; text is minimal and doesn't compete with the images.

8

Packaging is designed to showcase the beauty of the products.

a

Consistent with the other brand collateral, the paper tags are square with the logo foil-stamped in silver.

10

The neutral brown product tags fit well with a wide variety of textiles and patterns.

11

The launch invitation gives a feeling of unveiling and invites the reader to learn more about Ankasa.

CLIENT: Ankasa DESIGN FIRM: mCube ART DIRECTOR: Rachana Shah DESIGNER: Neha Mehta

CLIENT:
HARTER
DESIGN FIRM:
THE MODERNS

harter[•]

DESIGN TEAMS MOST OFTEN DEVELOP A BRANDING PROGRAM TO SUPPORT AN EXISTING PRODUCT, SERVICE, OR COMPANY. IN THIS CASE STUDY, THE INFLUENCE OF THE DESIGN TEAM EXTENDED TO PRODUCT DESIGN. HARTER ENGAGED THE MODERNS NOT ONLY TO REBRAND ITS COMPANY, BUT ALSO TO CURATE A NEW LINE OF PRODUCT FINISHES. ALIGNING THE PRODUCT TEXTURES AND COLOR PALETTES WITH THE BRANDING STRATEGY ADDED DEPTH, DIMENSION, AND CONSISTENCY TO THE BRANDING PROGRAM.

harter [♥] at the heart of the solution

CLIENT Harter has designed, manufactured, and sold office furnishings for more than seventy years. The company has a strong reputation for producing ergonomic seating and for its distinct design aesthetic. Harter intentionally focuses on lifestyle and solution-based products that meet the changing needs of today's flexible workplace environments.

PROJECT When Harter approached The Moderns, the furniture company had fallen off the radar screen in the design world and was struggling for exposure and relevance in an extremely competitive industry. Harter commissioned The Moderns to develop a holistic brand platform that would reinvigorate and ignite the Harter brand. Deliverables included a logo, a positioning statement, messaging, marketing materials, a website, showroom design, a product color and texture palette, and strategic business consulting services.

KNOW BY HEART The Moderns repositioned Harter as an agile and multilateral solutions provider. They created the positioning statement, "The Heart of the Solution," and used a heart as the main logo symbol. Hearts appear on a variety of collateral material, and the Harter website features customizable Valentine's Day cards.

NEW WORLD Taking their cue from the blurring lines between work and home, designers coined the phrase "work-life universe" and used the concept to define not only the brand positioning, but also Harter's business strategy. Harter's focus shifted away from providing furnishings for traditional office settings and toward designing and engineering flexible solutions for today's mobile workers.

ACTION-ORIENTED The new emphasis on the "work-life universe" transformed the way Harter organizes its product lines. The company now

The personality brochure features embossed hearts. The centrally placed logo provides a subtle spot of color.

presents its product lines based on the ways people live and work. Function-oriented categories such as action, side, train, and relax replaced traditional labels like chair, desk, and file drawers.

MOOD SELECTION The Moderns brought a fresh perspective to Harter's understanding of materials and textiles. Prior to engaging The Moderns, Harter viewed material and texture as secondary to ergonomic design and quality manufacturing of their products. Now, Harter views material and texture as critical components that can positively affect the work environment. The Moderns also curated the color and materials palette for Harter's product lines to reflect more contemporary colors and finishes. The Harter furniture designers worked within the palette, so the product lines reflect the holistic brand strategy.

.

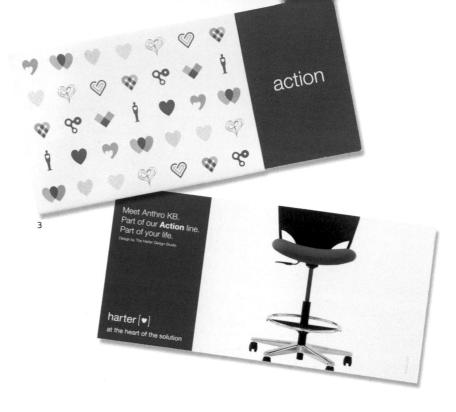

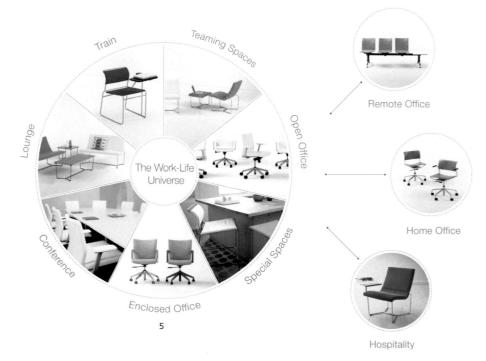

2
The annual personality brochure introduces product lines and familiarizes customers with the Harter brand.

3 Product cards feature photography and illustration that are also used in the personality brochure.

Advertising highlights the work-life universe theme.

5
The design team created the organizing theme of work-life universe to promote Harter's product lines.

6,8

The Moderns also curated the color and materials palettes for Harter products.

7 The Moderns designed the NeoCon

The Moderns designed the NeoCon exhibit for Harter, adding consistency to the brand experience.

9

The brand guide provides internal and external resources with strategic and creative direction.

10

This display window created for a major industry event, NeoCon, introduced both the brand and the product lines.

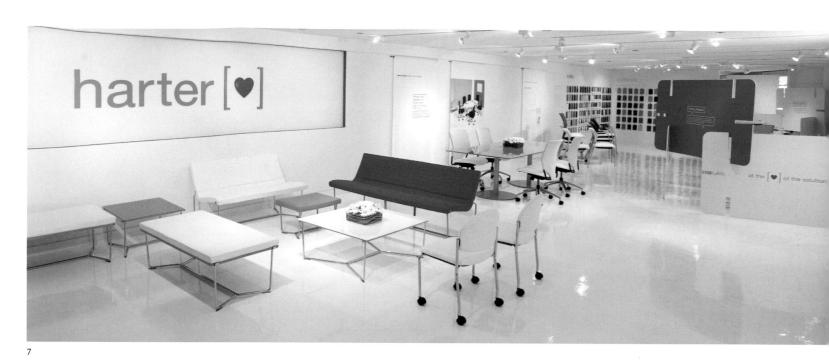

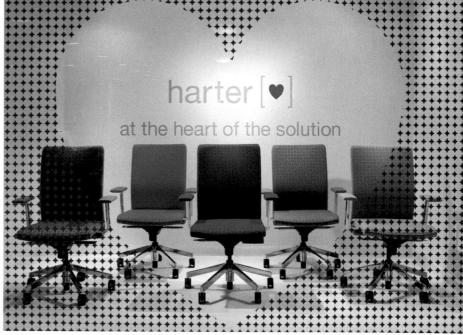

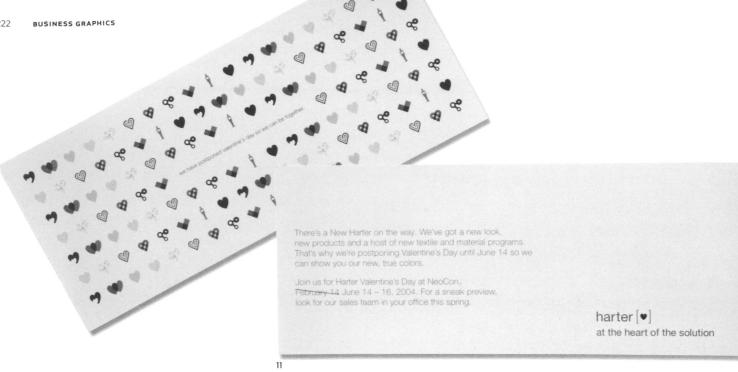

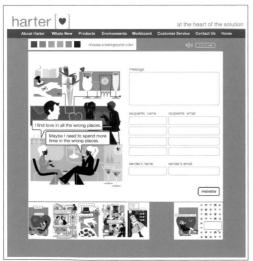

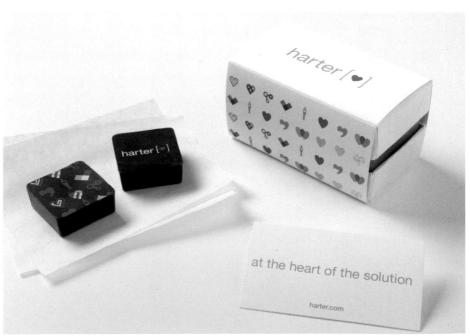

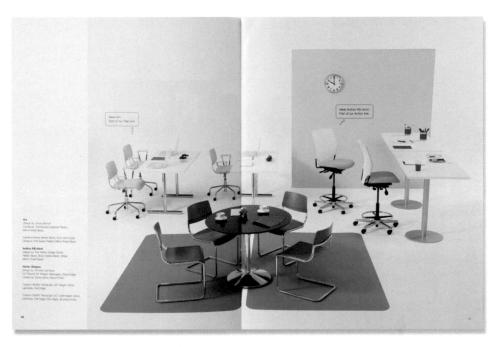

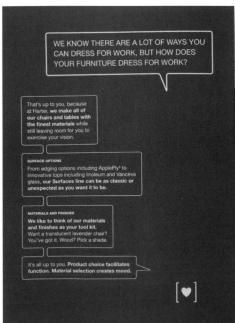

The brand launched at NeoCon on June 14, and was positioned as a postponed Valentine's Day event.

12

Custom e-cards for Valentine's Day are a natural fit with Harter's heart-driven identity.

13

Branded give-aways include custommade chocolates.

14

The personality brochure reveals product vignettes that contextualize the product lines. Speech bubbles punctuate Harter's friendly and conversational editorial voice.

CLIENT: Harter
DESIGN FIRM: The Moderns
ART DIRECTORS: Janine James, Kevin Szell
DESIGNER: Kevin Szell

Interface

Mission Zero: our promise to eliminate any negative impact our companies may have on the environment by the year 2020.

Interface FLOR"

One Earth. FOOTPRINTS,

Interface RAISE™

DESIGNERS CONDUCT MULTIFACETED RESEARCH BEFORE DETERMINING A CENTRAL FOCUS FOR A BRANDING PROGRAM. THEY CONSIDER CLIENT VALUES AND ATTRIBUTES, TARGET AUDIENCES, COMPETITOR POSITIONING, CULTURAL TRENDS, PRODUCT QUALITIES, AND DIFFERENTIATING CHARACTERISTICS. IN THIS CASE STUDY, DESIGNERS AT THE VALENTINE GROUP CHOSE TO BUILD A REBRANDING PROGRAM AROUND A SINGLE COMPANY VALUE THAT MOST DIFFERENTIATES INTERFACE: A CORPORATE COMMITMENT TO SUSTAINABILITY.

CLIENT Interface designs, produces, and sells modular carpet, broadloom carpet, panel fabrics, and upholstery. The company is publicly traded, with sales in more than 110 countries worldwide. Interface's position is unique; the company is not only committed to minimizing its impact on the environment, but it also strives to restore the environment. Interface diligently pursues its corporate goal of eliminating any negative impact it may have on the environment by the year 2020—a sizeable task and an admirable promise from the world's largest producer of modular flooring.

PROJECT The global rebranding program needed to work on many levels. Primary goals included streamlining the Interface brand portfolio and integrating the company's already well-developed message of sustainability, known as "ZERO." The design team had the added requirement of creating a flexible branding program that would

appeal globally. Deliverables included identity design, corporate collateral, print and outdoor advertising, showroom graphics, exterior signage, packaging, a website, PowerPoint presentations, press kits, trade show collateral, and a global standards manual.

the Valentine Group thoroughly reviewed the existing brand program to determine if it contained elements that could be leveraged in the rebranding effort. Its analysis revealed two components of significant value: the "voice bubble" element from InterfaceFLOR (Interface's consumer brand), and the message of sustainability, ZERO. The design team incorporated both components to create the Mission Zero concept and identity.

ENVIRONMENTAL GRAPHICS Environmental concerns have been central to Interface for many years. The design team brought the company's

The Mission Zero logo incorporates the voice bubble from the client's existing brand program.

<< 2

Floor decals at an industry trade show introduced the client's new look and reinforced the Mission Zero messaging.

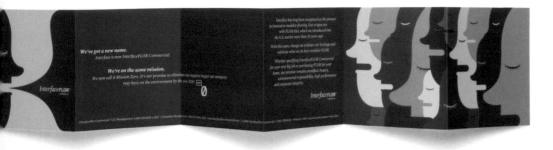

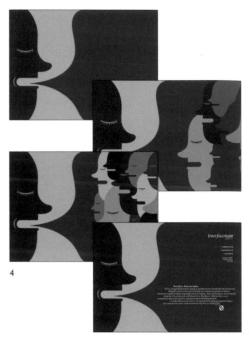

commitment front and center, both visually and verbally. This message clearly differentiates Interface from its competitors and unifies the company around its ambitious goal of minimizing its corporate environmental footprint. Each division of Interface adopted the sustainability promise and incorporated the Mission Zero graphic identity into its visual system.

GLOBAL POSITIONING Interface manufactures and sells its products in more than 110 countries. The design team needed to be aware of design trends across cultures, create visual and verbal language that would translate easily, and convey appropriate and contemporary meaning in different countries.

FAMILY TRAITS In addition to developing the Mission Zero identity, The Valentine Group rebranded the five divisions of Interface.

This process involved developing a master brand identity system that aligned each division more closely with the global Interface brand. This also included renaming two divisions, InterfaceFabric and InterfaceFLOR Commercial.

POP-UP The design team incorporated the existing voice bubble concept into the rebranding program. The voice bubble communicates Interface's voice and suggests its readiness to interact with customers. Designers applied the element to several communication pieces, including the Mission Zero identity, flash animation, bags, and floor decals. The voice bubbles combine to form a series of vine shapes that communicate that Interface is growing organically. They also appear as a component of a "multi-face" graphic used by InterfaceFLOR Commercial to communicate its new face to the industry.

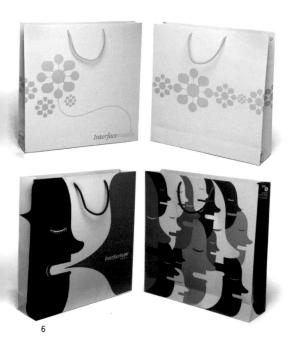

The direct mail piece uses the "multiface" graphic to announce the new name and identity of one of Interface's divisions, InterfaceFLOR Commercial.

4

The website for the InterfaceFLOR Commercial division uses the "multiface" graphic to communicate the company's approachability and introduce its new face to the industry.

5

The global website homepage opens with a flash animation that promotes the rebranding program.

6

The versatile use of graphic elements and color palettes allow both consistency and variety across different product lines.

7

To reinforce the rebrand internally, branded screensavers and a wallpaper application were installed on Interface's employee computers.

8

The corporate timeline poster features vines constructed of voice bubbles that reinforce messages of sustainability and growth.

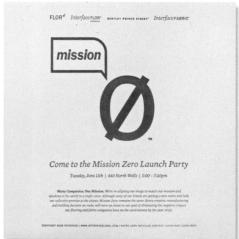

The design team customized press kits for each product line and the Mission Zero campaign. The digital kits contain USB drives that are pre-loaded with relevant information.

10

Branded items include water bottles, nametags, "museum" tabs, pins, shopping badges, napkins, silk ties, and scarves.

11, 12

Branded items at the Mission Zero launch party introduced the new visual system.

13

Company trucks also received a new design treatment, adding visibility to the brand.

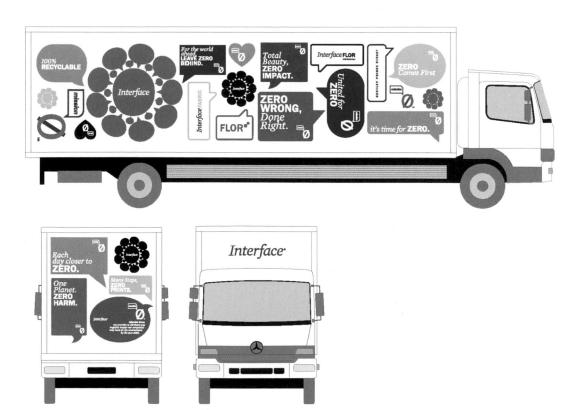

14 InterfaceFLOR Commercial's advertising incorporates the "multi-face" graphic and communicates the company's differentiating focus on sustainability.

CLIENT: Interface
DESIGN FIRM: The Valentine Group
ART DIRECTOR: Robert Valentine
DESIGNERS: Robert Valentine,
Brooke Romney

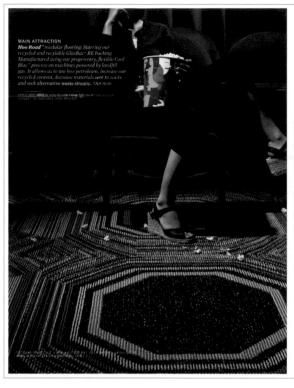

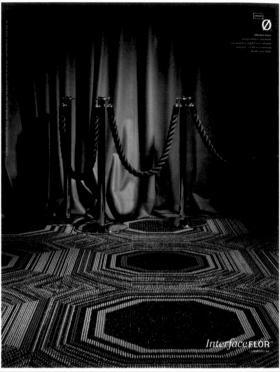

14

stability n:
firmness in position; permanence; constancy,
as of character or purpose; steadiness
syn: soundness, vitality, solidity, strength

agility n:
the state or quality of being agile; quick,
well-coordinated movement; the ability to
think quickly
syn: nimbleness, quickness, adaptability

pp | Stable strategies Agile responses,
pp | Letter to Shareholden
pp | Hevitt at a Claime
pp | Financial Results

2

Hewitt is a world leader in human capital management. We help companies and the people who work for them succeed—together—and by doing so, we help make the world a better place to work.

Much has changed. Much hasn't.

- CLIENT: Sal. Oppenheim jr. & Cie. KGaA
 DESIGN FIRM: Simon & Goetz Design
 GmbH & Co. KG
- CLIENT: Hewitt Associates
 DESIGN FIRM: Crosby Associates

3 CLIENT: VF Corporation DESIGN FIRM: And Partners

4
CLIENT: CWS Capital
Partners, LLC
DESIGN FIRM: Ramp Creative

5-Sided Polygon

A pentagon is a five-sided polygon. Commonly, the term "pentagon" is used to refer to the regular pentagon. The regular pentagon is the polygon with five sides illustrated below

Like the five lines of the pentagon that intersect to create its shape, our company also has five points that make us distinct. These are our company values. Our five values give us exceptional form. They define our culture, provide structure for strength and shape our unique personality that distinguishes us within the real estate investment management industry.

Our Core Values

Our core values are based on five key principles. These values are the foundation of our company culture. By building on a core of trust and open communication, we generate insightful investm opportunities, superior customer service, and long-term relation; with our investors, residents and employees.

- 1. A demand for excellence with a sense of urgence
- 2. A respect for people
- 3. A requirement for profitability
- 4. Honoring our word
- 5. Ethical dealings are paramount

Company History

where the second control of the cont

4

5 CLIFNT; Musica Viva Australia DESIGN FIRM: Boccalattë

6
CLIENT: The Joyce Foundation
DESIGN FIRM: Kym Abrams Design

7 CLIENT: New Jersey Resources DESIGN FIRM: Decker Design

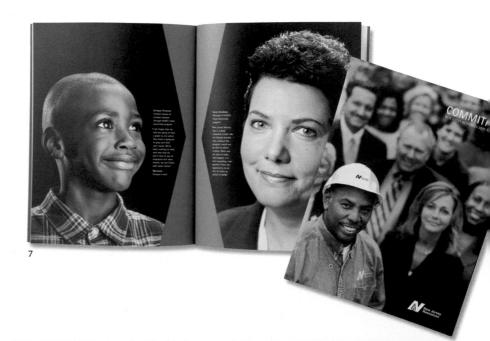

100 percent

in 2005, every legislator in Illinois heard from Women Employed about our top priorities: expanding ities and financial support for training and about the impact of policy decisions on particular districts, organized constituent visits, convened briefings for staff, and testified at hearings.

To respond, we are building a coalition to develop a family leave insurance program to meet the needs of employers and workers alike. In 2005 we doubled the size of our coalition from 12 to 24 participating organizations.

a no-win choice. If they stay home to take care of themselves or their families, they risk their jobs; if they go to work, they risk their health or their loved ones' well-being.

IMPROVING CARE.

IMPROVING LIVES.

IMPACTING COMMUNITIES.

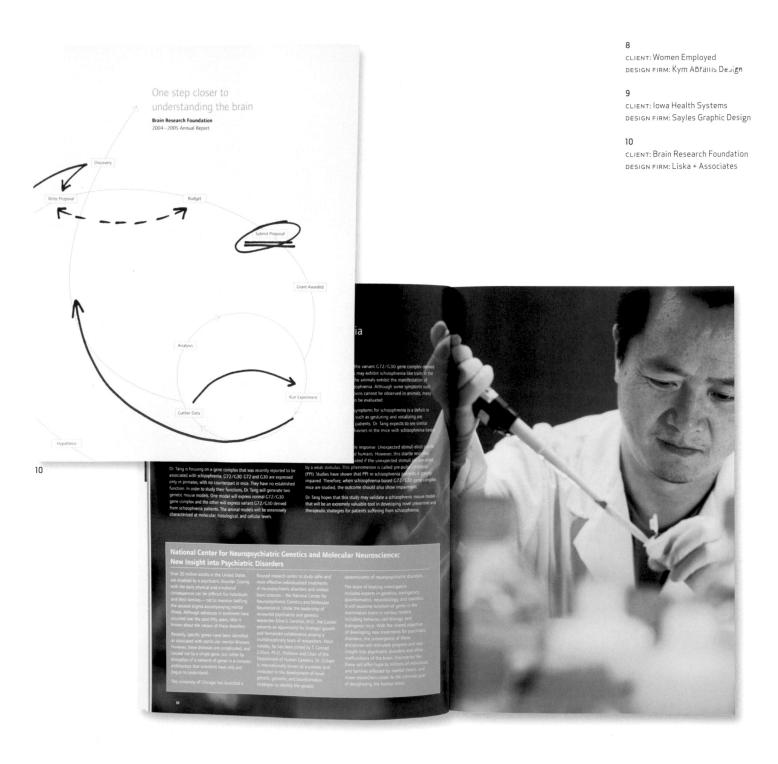

11 CLIENT: Adris Group DESIGN FIRM: Bruketa & Zinic

12
CLIENT: Harvard Divinity School
DESIGN FIRM: OrangeSeed Design

13
CLIENT: Council of Fashion Designers
of America
DESIGN FIRM: Liska + Associates

FULL FRONTAL EASHION RETURNS

The CFDA was an instrumental player in bringing Full Frantal Fashton, and its walt-to-wall coverage of Fashton Week, back to the thi-state area viewing public. Partnering with NYC TV 25, the new home of the show, and Ultra HD, the CFDA succeeded in securing a place for the show on basic cable, making it more easily available to the area's nine million viewers right in time for the Spring 2007 shows.

FULL FRONTAL FASHION

ASHION

RICHARD AVEDON'S WOMAN IN THE MIRROR

Takes a Fashion Vil

QVC PRESENTS

CFDA New Fashion Designer Showcase

2/24 and 10/28/2005 Always on the look-out for innovative ways to rise the profile of American designers, the CFDA partnered with shopping network QVC to bring six designers to the lattention of the network's devoted shoppers. The two GVC Presents CFDA Fashino Designer Showcase shows presented the work of emerging designers Alice Roi. John Bartlett. Liz Collins, and Maria Corneje on the February 24 show, and Pierre Carrillero of Pierrot and Steven Cox and Daniel Shiero fluxible Brown on October 25. Each created imfrated edition capsule collections reflecting their aesthetic, but selling for fashino-friendly prices ranging from S60 to \$100. Rois and Bartlett's appearances were so successful that they each returned with a stard-alone, one-hour program. The endeavor, which donates a protein of the proceeds to the CFDA's educational instaltwe, will contained in 2006.

14, 15

CLIENT: Edwards LifeSciences DESIGN FIRM: Ramp Creative

16

CLIENT: The Columbus Foundation DESIGN FIRM: Base Art Co.

17
CLIENT: Marlborough Wine Research
Centre
DESIGN FIRM: Lloyd's Graphic Design Ltd.

18 CLIENT: Dmatek DESIGN FIRM: Jason & Jason

CLIENT: SOGIN
DESIGN FIRM: Carré Noir Roma

of Perorder nating the both Pazza is a gibillion the substantial was seen located it, is known transformed it and residential land within it.

s. elopment will ents in a mis wavehouse style so include a is, cales, offices, don facility, an style piazza.

contract for management re precinct, install and n within used for the ctricity, gas onsumption, and services act is in

otal and the rts.

ntermoco's solution will enable the cost effective on selling of all services to residents and tenants. Electricity will be purchosed from suppliers at bulk rates and on sold to residents and tenants at significantly discounted rates. Gas as well as hot water and rain water will be on-sold with users receiving the one integrated bill Further, residents and tenants will be able to monitor their daily usage data through a secure website and to use this information to manage their usage more cost effectively. The bodies corporate and precinct management on the site will also benefit through significantly reduced costs for the supply of energy to common and public areas. Intermoco's billing software application provides occupiers and tenants with a detailed account of their energy usage on a monthly basis and graphical comparison of consumption for the same period last year.

Ecologically Sustainable Development One of the Pentridge Piazza's key objectives

is to implement the best standards of ecologically sustainable development (ESD) and accordingly, a number of ESD strategies have been incorporated into the overall design. These strategies include installation of rainwater tanks, recycling of rainwater, five star energy ratings for buildings, glazing and insulation techniques and solar panels. Consistent with this philosophy has been the selection of Intermoco's Utility solution. Utilitisation of this solution enables residents and tenants to more effectively manage their energy usage and reduce their consumption

2005 ANNUAL REPORT

MONITORING AND CONTROL

20

20
CLIENT: Intermoco Limited, Monitoring & Control Systems
DESIGN FIRM: Octavo Design/
Spark Studio

21 CLIENT: Robert Bosch Stiftung DESIGN FIRM: Hesse Design

Starke Familie.
Bericht der Kommission »Familie
und demographischer Wandel«
Im Auftrag der Robert Bosch Stiftung

Kurt Biedenkopf
Hans Bertram
Margot Käßmann
Paul Kirchhof
Elisabeth Niejahr
Hans-Werner Sinn
Frans Willekens

22, 24
CLIENT: Podravka
DESIGN FIRM: Bruketa & Zinic

23 CLIENT: Endeavor Global DESIGN FIRM: Goodesign 22

BITOEAVOR
unleashes the power of entrepeneurship in emerging markets.

23

END IMPACT REPORT
2004-2003 VOR

 Road new growth enablers. Support our growth plans by identifying and developing high potential employees and by recruiting qualified leaders with year skill sets.

Highlights of 2004

· Nace, set income, earnings per share and cash flow

«VI resplent four acquisition»— Hem* brand promising and called footwar and apparel for antinoadors and other action opens participants and orthosotte (Vann'), Köpling* brand backpack, and accessors (Köpling*), Kappigi** brand prisons outdoor based sportiouser (Nappigif*), and a 15% weters in an intensite apparel marketin acquisitio Mexicology.

No also increased 16% to \$6,054.5 million, is addition to sales of the 2004 Acquisitions, outributing to this increase were a full year of sale 2 Notice (compared with four months in the price sate belowing its acquisition) and organic sales continuous hoursease.

Act nome increased 19% to \$474.7 million, and cattles yet their increased 17% to \$4.21. (All period attention of adulted basis). Their increases resulted from improved operating criterianse in most core businesses, plus profit contraction from our 2004 and 2003 acquisition accessed disease.

ediction initiatives that will assist VF in meeting it begins also and earnings targets. This spending was not originally planned for 2004.

ret and our VF Playwear business, which had b interperforming in recent years.

organism of our recent acquisitions is proceeding or a shead of schedule.

25

CLIENT: Homewood Corporation DESIGN FIRM: Riordon Design

26

CLIENT: VF Corporation
DESIGN FIRM: And Partners

the Spin of Egi. In 2004 we described our Engage Europe, Sandyer and Ageng saviny the 1st declared by 2004 and described our Engage Europe Concernment and enhanced the 1st declared by 2004 About 1s from we odded Kipfing to our discission, which does not see 1st and the 1st declared by 2004 About 1st from the 1st 2004 we're baseding a complete segue? Increded apparel collection, forshoold become a many growth engine for this

ACT ANTEMANTS (1) Innie Guphic Designes Fast Apparel Grouns Georgia Berng dals to manage melopis (desetfications within secural catagories while taking disortion from antifolis amount and fill being life to man expectations Train DAS AREALESS, Beine DOMES Fast Apparel Moss are the money. Our apparel trans transformed is stragging design or a political beaution. Here Extrasted between 4 beauting topic in design, intribuolishing and

FF Janusser What Males He Day, Working with an enthusiastic term the thick sensel of uniformal creditor towns. What He World Hingles Sales of Rigg Herman," is Principled March 1997, and the Company of the Principled March 1997, and the Principled M

Solitoria trade engineering, was east being Lee flow. Engineering this distinct trade engineering, was east not continuous pass of grow become. Here, Lee Dongweer in the was, Leave Lawwee A. great with the was been Product Manage Med Done, Engineering or the was a been Product Manage Med Done, Engineering services founded on the same strange. Beighten Manage Receiving Award for University to Spirit, University Press, I whose our engineer. I was a supported by Spirit, University Press, I whose our engineer.

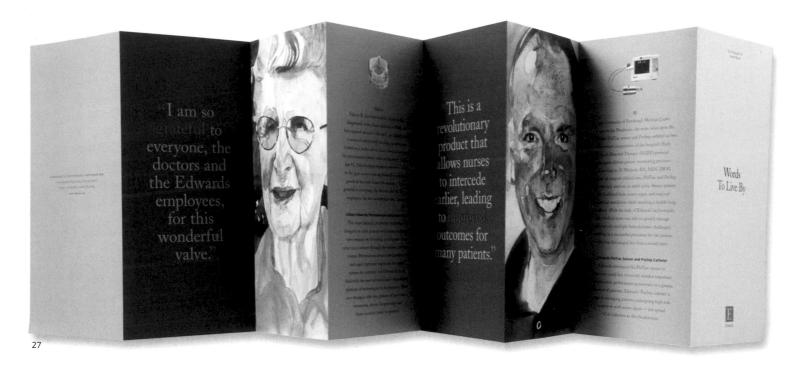

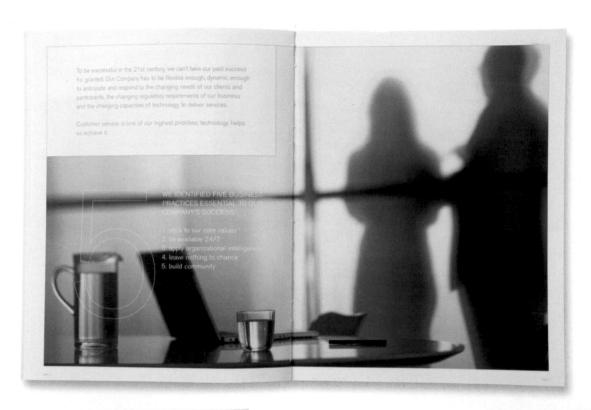

27
CLIENT: Edwards LifeSciences
DESIGN FIRM. Namp Creative

28
CLIENT: Mutual of America
DESIGN FIRM: Decker Design

29, 30
CLIENT: Northwestern Memorial
HealthCare
DESIGN FIRM: Liska + Associates

PROMISE

Use of the Bloodloc, along with the barcoding of blood samples in the

laboratory, reduces the potential

for error. At left: Barcoded blood products are stored by type in the

blood bank until needed for use.

Above: Blood products are scanned, inventoried and then secured with a

Bloodloc before they are dispensed.

Locking In Sa

Northwestern Memorial dispi products to our patients each or a wrongly administered-bli severe consequences.

To prevent misidentification a at Northwestern Memorial, w professionals and caregivers t goal was to understand why can lead to errors and to bett

Within six weeks, our team di Bloodloc⁷⁸ safety device. This to a bag containing any bloosi programmed with a three-letti the blood product is intended

While the Bloodloc system enefforts to reduce error begin a time. Before the blood specim code is affixed to each patient is labeled with a barcode for la

If a patient needs blood producthe product and then locks it is with the patient's three-letter chospital's pneumatic tube systems.

When the blood product arrive protocol requires that two nur correct blood for the intended three-letter code on the patien reason the lock does not open for resolution.

In industry terms, this method of mistake-proofing a process commitment to develop practie 31
CLIENT: Melbourne Pacific
Airports Corporation
DESIGN FIRM: Perks Design Partners

32 CLIENT: New Century Financial DESIGN FIRM: Ramp Creative

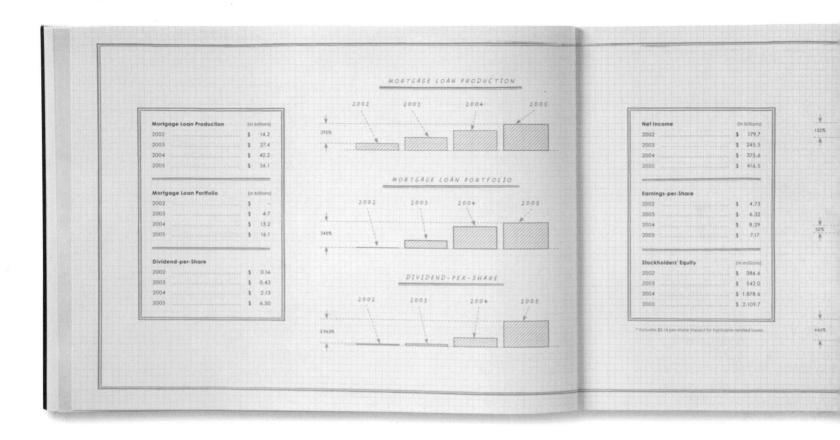

CUTTING FROM THE

STRENGTH

CLIENT:

DIAMOND BANK

ENTERPRISE IG

Diamond Bank

THIS CASE STUDY ILLUSTRATES TWO ELEMENTS OF THE DESIGN PROCESS: HOW A DESIGN TEAM CAN CREATE A VARIETY OF MATERIALS FROM A SINGLE SOURCE OF INSPIRATION, AND HOW A SINGLE THEME CAN CREATE A REMARKABLY CONSISTENT, YET BROAD, VISUAL LANGUAGE. IN THIS CASE, THE SOURCE OF INSPIRATION CAME FROM THE NAME OF THE CLIENT, DIAMOND BANK. THE DESIGN TEAM FOCUSED ON DEVELOPING A HOLISTIC BRANDING PROGRAM THAT RELATES CHARACTERISTICS OF DIAMONDS TO THE CLIENT'S ATTRIBUTES, PRODUCTS, AND SERVICES.

CLIENT Diamond Bank is one of Nigeria's largest retail banks. The company positions itself as sound, professional, flexible, and purpose-driven. After a recent merger and legislative changes within the Nigerian financial market, the company chose to upgrade its visual system to reflect its stature and breadth of service, while still maintaining a sense of approachability.

PROJECT Diamond Bank engaged Enterprise IG to design a comprehensive brand program that would set the bank apart from—and above—its competitors. The design team developed the visual system around the most prominent image in the existing identity, a diamond. Diamonds inspire each element of the brand, from the shape of the logo and a custom typeface to the spectrum of color and the use of diamond-oriented patterns. Enterprise IG expanded the diamond concept to provide the branding

program with depth while maintaining consistency by focusing each piece on various elements of a diamond. Deliverables included a logo, a custom typeface (appropriately named Facet Face), stationery, corporate collateral, a brand manual, signage, and retail and corporate interior design.

OPERATING SYSTEMS Enterprise IG used diamond-related color palettes to generate collateral for each operating division. For the Diamond Bank Group, the team used a graphite color palette. Graphite is derived from carbon, which is expressed in its purest form as a diamond. Design for the Private Banking division reflects the valuation component of diamonds; the less color a diamond contains, the greater its value. The collateral for this division appears colorless and makes use of varnishes and clear foils. The design team selected a range of color

The logo incorporates the lowercase letter "d" and the shape of an ideal cut diamond. The faceting adds dimension and African patterning.

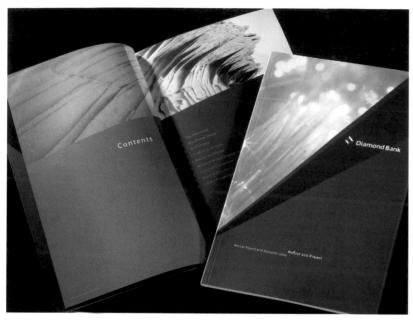

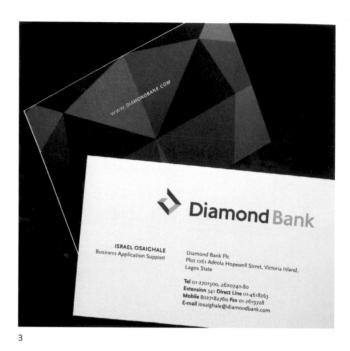

for the most public-facing division, Diamond Bank Retail, because a diamond radiates a spectrum of color when held up to the light.

of the pieces, including the primary identity. The logo combines the lowercase letter "d" and the shape of an ideal cut diamond. The faceting contributes added depth and dimension to the identity. The press kit also relies on diamond shaping for its design. It is folded in an origami style that re-creates the process of cutting a diamond. When fully opened, the kit radiates brilliant color and vibrant stories, like an expertly cut diamond reflects a spectrum of light.

CHANGING THE LANDSCAPE Diamond Bank's new identity demonstrates notable consistency within a holistic branding project. Relative to international competitors, this could be seen as standard practice; however, it is groundbreaking and exceptional within the Nigerian market.

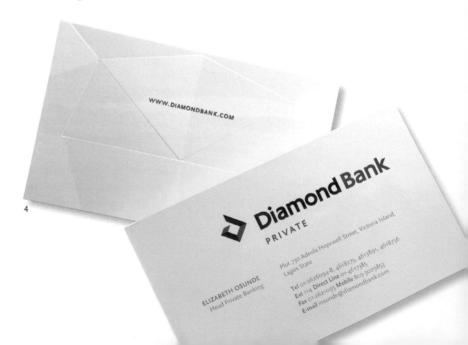

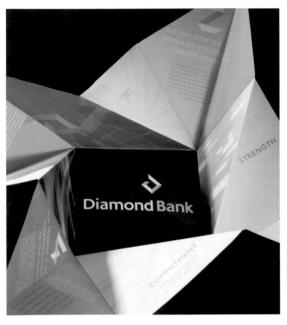

The annual report uses a graphite color palette, inspired by a diamond's elemental source, carbon.

3

The double-sided business card combines metallic inks and spot varnishes to create facets of a diamond that sporkle differently when held at different angles.

4

The less color a diamond has, the greater its value. Diamond Bank Private Banking collateral reflects this by using varnishes and clear fails.

5

The press kit unfolds in stages, re-creating the process of cutting a diamond. When fully opened, it radiates brilliant color and communicates vibrant stories.

6

The Private Banking folder is die-cut in the shape of an ideal cut diamond.

7

The decorative typeface, Facet Face, was designed exclusively for Diamond Bank.

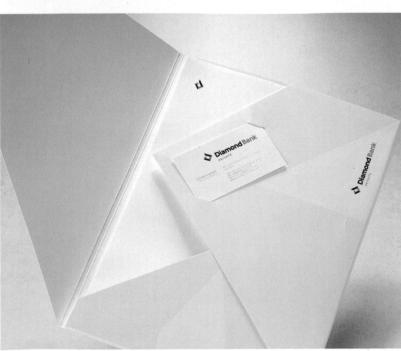

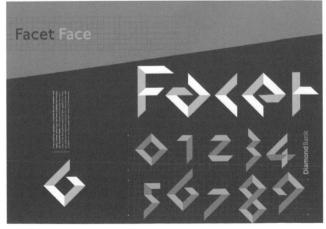

8
Each chapter of the brand manual,
Facets, begins with a story about
an aspect of a diamond that relates
to the chapter at hand.

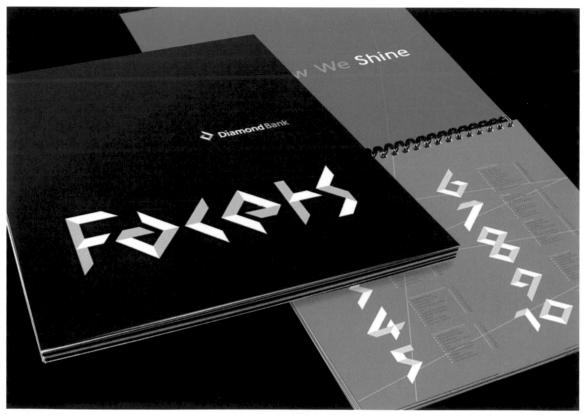

y

The most public-facing division uses collateral with brilliant colors because when a diamond is held to the light, it reflects a spectrum of light.

10

The logo is iconic and translates well through all brand materials, from stationery to signage.

11

In its holiday cards, the Diamond Bank symbol is transformed into seasonal iconography. Each accordian panel features a oneword message, ending with the word prosperity.

CLIENT: Diamond Bank
DESIGN FIRM: Enterprise IG
ART DIRECTOR: Dave Holland
DESIGNERS: Bronwen Rautenbach,
Leoni Watson

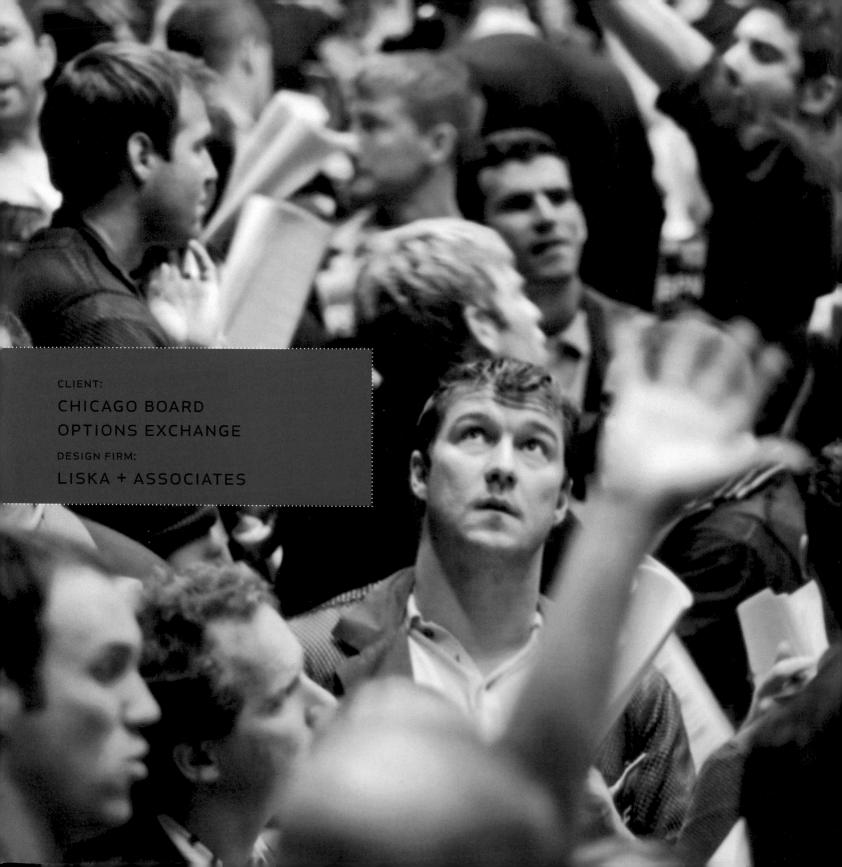

VISUAL AND VERBAL SYSTEMS WORK TOGETHER TO COMMUNICATE A CLEAR, ACCURATE, AND CONSISTENT MESSAGE. THE CONTENT, OR MESSAGE, DRIVES THE DESIGN SOLUTION; THE VISUAL DESIGN SUPPORTS AND REINFORCES THE CORE MESSAGE. WHEN A CLIENT'S CONTENT REMAINS VIRTUALLY THE SAME OVER THE COURSE OF SEVERAL YEARS, DESIGNERS FACE THE CHALLENGE OF COMMUNICATING THE MESSAGE ACCURATELY WHILE ALSO EVOLVING THE VISUAL DESIGN. THIS CASE STUDY SHOWCASES DESIGN SOLUTIONS CREATED FOR THE CHICAGO BOARD OPTIONS EXCHANGE (CBOE), A BUSINESS WHOSE MESSAGE REMAINS RELATIVELY CONSTANT.

CBOE is the largest and most successful options marketplace in the world.

CLIENT Founded in 1973, the Chicago Board Options Exchange was the first U.S. options exchange. Every year since its inception, CBOE has been the world leader in options volume. The company is positioned as an options exchange with multiple products, as well as the first exchange to develop a successful hybrid trading system that truly marries floor-based (open outcry) trading with screen-based, electronic trading.

PROJECT For several years, CBOE has engaged Liska to design a variety of corporate communication materials. The central design challenges remain the same from project to project. CBOE's messaging is relatively constant; the business model may evolve, but the overall incomegenerating activity of options trading remains the same. Yet while the core message remains consistent, the design needs to suggest a sense of difference and progress from year to year.

INCOME GENERATOR CBOE develops markets and platforms that generate new options, literally and figuratively, for trading. The drive to create new products and enhanced methods of trading is elemental to the CBOE brand and critical to CBOE's long-term success. Liska uses a combination of illustrations, photography, and diagrams to communicate CBOE's active process of generating new markets and enhanced trading methods.

ABSTRACT ART The business of CBOE is extremely complex and abstract. Liska focuses intently on developing visual solutions that help display the complicated processes and products of CBOE. The design team presents key performance data in clear and straightforward ways.

HYBRID OPTION The core business of CBOE is facilitating options trading; it provides the mechanisms and venues that traders use to

make transactions. As CBOE integrated the hybrid system, which combines both open outcry and electronic trading, Liska incorporated photography that communicates the simultaneous presence of human interaction and technology.

LONG-TERM ENGAGEMENT Designers face the challenge of communicating CBOE's consistent core message in accurate and clear ways that are also editorially stimulating. The challenge is compounded by the finite audience for most of CBOE's communications; the audience remains very similar from year to year. Liska resolves this issue by supporting the messaging with visual cues that communicate a variety of aspects of the CBOE experience. From photographs of the trading jackets to dramatic images of the trading floor, the design team engages the reader and demonstrates the richness and depth of CBOE.

1
This annual report cover balances the intensity and immediacy of floor-based trading with the open and visionary attributes of CBOE.

2

The need for clarity drives the visual presentation of financial data.

7

Liska's design solutions present CBOE's complex processes, financial performance, and key events in visually engaging and memorable ways.

ESCENSE CONTROLLES

STORY

TASK EVENT

TAS

Spring It Shark Mith Mambara

Service: It Starts With Members

Design from the control of the contr

550,000__

Influence Constant

1,000 inspireme resisions

1,000 inspirement

1,000 inspireme

decause individual market makers now have electronic quoting capability, CBOE, for the first time, allows for the "opening of the Limit Order Book" to customer, firm and Broker/Dealer orders. Orders entered in the Book are afforded priority according to price and are eligible.

Innovation: Expanding Possibilities

CROT for shorps here and still remains the technological leader among options exchanges.

Best Execution
Assurance Program
On August 1, 2000, CBOE as enhanced its execution quality programs through on the second programs through the new Best Execution. The execution is a second program. The

Trading via Techn
100 94% of all custor
other are suited electro
at to CBOE and exe
dation. electronic system
12 seconds in the

ading via Technology
This of all customer orders
is trained electronically
CROIC and electronically
Application
Ap

1St CROE has the most betweetgically velvinced tracing floor in the sistons markets.

Necess through immovation is the key to CROE's shallegic philosophy.

Screen-Based Trading
In line with CBDIC's Stategic
Pain of offenge pustoners 2001
a vast easy of hading opportunities and choices. Of pu CBDICArech'; the Echange's unit new screen-based trading platfe

aled for "take-0f" to the system achieves precedented goal ing the entitle options to ordio a single. In the sold of continually inflighting to critical sold of continually inflighting to comb a single. In the sold of continually inflighting to comb a single with open outbry to best service the outstorner.

GOALS

ON TRADE THRU

PREST SERVICE

FORT THOSE SLATCHES

PARS = NBBO

RAES = NBBO

PARSENTE - WHAT IF TRADE THRU?

PRINCIPLE ON THE

PRIN

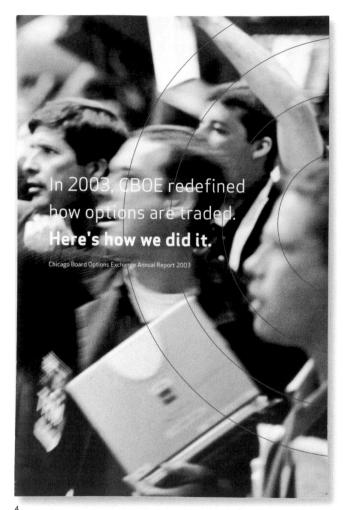

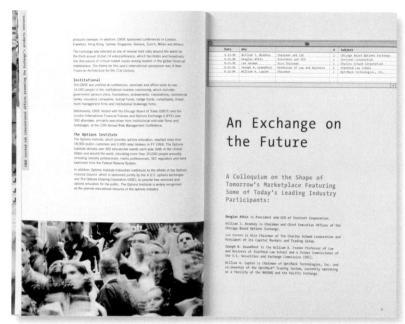

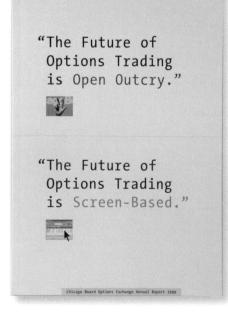

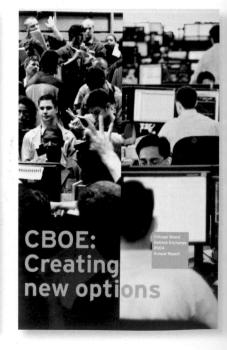

CHICAGO BOARD OPTIONS EXCHANGE 2005 ANNUAL REPORT

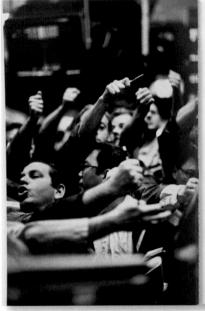

TO BE THE LEADING MARKETPLACE FOR FINANCIAL DERIVATIVE PRODUCTS, WITH FAIR AND EFFICIENT MARKETS CHARACTERIZED BY DEPTH, LIQUIDITY AND BEST EXECUTION OF PARTICIPANT ORDERS."

CBOS MISSION

LETTER FROM THE OFFICE OF THE CHAIRMA

Unprecisional challenges and a need for strategic salps, included and public bull challenges in the new properties of the challenges of the public salps, and the new properties of the engine a record develop facel part, with a 27th growth in contract that deal where companies of Final New 2002 days or record-leveling in addition, a record for facial year develop daily column was set in 2012 with an average of 2172-big contracts better daily, an increase of 12th one 17 2000. During the week of Agril 15, 2000, CDEC 2012 with an average of 2172-big contracts better daily, an increase of 12th one 17 2000. During the week of Agril 15, 2000, CDEC The single-day record for trading values was set on Westerday's Agril 18, 2001 where 2722-big contracts traded Agril 18 revised only the second more in the hosting of the Escharge and 1500 values.

CROE HAS 40.5% OF TOTAL OPTIONS Due to the commitment of CRIDE is membership, the follog of new and affarching production, and extensible production services, CRIDE and affarching production services, CRIDE in transaction is basisfering position within the options ordinary in Focul 14 (2010), capturing a harbitist position within the options market of their 2010, capturing a harbitist position and \$2.7% of orders options. The committee which the extends of their and \$2.7% of orders options and committee which the extends of their and capturing which their analysis of their anal

As competitive pressures mounted, firms devised strategies to combat t independent market-making firms affiliated with larger firms in order t

independent market-making firms were either acquired or became affiliated with larger firms in order to best service customers as consolidation swept the options industry. Consolidation attowed for the economies of scale so essential to success in today's global economy.

01 0806 11

6

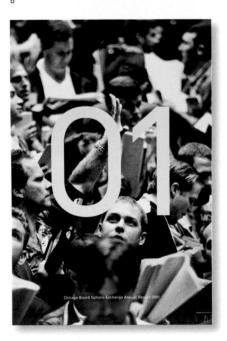

1

As CBOE introduced electronic trading and other high-tech processes, Liska began to integrate images that show both the human experience of the trading floor and the ubiquitous support of technology.

5

The design for this annual report follows the core message and communicates that 2005 brought significant change to CBOE's business model.

6

Dramatic photography communicates the dynamic energy of open outcry trading.

CLIENT: Chicago Board Options Exchange DESIGN FIRM: Liska + Associates ART DIRECTOR: Steve Liska DESIGNERS: Kim Fry, Amy Hogan, Tory Knappenberger

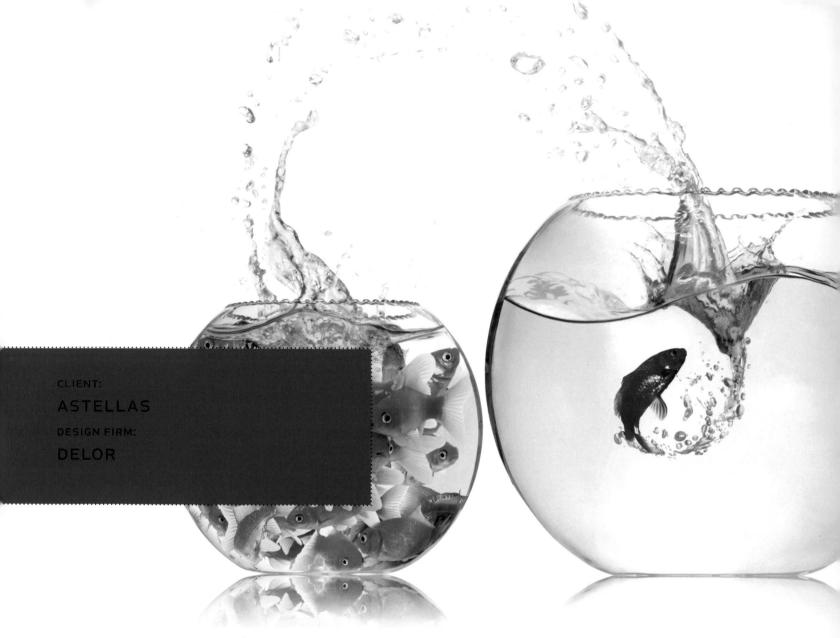

different from the

INDUSTRIES TEND TO DEVELOP PARTICULAR TRENDS IN VISUAL AND VERBAL COMMUNICATION. FINANCIAL SERVICES COMPANIES, FOR EXAMPLE, TEND TO REFLECT A SERIOUS, CONSERVATIVE TONE WHEREAS THE FASHION INDUSTRY RELIES HEAVILY ON LIFESTYLE IMAGERY. THE PHARMACEUTICAL INDUSTRY TENDS TO BE DOMINATED EITHER BY IMAGES OF HAPPY, SMILING PATIENTS OR PLAYFUL CARTOON ILLUSTRATIONS. **ASTELLAS** WANTED TO SET ITSELF APART AND BE TRUE TO ITS CORE ATTRIBUTE OF BEING A DIFFERENT KIND OF PHARMACEUTICAL COMPANY. THE DESIGN TEAM AT DELOR ROSE TO THE CHALLENGE.

CLIENT Astellas is a pharmaceutical products company formed by the merger of two related companies: Fujisawa and Yamanouchi. Although Astellas does not share the size of major pharmaceutical corporations, it still competes globally with companies such as Pfizer, Astra Zeneca, and Lilly. It does so by focusing on niche categories in contrast to "big pharma's" emphasis on volume-driven products.

PROJECT Astellas approached DeLor with the task of building a branding program for the United States market. Astellas requested that the branding program honor the existing name and logo and appropriately integrate the global tag line, "Leading Light for Life." Project deliverables included sales and marketing materials, corporate communications, global brand guidelines, and multimedia collateral for internal sales.

smaller and slower, by design Delor focused its design on demonstrating clearly that Astellas is not what healthcare professionals have come to expect from big pharma. Big pharma tends to be impersonal and volume-driven and operates from a speed-to-market perspective; Astellas approach is relationship-driven, niche-product oriented, and slow-to-market, ensuring that every possible variable has been tested in its clinical trials. These attributes led Delor to position Astellas as a refreshing contrast to big pharma.

APPLES, EGGS, AND GOLDFISH The design team used primarily iconic imagery to communicate the Astellas brand—a striking difference from the cartoon illustrations and smiling patients that dominate the industry. They supported the theme of difference by presenting Astellas as the sole item that stands out. One image presents

The corporate brochure uses smart, iconic images to communicate the Astellas brand.

three eggs, with one colored differently. Another shows a single goldfish leaping from the full bowl into a larger bowl where it is the only fish.

developed the branding program based on the theme, "Different from the Start" and extended the idea of difference throughout the communication pieces. For example, sales collateral for various product categories incorporated customizable headlines that begin with, "Making a Difference in..." (i.e., dermatology, cardiology, immunology). Launch teasers for the internal sales team used the headline "You're not one of the crowd."

CORE IDENTITY In addition to the central theme of difference, Astellas needed to communicate its other core attributes: disciplined, efficient, respected, and creative. The design team incorporated the brand attributes with smart, iconic images to add depth to the Astellas brand image. Words like "fresh" and "trusted" accompany the images and are designed to draw the reader's attention.

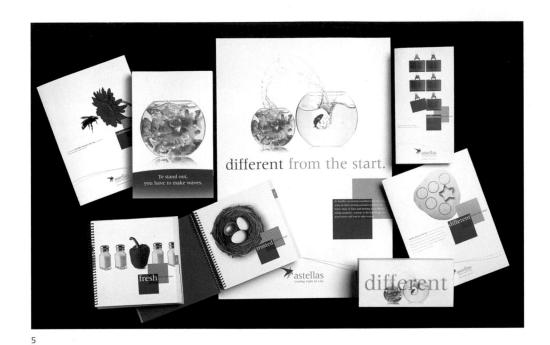

This piece served as a pre-launch announcement that introduced the new company. The arrows represent the two companies that merged to create Astellas. The two colors combine to form the "flying star" logo.

3

DeLor designed multimedia collateral that introduced the brand to Astellas associates at an internal sales meeting.

4

The ad campaign will help the company stand out in an industry dominated by cartoon illustrations and images of smiling patients.

5

While the images are as diverse as a flower, eggs, and a saltshaker, the branding program reflects remarkable design consistency.

6

The calendar reinforces the Astellas brand position as a different kind of pharmaceutical company.

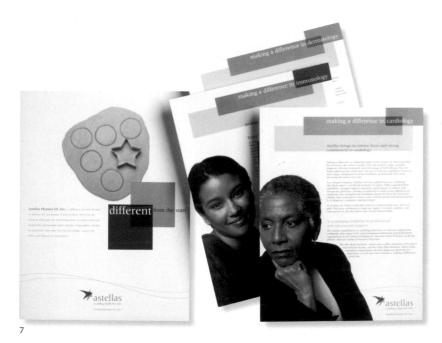

Sales collateral uses a cookie cutter image to demonstrate that while Astellas may be in the same industry as other pharmaceutical companies, its shape and style is completely different.

8

Branded launch items included a calendar, flashlight, pen, and T-shirt.

9

The use of iconic imagery, overlapping graphic elements, and red and gray colors collectively tie together the Astellas brand.

CLIENT: Astellas
DESIGN FIRM: DELOF
ART DIRECTOR: Kenneth DeLor
DESIGNER: Chris Enander

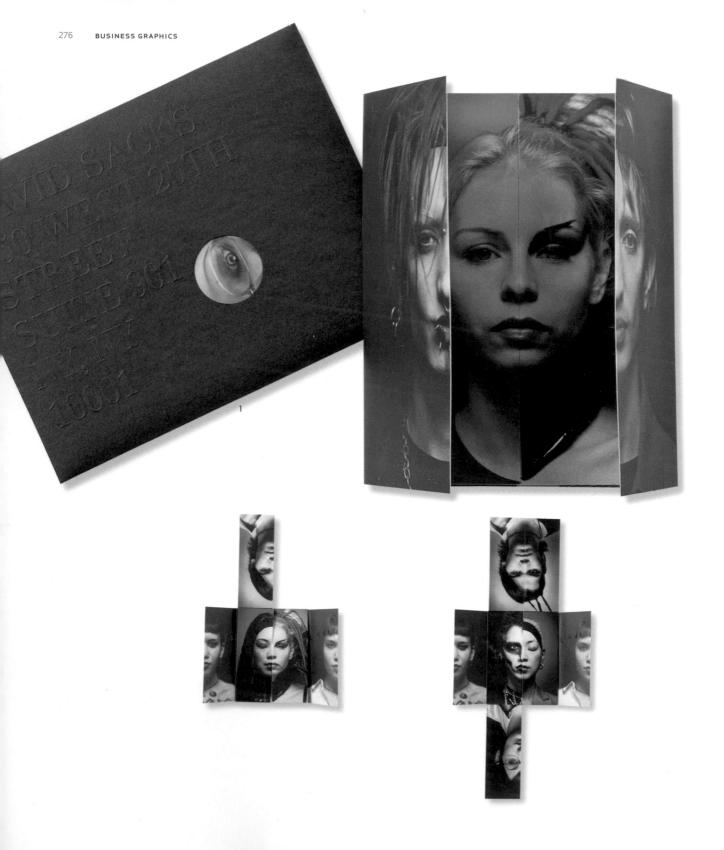

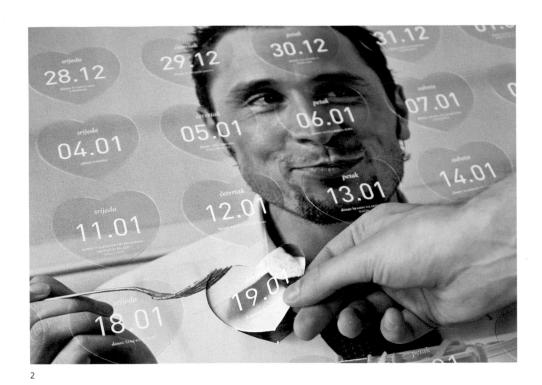

CLIENT: David Sacks
DESIGN FIRM: The Buddy Project/
Squarehand

2 CLIENT: Podravka DESIGN FIRM: Bruketa & Zinic

3 CLIENT: Lenovo 2006 Winter Olympics DESIGN FIRM: Stoller Design Group

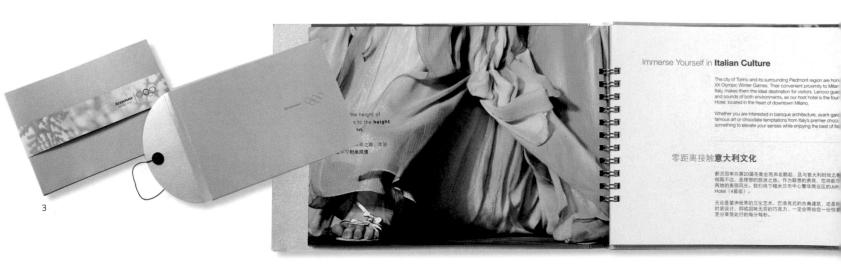

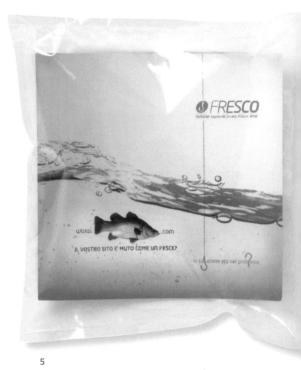

BRANDOCTOR

| POTICIO DE LA CONTRACTOR | POTICIO DEL CONTRACTOR | POTICI

4 CLIENT: Motorola DESIGN FIRM: Liska + Associates

5 CLIENT: Fluid Design Lab DESIGN FIRM: Fluid Design Lab

6
CLIENT: Brandoctor
DESIGN FIRM: Brandoctor

7 CLIENT: Nita B. Creative DESIGN FIRM: Nita B. Creative

8
CLIENT: Ranquist Development
DESIGN FIRM: Kym Abrams Design

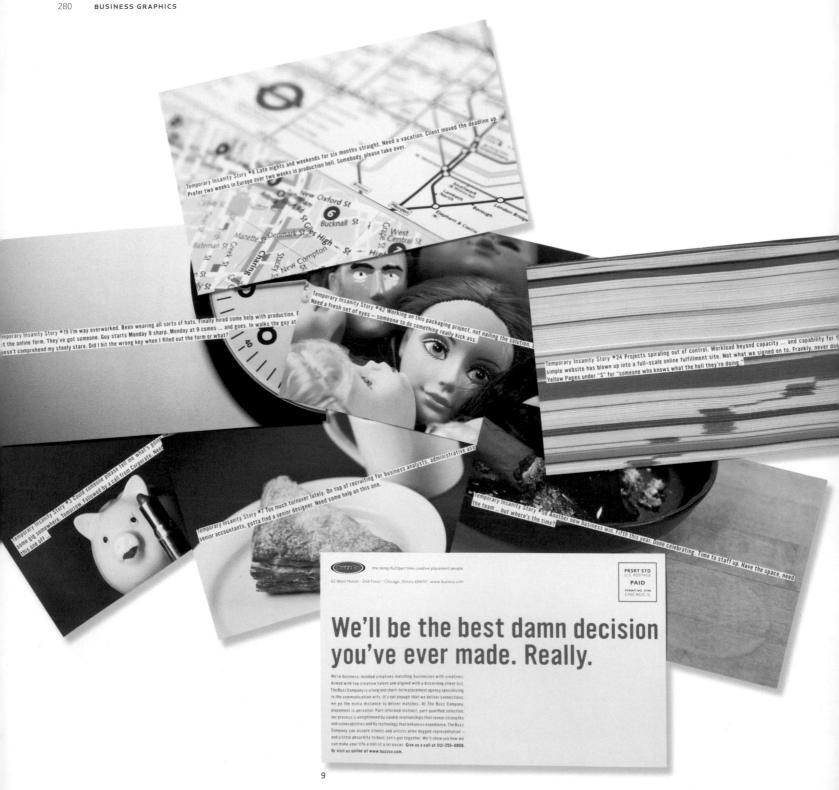

CLIENT: The Buzz Company DESIGN FIRM: Faust Associates

10

CLIENT: OrangeSeed Design DESIGN FIRM: OrangeSeed Design

11

CLIENT: IntraSpec Solutions
DESIGN FIRM: Sussner Design Company

CLIENT: Kaiser Permanente
DESIGN FIRM: Stoller Design Group

13, 15

CLIENT: Creative Pitch
DESIGN FIRM: Brainforest, Inc.

14

CLIENT: Yes Design Group
DESIGN FIRM: Yes Design Group

16

CLIENT: Riordon Design DESIGN FIRM: Riordon Design

TAKE YOUR TRASH TO SCHOOL DAY

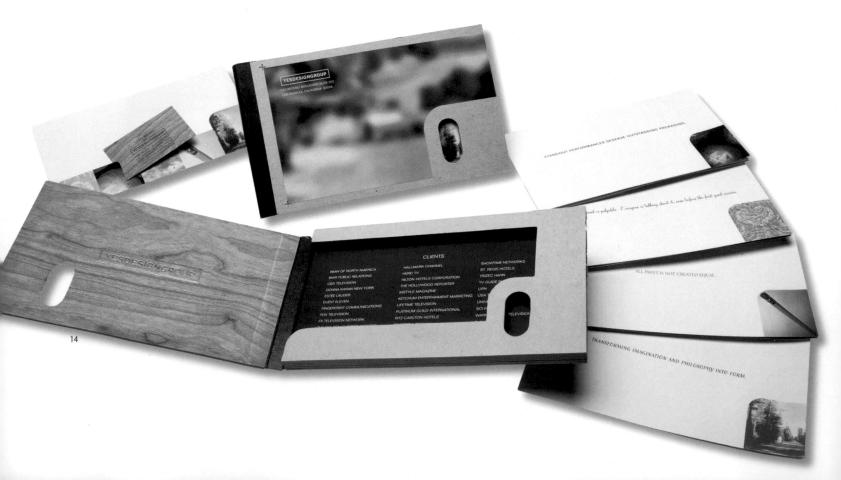

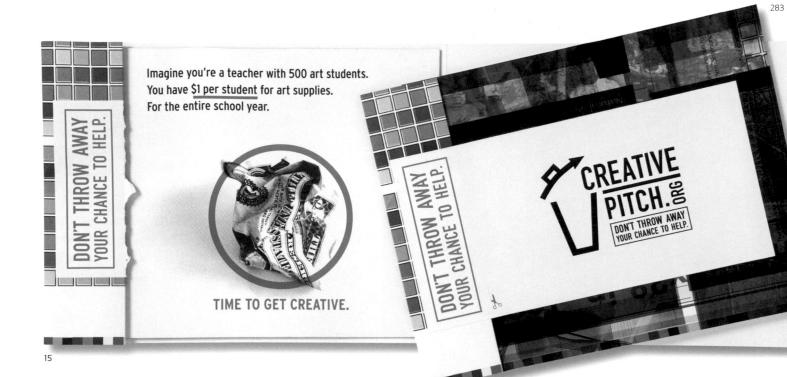

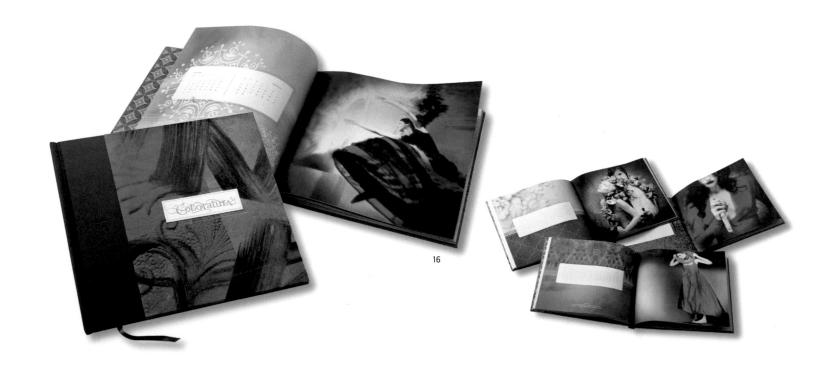

carpet

all types of carpet - regardless of make, manufacturer, construction or fiber type.

To date, we've collected over 125 million pounds of carpetand conserved over 500,000 cubic yards of landfill space. And we issue a certificate of reclamation, guaranteeing your carpet has been reclaimed.

The Antron® Reclamation Program is open to **everyon** \ominus

 dealers, facility managers, building owners, architects and designers. Everyone. every

To find out more about the Antron®
Reclamation Program, contact your local
Fiber Consultant today. Or visit antron.net
anytime to find out more and view online
carpet reclamation specifications.

CLIENT: Ribarić d.o.o. DESIGN FIRM: Bruketa & Zinic

18

CLIENT: Antron DESIGN FIRM: Wages Design

19

CLIENT: The Columbus Foundation DESIGN FIRM: Base Art Co.

20

CLIENT: USA Network
DESIGN FIRM: Yes Design Group

21 CLIENT: Clemenger BBDO DESIGN FIRM: Clemenger BBDO

22 CLIENT: Reflections Printing DESIGN FIRM: Sussner Design Company

23 CLIENT: Target Commercial Interiors DESIGN FIRM: Sussner Design Company

24 CLIENT: Hubbard Street Dance Chicago DESIGN FIRM: Liska + Associates

CLIENT: Fine Art & Antiques
DESIGN FIRM: Curious

26

CLIENT: Croatian National Tourist Board
DESIGN FIRM: Studio International

27

CLIENT: Showtime
DESIGN FIRM: Yes Design Group

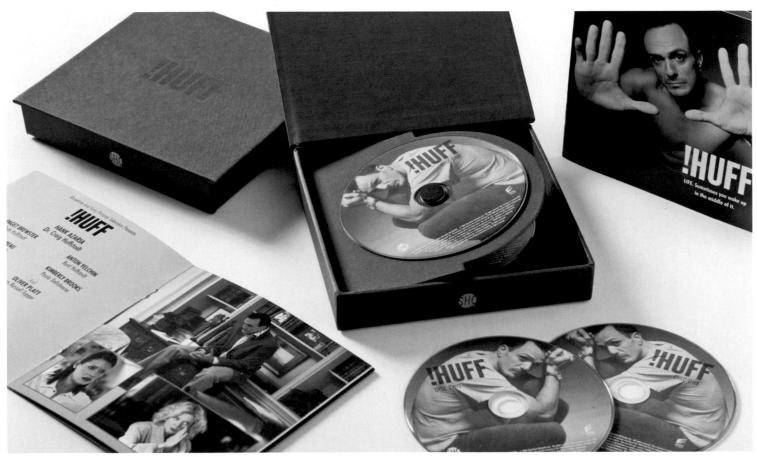

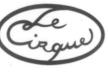

FOR A BRAND TO ACHIEVE LONGEVITY, IT NEEDS TO COMMUNICATE ACCURATELY WHAT A CUSTOMER WILL EXPERIENCE WHEN INTERACTING WITH A PARTICULAR COMPANY, PRODUCT, OR SERVICE. LE CIRQUE IS A RESTAURANT THAT PROMISES BOTH A REFINED DINING EXPERIENCE AND A "CIRCUS" OF ACTIVITY—ENERGY, FUN, AND A LEVEL OF QUALITY THAT MAKE AN EVENING A MEMORABLE EVENT. THE VISUAL SYSTEM IN THIS CASE STUDY CLEARLY COMMUNICATES THE BRAND PROMISE THAT LE CIRQUE DELIVERS.

CLIENT Le Cirque is one of the most venerable "A-list" restaurants in New York. Newer, yet equally exclusive Le Cirque locations include Las Vegas and Mexico City. The restaurant is positioned as the place where food, fashion, art, and culture converge.

PROJECT For more than thirty years, Le Cirque has been consistently known as one of New York's top restaurants. It's tasteful, established, and always fashionable. Both the food and clientele are noteworthy and elegant. When Le Cirque moved to a new location, the company commissioned Mirko Ilić Corp. to update the existing logo and create a visual system to support the newly designed, yet deeply established restaurant. Deliverables included a logo, a stationery system, menus, place cards, dishes, chocolate boxes, bags, matchbooks, and carry-out packaging.

ICONIC CHANGE This project brought a particular challenge: Le Cirque has a rich history, a strong tradition, and established success. Rebranding a company of legendary status requires retaining elements of the existing brand in the new visual system. The design team achieved congruence with the established brand by focusing the design on the unchanging brand promise.

THREE RING AND FIVE STAR Le Cirque, by name, suggests acrobats, animals, and accessible entertainment. By contrast, the food, clientele, and price points of Le Cirque communicate luxury and haute couture. Ilić found a way to blend both concepts into the visual system. The design team used shapes and colors that are primary and fun, but also communicate elegance and finery. The design is at once playful, refined, light, and lavish.

Le Cirque is as venerable as it is fashionable, a place for exquisite food and fashionable clientele. The visual system communicates that the location is both lively and refined.

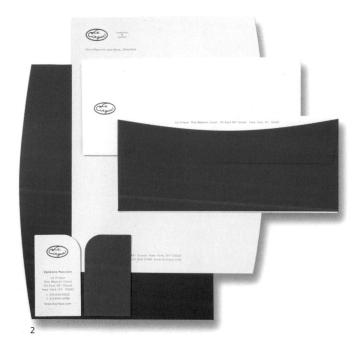

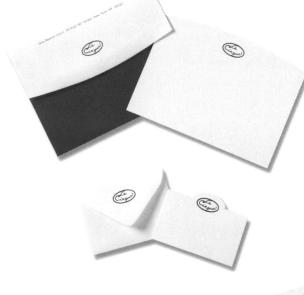

MONKEYS ON YOUR PLATE White plates, white linen, and crystal set the standard for most elegant dining establishments. Fueled by a strong client relationship that encourages moving beyond the expected, the design team developed a much less common and far more conceptual approach to the brand. They chose to incorporate a lighter tone into the serious nature of the restaurant, creating illustrated "scenes" that feature monkeys attempting to steal jewels. This playful theme was applied to tableware, menus, bags, and other collateral pieces. By setting aside the standard, designers added a unique and notable personality to the highend experience at Le Cirque.

COLLABORATION Restaurants rely on a combination of food, service, and ambiance to attract and retain clientele. While the staff manages food and service, designers—both graphic and interior—create the look and feel of the restaurant. Le Cirque needed a visual system that would appropriately reflect the energy and activity that make its restaurant one of the best-known places to see and be seen in New York City. The graphic design team worked closely with the interior designer, Adam Tihany, to develop a unified brand experience.

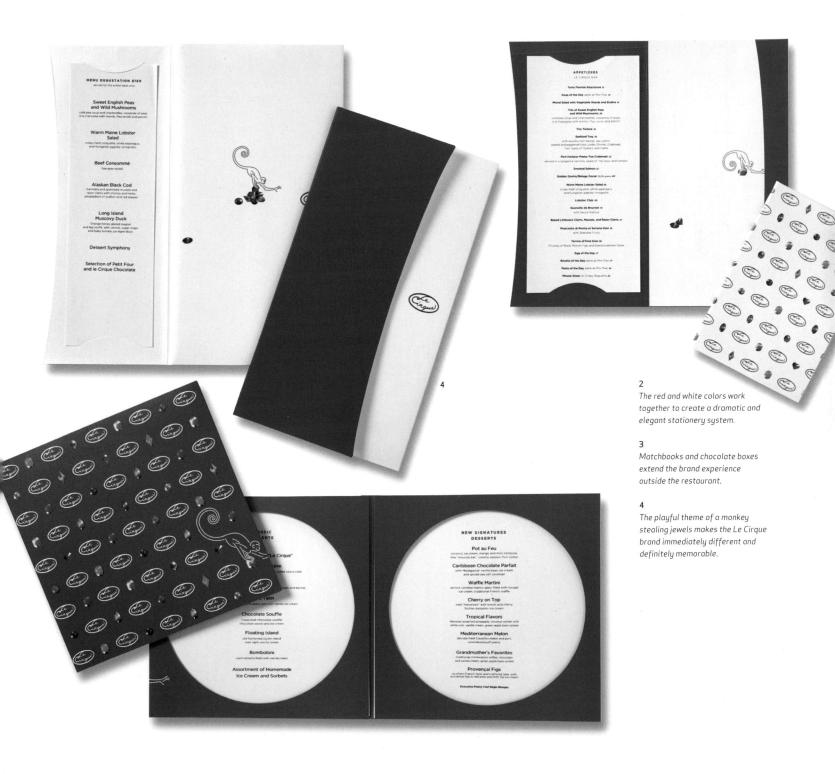

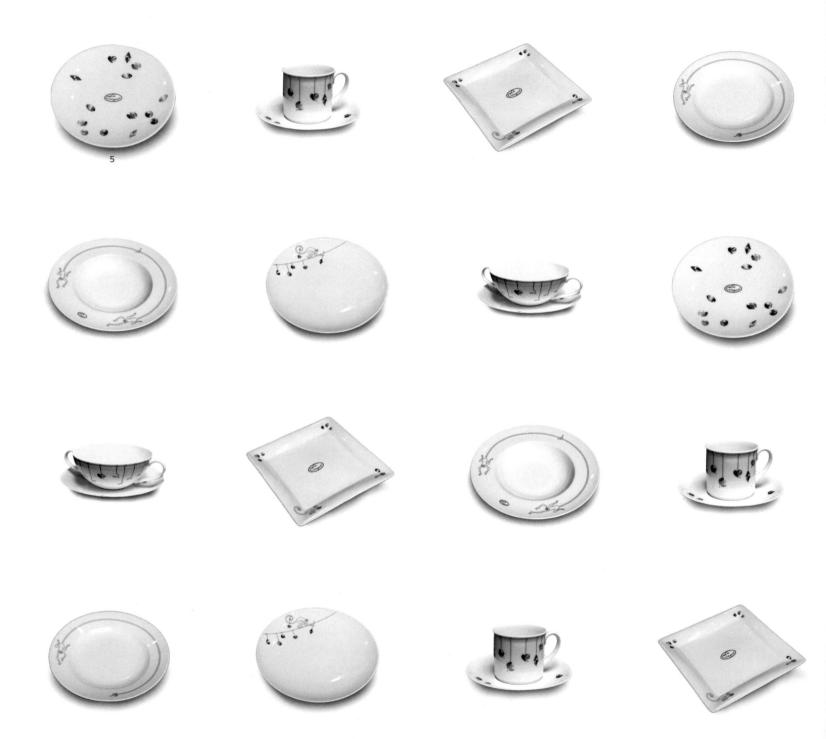

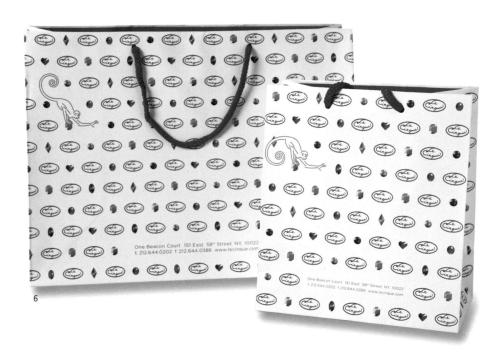

The visual system extends intimately into the actual dining experience, where monkeys attempt to steal the jewels that dot the plates and cups.

6,8

Bags and carry-out boxes create a patterned appearance by repeating the logo and jewels, and feature the illustrated monkey.

7

The curved lines for the logo find new expression in the illustrated monkeys.

CLIENT: Le Cirque DESIGN FIRM: Mirko Ilić Corp. ART DIRECTOR: Mirko Ilić DESIGNER: Mirko Ilić

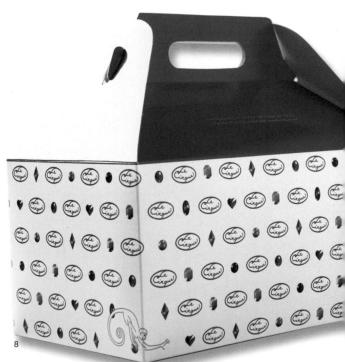

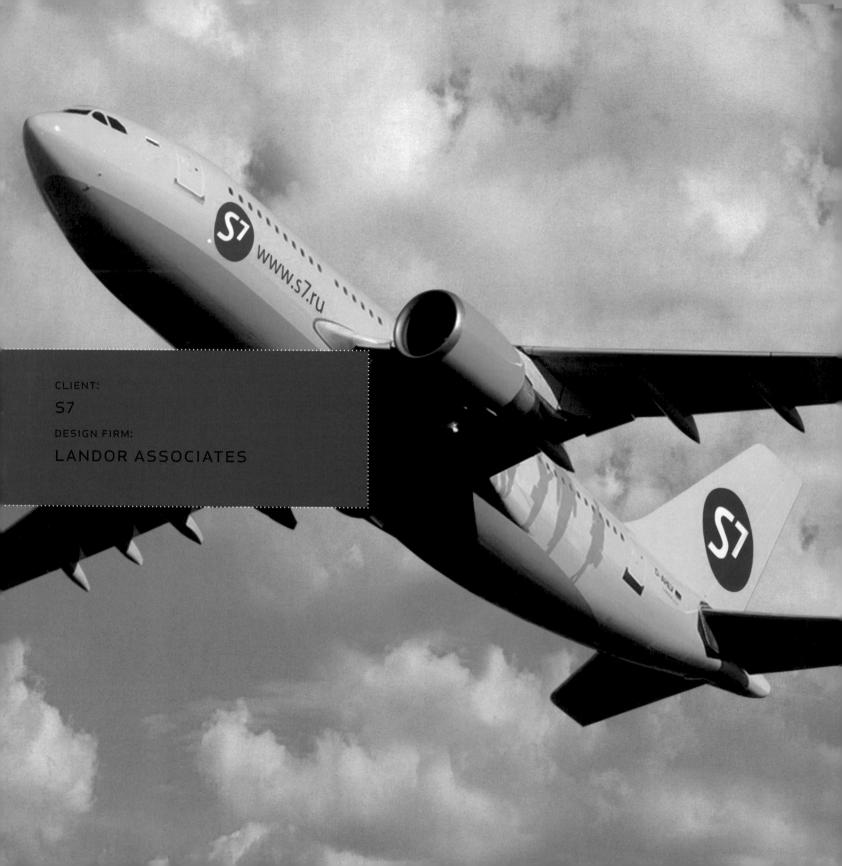

PRIOR TO THE LAUNCH OF S7, FORMERLY SIBERIA AIRLINES, THE RUSSIAN DOMESTIC AIRLINE MARKET WAS DOMINATED BY VERY "GRAY" EXPERIENCES, LITERALLY AND FIGURATIVELY. AIR TRAVEL FUNCTIONED MORE AS A COMMODITY AND, NOT SURPRISINGLY, CUSTOMER EXPECTATIONS WERE EXTREMELY LOW. THE LAUNCH OF THE \$7 BRAND CHANGED ALL THAT—FOR GOOD. THIS CASE STUDY SHOWS HOW A HOLISTIC BRANDING PROGRAM CAN COMMUNICATE BOTH THE TANGIBLE FEATURES AND THE INTANGIBLE SPIRIT OF A COMPANY, PRODUCT, OR SERVICE.

CLIENT Siberia Airlines competes in a marketplace where most airlines, or at least the aircraft, look alike. The early 1990s breakup of the state airline, Aeroflot, created thousands of local and regional airlines, often made up of just one or two aircraft. Many of the small airlines couldn't afford to repaint their aircraft, so the blue and white design of the ex-Aeroflot aircraft remains the norm and national standard.

Siberia Airlines emerged from this environment as the largest domestic airline in Russia and the fifth fastest growing airline in the world. The state of the airline industry in Russia created enormous opportunity for Siberia Airlines to stand out from competitors by developing and executing a comprehensive brand program.

PROJECT Landor Associates began by gathering research and hosting collaborative workshops with Siberia Airlines management. Collectively,

the team discovered the relevant differentiating factor for Siberia Airlines. The design team centered their approach on the brand position, "A breath of fresh air," based on the existing perception of air travel in Russia and the potential to significantly improve consumer experiences. Project deliverables included a strategic brand review, naming, visual identity, collateral brand manual and environmental design for livery, lounges, aircraft interiors, check-in desks, ticketing offices, and uniforms.

ALPHANUMERIC Part of the rebranding efforts included creating a new name. The previous name communicated strength, health, and simplicity, but also identified the airline as regional and provincial. The new name needed to indicate the size of the airline; appeal to younger, more cosmopolitan Russians; and be elastic enough to move beyond the airline category. It also had to use letters common to

<< 1

The livery departs radically from Russian airline conventions (using two bright greens and red) and ensures that the aircraft stand out on the tarmac.

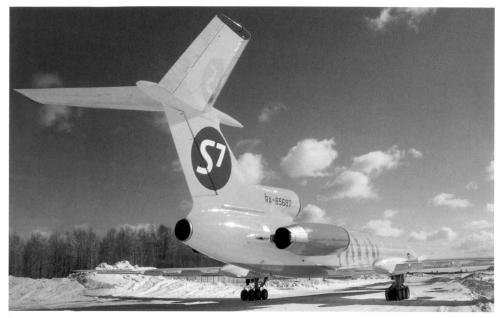

both Cyrillic and Roman alphabets, heightening the challenge.

The name S7 meets each requirement and offers the added bonus of existing awareness. S7 is the airline's IATA code, the prefix to the airline's flight numbers and the existing Web address. Using S7 as the airline name builds on the awareness and infuses the airline with a new and modern image. It also gives the brand the "stretch factor" needed as the airline's business expands.

JET SET The look of the aircraft dramatically represents the design theme, "A breath of fresh air." The design team selected two shades of

vibrant green for the livery to communicate without question that S7 is new, modern, and distinctive. The colors stand out for miles on the tarmac, particularly in the snow—especially important in the eastern regions of Russia. The use of green provides a striking contrast to the red logo that appears on the fuselage and fin. The core value of customer care is represented by the use of silhouettes in a deeper shade of green above the wing. The differentiating design continues throughout the interior of the aircraft, where the seats feature colorful fabrics covered in dots, a reference to the S7 mark.

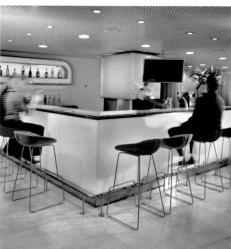

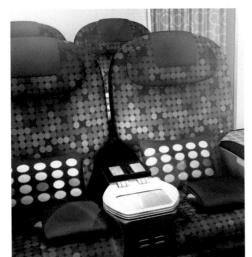

8

2

The S7 livery is strikingly different from other Russian airlines, especially in the snow.

3, 4

The brand experience carries through into the Business Class lounge in Moscow's Domodedovo Airport.
Lighting changes the environment and mood over the course of the day.

5

The brand positioning, "A breath of fresh air," carries through into the economy-class cabins, revealing a multicolored, multidimensional passenger experience.

6

The office/home space of the Business Class lounge has an upscale, modern design, and incorporates colors from the 57 brand palette.

7Seats in Business Class feature colorful fabrics covered in dots—a reference to the S7 mark.

8

The previous Siberia Airlines identity presented a "gray" experience and did not stand out among regional competitors. S7 branding dramatically changed that.

9

Live piano music creates the ambience of being in an intimate club in S7's Business Class lounge.

CLIENT: S7
DESIGN FIRM: Landor Associates
ART DIRECTOR: Peter Knapp
DESIGNER: John Stanley

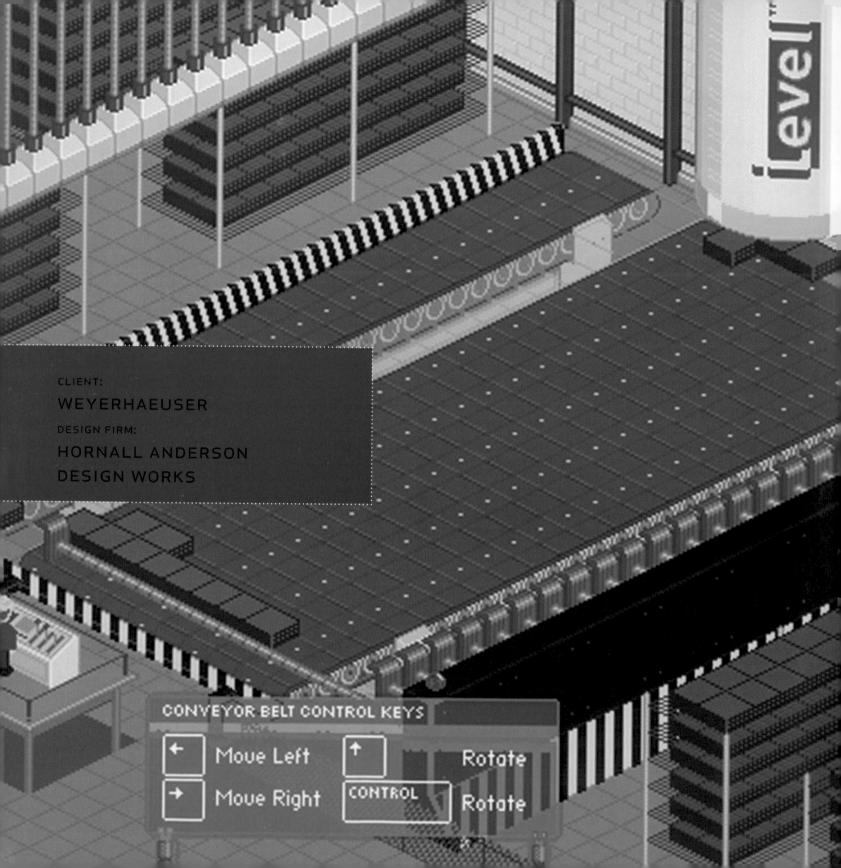

EFFECTIVE BRAND PROGRAMS REQUIRE CONSISTENT MESSAGING AT EVERY CUSTOMER TOUCH POINT. EMPLOYEES AT EVERY LEVEL OF THE ORGANIZATION MUST HAVE A THOROUGH UNDERSTANDING OF THE BRAND ATTRIBUTES AND EDITORIAL VOICE. INSPIRED AND EDUCATED EMPLOYEES ARE THE MOST VALUABLE BRAND ADVOCATES, EFFECTIVELY PROMOTING AND CONTRIBUTING TO THE SUCCESS OF A BRAND PROGRAM. THIS CASE STUDY FOCUSES ON THE AMBITIOUS AND INNOVATIVE INTERNAL LAUNCH OF WEYERHAEUSER'S ILEVEL BRAND PROGRAM.

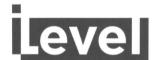

CLIENT Weyerhaeuser Company is an international forest products company and one of the 100 largest companies in the United States. The company decided to consolidate five operating units into a single, unified business—iLevel. iLevel provides residential builders and dealers with a single source for integrated, structural frame products and related software resources.

PROJECT Weyerhaeuser engaged Hornall Anderson Design Works to name the company and develop its visual brand program. Since iLevel is a new entity, the brand program focused on building a corporate culture to support the emerging iLevel brand. Project deliverables included the new name, identity, website, corporate collateral, external launch materials, convention signage, an internal launch strategy including the iLevel 2006 interactive game, promotional game collateral, posters, and a brand movie.

TEAM PLAYERS The ultimate goal of the internal launch was to link the brand personality with the daily working decisions of iLevel employees—all 16,000 of them. The design team chose a video game (and corresponding offline version of the game) as the primary tool for achieving the goal. The innovative approach worked amazingly well. Over eighty percent of iLevel employees participated, and feedback throughout the organization was universally positive.

construction tools The interactive game met three strategic objectives. First, it provided an active and engaging way to educate employees about the structures, goals, and attributes of iLevel. Second, the game provided a chance for employees to interact with one another, regardless of title, division, or physical location. Third, the game provided a real-life demonstration of the brand attributes: innovation, integration, interaction, and information.

RULES OF ENGAGEMENT Employees formed teams across all disciplines and management levels to learn about and demonstrate understanding of key brand messages. The game lasted four weeks, and each week focused on a different brand attribute. The themes were hardwired into the game's DNA. For example, when employees registered to play, they were grouped into teams (integration). Teams worked together (interaction) to perform tasks. Teams reached different levels of play based on correct answers about the new company (information). The game itself served as an example of the fourth attribute (innovation).

THREE IN ONE The internal launch slogan, "All In One," encompassed three dimensions of the iLevel story. It expressed the functional benefits of iLevel products, the synergy and mutual interdependence of an integrated organization, and the company values of camaraderie and shared effort.

BUILDING FOUNDATION The design team integrated the core business of iLevel, construction, into its choice of launch items. Branded items included building blocks, thermoses, and hard hats. The iLevel game is also built around the daily work of the construction business.

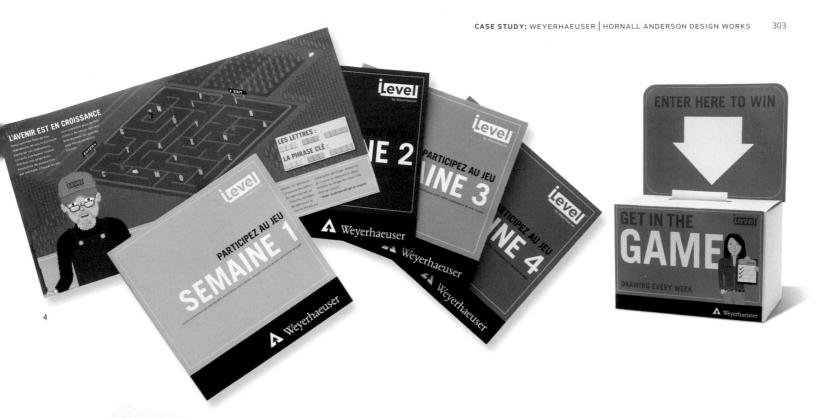

The iLevel game provided an interactive way for employees to learn about the iLevel brand.

2

The design team created two CD-ROM movies to help introduce the new brand.

3

Table toppers with a "building block" base provided information about the iLevel game and other launch events.

4

Designers created offline versions (in English and French) of the game so that those without computer access could participate. Perforated raffle tickets were included in the back of the brochures, which could be filled out and deposited into the game box.

.

"All In One" functioned as the internal launch slogan.

"It Works" is an external brochure sent to iLevel customers after the launch.

7

The "Starting Now" brochure, shown here in English and French, provided in-depth information about the new brand for iLevel employees.

8

The iLevel website uses a combination of photography and illustration and features a unique interface.

9

The square shape and vibrant green color palette are repeated across several launch items to provide consistency for the brand program.

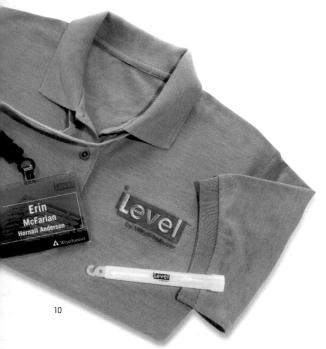

Brand champions, named Transition Agents, received branded polo shirts, promotional glow sticks, and name badge holders.

11

Designers provided signage and multimedia collateral for the Transition Agent launch conference.

12

The design team chose hard hats and thermoses as prizes for the iLevel game to reflect the company's core construction business.

13

All 16,000 employees received a branded T-shirt, cap, pencil, and level key chain.

CLIENT: Weyerhaeuser

DESIGN FIRM: Hornall Anderson Design Works ART DIRECTORS: Jack Anderson, James Tee DESIGNERS: James Tee, Andrew Wicklund, Elmer Dela Cruz, Holly Craven, Jay Hilburn, Hayden Schoen, Belinda Bowling, Yuri Shvets, Michael Conners

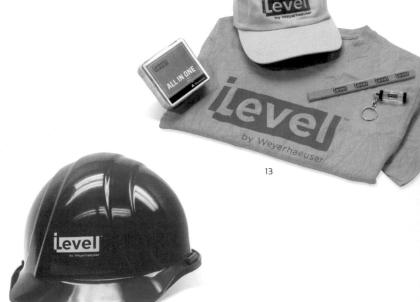

CLIENT: Target Commercial Interiors
DESIGN FIRM: Sussner Design Company

2 CLIENT: Tower 23 Hotel DESIGN FIRM: Hollis Brand Communications

3 CLIENT: Time Warner, Inc. DESIGN FIRM: Poulin + Morris Inc.

4
CLIENT: EOS Airlines
DESIGN FIRM: Hornall Anderson
Design Works

5 CLIENT: Mirvac, HPA Architects DESIGN FIRM: Perks Design Partners

6 CLIENT: America Online DESIGN FIRM: Sky design

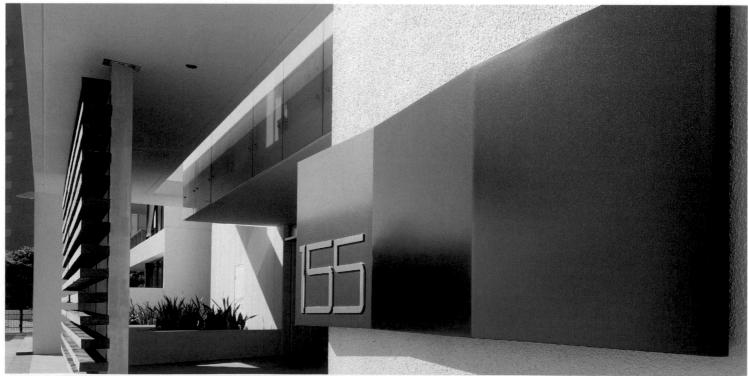

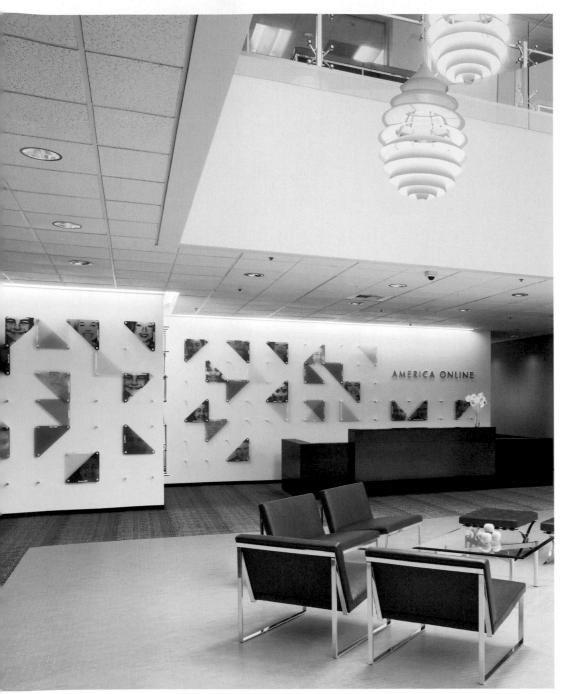

8220 La Mirada NE Suite 500 Albuquerque, NM 87109 USA 505.293.2333 www.whois3.com PAGES 16. 26-27

3rd Edge Communications

162 Newark Avenue Jersey City, NJ 07302 USA 201.395.9960 www.3rdedge.com

98pt6

443 Greenwich Street Suite 5A New York, NY 10013 USA 212.625.2054 www.98pt6.com

AdamsMorioka

8484 Wilshire Blvd.
Beverly Hills, CA 90211
USA
323.966.5990
www.adamsmorioka.com
PAGES 20-21, 38, 45, 92-97, 156

Addis Creson

2515 Ninth Street Berkeley, CA 94710 USA 510.704.7500 www.addiscreson.com PAGES 14, 44, 49, 89, 120, 202

And Partners

158 West 27th Street 7th Floor New York, NY 10001 USA 212.414.4700 www.andpartnersny.com PAGES 161, 234, 251

Ant Industrial Design Pte. Ltd

31 Toh Guan Road East Lw Technocentre 07-07 Singapore 608608 Singapore 65.6425.3181 www.ant.sg

Archrival

720 "0" Street Lincoln, NE 68508 USA 402.435.2525 www.archrival.com PAGES 42-43, 188

ASID Labs. Inc.

110 Greene Street Suite 605/Nasty Little Man New York, NY 10012 USA 212.866.4402 www.asdlabs.com PAGES 62, 159

Ayse Celem Design

Birinci Cadde No. 89 Arnavutkoy Istanbul, 34345 Turkey 90.212.358.20.93 www.aysecelemdesign.com PAGES 144, 160

Base Art Co.

623 High Street Worthington, OTI 43085 USA 614.841.7480 www.baseartco.com PAGES 243. 285

BIZ-R

35A Fore Street Totnes Devon TQ95Hn Great Britain UK 44(0).1803.868.989 www.biz-r.co.uk PAGE 87

Boccalatte

P.O. Box 370 Surry Hills Sydney, New South Wales, 2010 Australia 61.2.9310.4149 www.boccalatte.com PAGES 155, 236

Brainforest, Inc.

2211 N. Elston Suite 301 Chicago, IL 60614 USA 773.395.2500 www.brainforest.com

Brandoctor

Zavrtnica 17 Zagreb 10000 Croatia 385.1.6064.006 www.brandoctor.com PAGES 39, 84, 112, 278

Bruketa & Zinic

Zavrtnica 17 Zagreb 10000 Croatia 385.1.6064.000 www.bruketa-zinic.com PAGES 10, 36, 240, 248–249, 277, 284

Carbone Smolan Agency

22 West 19th Street 10th Floor New York, NY 10022 USA 212.807.0011 www.carbonesmolan.com PAGES 178-180

Carré Noir Roma

Via Giovanni Miani 37/b Roma 00154 Italy 39.06.571784.1 www.carrenoir.com PAGES 66. 164. 245

CDI Studios

2215A Rennaissance Drive Las Vegas, NV 89119 USA 702.876.3316 www.cdistudios.com

CFX Creative

259-3495 Cambie Street Vancouver, BC V5Z 4R3 Canada 604.676.1866 www.cfxcreative.com PAGE 90

Clemenger BBDO

8 Kent Terrace
Wellington
New Zealand
64.4.802.3362
www.clemengerbbdo.co.nz
PAGES 50, 56, 145, 148–149, 286

Crosby Associates

203 N. Wabash Chicago, IL 60601 USA 312.346.2900 www.crosbyassociates.com PAGES 98–103, 233

Curious

19A Floral Street London, WC2E 9D5 UK 44(0).20.7240.6251 www.curiousdesign.com PAGES 136, 153, 162, 191, 288

Davidson Design

Level 1, Bldg 5 658 Church Street Richmond, Victoria 3121 Australia 61.3.9429.1288 www.davidsondesign.com.au PAGES 46, 63, 151, 194, 197

Decker Design 14 W. 23rd Street

3rd Floor New York, NY 10010 USA 212.633.8588 www.deckerdesign.com PAGES 31, 58, 80, 116, 137, 182, 193, 203, 207, 253

DeLor

613 W. Main Street Louisville, KY 40202 USA 502.584.5500 www.delor.com PAGES 270-274

Design Source East

235 Birchwood Avenue Cranford, NJ 07016 USA 908.653.9797 www.dsebrand.com PAGES 59, 127, 138

Di depux

Eratous 4 Dafni-Athens 17235 Greece 30.210.975.5850 www.depux.com PAGE 57

Diseño Dos Asociados

Privada 25 A sur 913-6 Col. La Paz Puebla, Puebla 72160 Mexico 522 (222) 231.34.73 www.disenodos.com PAGES 44, 55, 74, 165, 188

Elevator

B. Berislavica 1 Split 21000 Croatia 385.98.434.556 www.elevator.hr PAGES 68, 70, 78

Emmi Salonen

Studio 17 310 Kingsland Road London E8 4 DB UK 44(0).77.5200.1311 www.emmi.co.uk PAGES 23, 63, 84, 113, 123

Enterprise IG

19 Tambach Street Sunninghill, Uhb South Africa 27.011.319.8000 www.enterpriseig.co.za PAGES 60, 258–263

Faust Associates

360 Utedale Road Riverside, IL 60546 USA 708.447.0608 www.faustltd.com PAGES 134, 280

Fluid Design Lab

36 Cavazzoni Street Tezze sul Brenta Vicenza 36056 Italy 33.3472.8116 www.fluiddesignlab.com PAGES 48, 142, 165, 278

Front Media Studio

Courtyard Offices Braxted Park Great Braxted, Essex CM8 3GA UK 44(0).1621.890220 www.frontmedia.co.uk PAGES 139, 183

Goodesign 68 Jay Street

Suite 901 Brooklyn, NY 11201 USA 718.254.8738 www.goodesignny.com

Go Welsh

987 Mill Mar Road Lancaster, PA 17601 USA 717.569.4040 www.gowelsh.com PAGE 123

Hardy Design

Rua Araguari 1541/5° andar Belo Horizonte/Minas Gerais Brazil 55.31.3275.3095 www.hardydesign.com.br PAGES 12, 19, 35, 72, 73, 82, 85, 89, 184

Hartford Design

954 W. Washington 4th Floor Chicago, IL 60607 USA 312.563.5600 www.hartfordesign.com PAGES 11, 44, 49

Heath Kane Design

35 Muswell Hill Road London 10 3J8 UK 44(0).208.374.0576 www.heath-kane.com

PAGES 166-171 Hesse Design

Duesseldorfer Str 16 Erkrath 40699 Germany 49.211.2807.200 www.hesse-design.de

Hollis Brand Communications

680 West Beech Street Suite 1 San Diego, CA 92101 USA 619.234.2061 www.hollisbc.com PAGES 66, 67, 158, 309

Hornall Anderson Design Works

710 2nd Avenue Suite 1300 Seattle, WA 98104 USA 206.826.2329 www.hadw.com PAGES 14, 16, 28, 36, 84, 127, 189, 190, 193, 198, 206, 209, 300–306, 311

Jason and Jason

7713 Hayetzira Street Ra'anana 43663 Israel 972.7444.282 www.jandj.co.il PAGES 150, 152, 244

JDAnthony

945 Liberty Avenue 16th Floor Pittsburg, PA 15222 USA 800.983.6792 www.jdanthony.com PAGES 70, 74, 84

John Wingard Design

925 Bethel Street Suite 306 Honolulu, HI 96813 USA 808.529.8833 www.johnwingarddesign.com

KASHI design

Fröbelgasse 33/10, A-1160 Vienna Austria 43.699.12.915.349 www.kashi.at PAGE 162

KesselsKramer

Lauriergrachat 39 1016 RG Amsterdam The Netherlands 31(0)20.5301060 www.kesselskramer.com PAGES 104–110

Kinesis

P.O. Box 683 Ashland, OR 97520 USA 544.482.3600 www.kinesisinc.com

Kinetic

2 Leng Kee Road Thye Hong Centre 04-03A Singapore 159086 65.637.957.92 www.kinetic.com.sg PAGES 11, 13, 54, 63, 185, 192

KROG, Ljubljana

Krakovski nasip 22 1000 Ljubljana Slovenia 386.41.780.880 PAGES 163, 205

Kym Abrams Design

213 West Institute Place Suite 608 Chicago, IL 60610 USA 312.654.1005 www.kad.com PAGES 131, 200, 237, 238, 279

Lain Livingston Marketing Studio

Suite 49, 191 Marietta, GA 30066 USA 404.550.5508 www.lainlivingston.com PAGE 119

3595 Canton Road

Landini Associates

42 Davies Street Surry Hills, Sydney, NSW 2010 Australia 612.9360.3899 www.landiniassociates.com PAGES 172-177

Landor Associates

Klamath House 18 Clerkenwell Green London EC1R ODP UK 44.20.7880.8000 www.landor.com pages 296–299

Lienhart Design

939 W. Huron Suite 310 Chicago, IL 60622 USA 312.738.2200 www.lienhartdesign.com PAGE 89

Liska + Associates

515 North State Street 23rd Floor Chicago, IL 60610 312.644.4400 www.liska.com PAGES 23, 28, 36, 89, 130, 135, 144, 146, 154, 157, 187, 195, 208, 239, 241, 254–255, 264–269, 278, 287

Lloyd's Graphic Design Ltd.

17 Westhaven Place Bienheim 7301 New Zealand 643.578.6955 PAGES 76. 244

Lowercase, Inc.

213 West Institute Place Suite 311 Chicago, IL 60610 USA 312.274.0652 www.lowercaseinc.com PAGES 88, 151, 160

Mad Dog Graphx

1443 W. Northern Lights Blvd. Suite U Anchorage, AK 99503 USA 907.276.5062 www.thedogpack.com PAGES 52, 62

Manasteriotti Design Studio

Sestinsky dol 99A

Zagreb 10000

Croatia
385.98.253.466
www.mds01.com
PAGES 62, 70

Matthew Schwartz Design Studio
611 Broadway

Suite 430

New York, NY 10012 USA 212.925.6460 www.ms-ds.com PAGES 49, 52, 91, 141, 150

mCube

11 Zaver Mahal 5th Floor 66 Marine Drive Mumbai 400020 India 91.98811.49455 www.mcubedesign.com PAGES 15, 210–215

Michele Moore Design

4885 Avoca Street Los Angeles, CA 90041 USA 323.528.7404 www.mooregraphicdesign.com

Mindseye Creative

21 B Anand Darshan 13 Peddar Road Mumbai 400026 India 201.377.2494 www.mecstudio.com PAGE 84

Mirko Ilić Corp.

207 E. 32nd Street New York, NY 10016 USA 212.481.9737 www.mirkoilic.com PAGES 17. 22. 290–295

The Moderns

900 Broadway Suite 903 New York, NY 10003 USA 212.387.8852 www.themoderns.com PAGES 216–223

Monderer Design

USA 617.661.6125 www.monderer.com PAGE 147 Morla Design, Inc.

San Francisco, CA 94107

2067 Massachusetts Avenue

Cambridge, MA 02140

1008A Pennsylvania Avenue

USA 415.543.6548 www.morladesign.com PAGE 163

Nazy Alvarez

12321 Ocean Park Blvd. Los Angeles, CA 90064 USA 310.270.7576 www.nazyalvarez.com PAGE 76

Nita B. Creative

991 Selloy Avenue St. Paul, MN 55104 USA 651.644.2889 www.nitabcreative.com

PAGE 279

Nothing: Something: NY

242 Wythe Avenue Studio 3 Brooklyn, NY 11211 USA 646.221.9972 www.nothingsomething.com PAGES 34, 47, 183, 186, 196, 207

Oliver Russell

217 S. 11th Street Boise, ID 83702 USA 208.287.6528 www.oliverrussell.com

One Method Inc.

7145 West Credit Avenue Mississauga, Ontario L5N6J7 Canada 905.603.0180 www.onemethod.com PAGES 49,86

800 Washington Avenue N.

OrangeSeed Design

Suite 461

Minneapolis, MN 55401 USA 612.252.9757 www.orangeseed.com PAGES 113, 240, 281 p11 Creative

20331 Irvine Avenue

Suite E5 Santa Ana Heights, CA 92707 USA 714.641.2090 www.p11.com PAGES 30, 43, 52, 70, 80, 203, 205, 207

Perks Design Partners

333 Flinders Lane 2nd Floor Victoria 3000 Australia 613.9620.5911 www.perksdesignpartners.com PAGES 198. 204. 206. 256. 312

Poulin & Morris, Inc.

286 Spring Street 6th Floor New York, NY 10013 USA 212.675.1332 www.poulinmorris.com PAGES 60, 155, 310

Ramp Creative

453 South Spring Street Suite 819 Los Angeles, CA 90013 USA 213.623.7267 www.rampcreative.com PAGES 235, 242, 252, 257

The Republik

313 West Main Street Durham, NC 27701 USA 919.956.9400 www.therepublik.net PAGES 83, 203

Riordon Design

131 George Street
Oakville, Ontario L6J3B9
Canada
905.339.0850
www.riordondesign.com
PAGES 250, 283

Ross Levine Design 2237 Parker Street Berkeley, CA 94704

USA 510.665.4551 www.rosslevinedesign.com PAGE 28

Flat 2304

Progress Commercial Bldg 9 Irving Street, Causeway Bay Hong Kong 852.9707.0066 www.rootidea.com PAGE 53

Sayles Graphic Design

3701 Beaver Avenue Des Moines, IA 50310 USA 515.279.2922 www.saylesdesign.com PAGE 238

Seltzer Design

45 Newbury Street Suite 406 Boston, MA 02116 USA 617.353.0303 www.seltzerdesign.com PAGES 40, 73, 117

Sharp Communications, Inc.

425 Madison Avenue New York, NY 10017 USA 212.829.0002 www.sharpthink.com PAGES 31, 87, 89

Simon & Goetz Design GmbH & Co. KG

Westhafen Pier 1, Rotfeder-Ring 11 Frankfurt am Mai/Hessen/60327 Germany 49(0).69.968855.0 www.brand-equity-group.com PAGES 121, 132, 232

sky design

50 Hurt Plaza Suite 500 Atlanta, GA 30303 USA 404.688.4702 www.skydesigngraphics.com PAGE 313

Sockeye Creative

800 NW 6th Avenue Suite 211 Portland, OR 97209 USA 503.226.3843 www.sockeyecreative.com PAGES 55, 84, 159

Spark Studio

11 Yarra Street South Melbourne, Victoria 3205 Australia 613.9686.4703 www.sparkstudio.com.au PAGES 11, 18, 36, 37, 38, 51, 57, 61, 71, 115, 128, 131, 133, 136, 138, 201, 205, 246

Springboard Creative

5606 Outlook Mission, KS 66202 USA 913.789.7408 . www.springboardcreative.biz PAGE 76

Squarehand/The Buddy Project

21-38 31st Street Suite 5P Astoria, NY 11105 USA 646.285.5600 www.squarehand.com PAGE 276

Stoller Design Group

1818 Harmon Street Berkeley, CA 94703 USA 510.658.9771 www.stollerdesigngroup.com PAGES 114, 128, 135, 140, 277, 282

Studio International

Bucomjicarva 43 Zagreb 10000 Croatia 385.137.60171 www.studio-international.com PAGES 55, 289

Sussner Design Company

212 3rd Avenue N.
Suite 505
Minneapolis, MN 55401
USA
612.339.2886
www.sussner.com
PAGES 11, 23, 24, 69, 70, 81, 133, 136, 142, 186, 194, 202, 281, 287, 308

Taber Creative Group

1693 Eureka Road Suite 200 Roseville, CA 95661 USA 916.771.6868 www.tabercreative.com

Talisman Interactive

4169 Main Street Suite 200 Philadelphia, PA 19127 USA 215.482.6000 www.talismaninteractive.com PAGES 11, 36, 44, 49, 62, 89, 119, 122, 129

TD2

Ibsen 43
Ibs

Timber Design Company

4402 N. College Avenue Indianapolis, IN 46205 USA 317.213.8509 www.timberdesignco.com PAGES 23, 41, 44, 62

urbanINFLUENCE Design Studio

423 Second Avenue, Ext. South Suite 32 Seattle, WA 98104 USA 206.219.5599 www.urbaninfluence.com PAGES 29, 39, 55, 62, 67, 80, 91, 115, 140

The Valentine Group

555 West 25th Street Floor 3 New York, NY 10001 USA 212.989.8188 www.valentinegroup.com PAGES 74-75, 118, 124-125, 126, 224-230

Valiant Media. Inc.

3116 Commerce Street Suite D Dallas, TX 75226 USA 214.741.4300 www.valiantmedia.com PAGES 11, 23, 49, 70

Voice

217 Gilbert Street Adelaide, SA 5000 Australia 618.8410.8822 www.voicedesign.net PAGES 32–33, 114

Wages Design

887 West Marietta Street Suite S-111 Atlanta, GA 30318 USA 404.876.0874 www.wagesdesign.com PAGES 44, 199, 284

Yes Design Group

7220 Beverly Blvd.
Suite 202
Los Angeles, CA 90036
USA
323.330.9300
www.yesdesigngroup.com
PAGES 59, 282, 285, 289

ABOUT THE AUTHOR

Steven Liska founded Liska + Associates, Inc. in 1980. The visual design firm, based in Chicago and New York, creates strategy-driven, comprehensive branding programs. Liska + Associates partners with and designs for a wide range of clients—from image-conscious businesses to complex corporations—that need help clarifying their brand messages.

ACKNOWLEDGMENTS

We wish to thank enlightened clients everywhere who understand the value of design and appreciate the expertise of designers. Thanks also to the array of professionals who regularly collaborate with designers—from photographers and printers to writers and programmers. Your work is vital to any successful design project. Special thanks to Carole Masse, Jamie Jazdzyk, and all the people at Liska + Associates.

CARDONALD	COLLEGE LIBRARY
	3230215258